ART & DESIGN

The Essential Guide to

Patrick Lowry

Hodder & Stoughton
A MEMBER OF THE HODDER HEADLINE GROUP

A catalogue record for this title is available from The British Library

ISBN 0 340 674059

First published 1997
Impression number 10 9 8 7 6 5 4 3 2 1
Year 2002 2001 2000 1999 1998 1997

Typeset by Wearset, Boldon, Tyne and Wear.
Printed in Great Britain for Hodder & Stoughton Educational, a division of Hodder Headline Plc, 338 Euston Road, London NW1 3BH by Scotprint, Musselburgh, Scotland.

Contents

Acknowledgements

The author and publisher would like to thank the following for permission to reproduce material in this book:

AKG Photo, London: 3.6 Andy Warhol; 4.1 Willem de Kooning; 4.5 Roy Lichtenstein; 8.1 Andy Warhol; page 86 Pablo Piccasso/Museo Nacional Reina Sofia; page 121 Marcel Duchamp; *Annely Juda Fine Art*: 2.2 Anthony Caro; Artangel: page 32 Rachel Whiteread (House Oct '93 - Jan '94); *Bridgeman Art Library*: page 24 top right © Umberto Boccioni/Mattioli Collection, Milan; *British Museum*: page 24 bottom left *Bournemouth and Poole College of Art and Design*: 9.2; *Corbis*: 1.1 Gianni Orti; 3.2 Paul Klee/The Barnes Foundation; 4.2 and 4.7 © Alexander Burkatowski; 4.3 Kimbell Art Museum; 4.4 Claude Monet/Philadelphia Museum of Art, 6.1 George Braque/Philadelphia Museum of Art; 4.6 Charles & Josette Lenars; page 13 top Thomas Gainsborough/The National Gallery, London; page 23 Araldo de Luca; page 80 © Donald Judd/State of New York; page 85 Frank Lloyd Wright photo © Richard Cooke; Crafts Council: 2.4 Paul Spooner; page 31 top Claire Guest; *General Motors*: page 115; page 10 reproduced by permission of Henry Moore Foundation; *Institut Amatller D'Art Hispanic*: page 95 Pablo Picasso; *Jay Joplin*: page 98 courtesy of Gateshead City Council; *Kingston University*: 9.4; *Kunsthalle Tubingen*: page 13 centre Richard Hamilton; *Life File*: page 77 photo © Andrew Ward; *Loughborough College of Art and Design*: 9.5; *Mario Carrieri/Cassina I Maestri Collection*; 2.1 Martin Charles: page 79; *Musee National d'Art Moderne, Paris*; 1.4 © Succession H. Matisse; *Rochester School of Three Dimensional Design and Technology*: 9.6; *Rover Group Ltd*: page 11; The Surrey Institute of Art and Design: 9.7; Tate Gallery London: 1.3 Mark Rothko; 3.1 Frank Stella; 4.8 Jackson Pollock. page 28, 31 bottom Naum Gabo; page 82 © Bridget Riley (To a Summer's Day 2, 1980); page 89 Richard Deacon; *The Tate Gallery St Ives*: page 14, page15; *Virlane Foundation Collection, New Orleans*: page 24 top left Duane Hanson; *Zanotta Spa*; page 26 left © Marino Ramazzotti, page 26 right Mauro Masera.

The author and publisher are grateful to Mark Lewis for permission to reproduce the picture of his work *Straining at the Leash* on the cover of this book.

Introduction

This book is intended for students who are seriously considering a career in art, craft or design and are on, or are about to start, a diagnostic art and design course:

- Advanced GNVQ
- BTEC National Diploma in General Art & Design
- BTEC National Diploma in Foundation Studies

The book is designed to help develop an understanding of the various principles, fundamental skills and knowledge associated with creating work, ideas and intellectual inquiry within the areas of Fine Art, Crafts or Design, whilst presenting a range of information that will allow students to recognise and identify the areas of particular interest in relation to their own personal development.

It is important to recognise that whilst this book will examine, explain and illustrate a wide range of issues, the essential aspect of achieving success is combining the practical process of making work, and an on-going intellectual dialogue with the work as it develops. Becoming an artist, craftsperson or designer is not an easy option and cannot be achieved without personal commitment. It is also impossible to accomplish without involvement in the process of examination, exploration, enquiry and development.

Although this book has been written and presented in a way that identifies, examines and explains different aspects of the activities that contribute to the successful development of art, craft and design work, these individual aspects rarely exist in isolation. Developing ideas and making any form of work will require an understanding of the visual language being used, the media, methods and technology involved, as well as an awareness of the work of others that have explored similar issues and also the context in which you are working. You may need to refer to more than one chapter in the book when tackling a particular task or assignment; you may need to look for example at Chapter 6, **Working to self-devised briefs**, or Chapter 7, **Working to design briefs**, to

clarify the context in which you are working; Chapter 4 to identify artists, designers or craftspersons that have dealt with similar issues, and Chapter 3 to help you assess the most appropriate methods of making your work. To help you use the range of information available, at the beginning of each chapter you will be referred to the other chapters that closely relate.

Throughout the book you will find sample assignments that have been designed to focus on particular issues, and through examples of students work illustrate how various issues have been explored.

Later in the book, you will find a chapter dedicated to the range of available careers and future progression opportunities, including the process of application to higher education courses such as the BA(Honours) Degree and Higher National Diploma in art, crafts or design.

General, diagnostic Art and Design courses

A general, diagnostic art and design course should perform two main functions:

1 to help students recognise the exciting range of opportunities that exist within this area of creativity; and
2 to develop and establish fundamental skills, process and understanding as a foundation on which to build future development.

Whilst courses are structured and presented in different ways, the common intention is to allow a student to develop their individual creative abilities and personal interests to a level where they can progress either onto a higher level course of study or into employment. In nearly all cases, students will firstly be introduced to basic practical and intellectual principles. These in turn will be used to explore a range of art, craft and design problems and activities, allowing individuals to recognise and develop their own particular interests and strengths. Finally individual interests and direction will be confirmed and established through the development of an individual and personally focused body of work within broad specialist areas such as Fine Art, Graphic design, Fashion and textiles or Three-dimensional design.

The Advanced GNVQ Art and Design qualification has been devised to reflect and support this development. The qualification is broken down into three main groups of units, Mandatory, Optional and Additional, and there is also a range of key skills units which are common to all GNVQs. Whatever changes to GNVQ specifications are made, the basic artistic experience that lecturers devise for students will remain the same. The breakdown of content into units may alter slightly, or a new assessment regime may be introduced.

Mandatory units form the basis of the qualification and cover the knowledge and understanding that is common to all art, craft and design disciplines. These units have been used as the focus for the individual chapters in the book, and comprise:

- Unit 1 Two-dimensional visual language covered in Chapter 1
- Unit 2 Three-dimensional visual language covered in Chapter 2
- Unit 3 Materials, technology and process covered in Chapter 3
- Unit 4 Historical and contemporary contextual references covered in Chapter 4
- Unit 5 Business and professional practice covered in Chapter 5

- Unit 6 Working to self-identified art briefs covered in Chapter 6
- Unit 7 Working to set design briefs covered in Chapter 7
- Unit 8 Presenting work covered in Chapter 8

Optional units comprise of a group of eight units that provide a continuation and development from the mandatory units, whilst encouraging a more selective personal development. Students chose four of the units which reflect their own broad interests. Optional unit titles vary slightly from one examining body to another.

Additional units: as the name implies, this range of units are extra to those needed to achieve the basic qualification. They are intended to support and reflect a greater depth of personal exploration and enquiry within your chosen area of specialisation. If you are serious about pursuing a career in art or design, it is likely that you will need to develop your work to this level, particularly if you wish to apply to higher education. These units reflect a level of development comparable to a National Diploma in Foundation Studies or a two-year General Art and Design National Diploma.

Key Skills

All General National Vocational Qualifications, of whatever discipline, require that students are able to demonstrate their abilities in three key areas:

- application of number
- communication
- information technology

National Diploma students have similar requirements which are identified as common skills. In both cases it is important to recognise that we all need these skills to function and survive in society today, and that they should be easily demonstrated if you are using your course effectively and fulfilling the requirements of set briefs and assignments.

How key skills are identified and assessed will vary according to how your own course is structured, but in most cases opportunities to demonstrate particular aspects of these skills will naturally occur in practical or research, art, craft or design based, assignments.

The skills you are required to demonstrate for Advanced GNVQ are:

Application of number
3.1 Collect and record data
3.2 Tackle problems
3.3 Interpret and present data

Communication:
3.1 Take part in discussions
3.2 Produce written material
3.3 Use images
3.4 Read and respond to written materials

Information Technology:
3.1 Prepare information
3.2 Process information
3.3 Present information
3.4 Evaluate the use of information technology

We hope you enjoy using this book as you progress and develop your artistic career.

1

Two-dimensional visual language

Introduction

This chapter introduces and examines the processes, skills, concepts and ideas associated with two-dimensional work. The ability to work in two dimensions and to use two-dimensional visual language is fundamental to working as an artist, designer or craftsperson. To allow a clearer explanation and understanding, various individual aspects of two-dimensional visual language such as line, tone or colour have been identified. It is important to recognise however, that in practice these aspects are rarely used in isolation from one another. Throughout the chapter, reference will be made to the methods, **media**, materials and technology used to create images. In Chapter 3, **Media, materials and technology**, you will find more detailed information on the practical aspects of materials and tools used by artists and designers in the execution of their work. Throughout this and subsequent chapters, reference will also be made to individual artists, designers, craftspersons and art and design movements. These references form the basis of an understanding and recognition of the work of others and their relationship to your own work. Chapter 4, **Historical and contemporary contexts**, enlarges on this important area of study.

This chapter will focus on:

- two-dimensional formal elements
- the use of two-dimensional visual language
- the use of two-dimensional techniques

Two-dimensional visual language

If we consider the chapter title, 'Two-dimensional visual language', it will help to explain what we shall be examining. The processes and work that we shall be looking at are two-dimensional, that is, work that is flat and seen from one viewpoint.

Verbal language

The word 'language' is one that we usually associate with speaking, reading or writing. Learning to speak, read and write is something we spend a lot of time doing as we grow up, and something we continue to develop and refine throughout our lives. We gain information through verbal communication. Almost as soon as we have learnt to speak, we learn to ask questions and acquire knowledge and understanding through verbal instruction and explanation. We also learn different ways of speaking by experience and practice. We change our tone and our vocabulary according to whom we are speaking and what we are saying: talking casually to a close friend and giving instructions or information to a stranger will involve using speech or verbal communication in different ways. We also demonstrate our emotions through the tone and inclination of our voice.

We learn to use writing in a similar way. We learn the formal aspects of writing, i.e. spelling, grammar, punctuation and presentation. The essential function of written communication is the ability to convey information. Virtually everything we read informs us in some way or other. And this form of communication, too, involves different styles. A scribbled note to a friend on a scrap of paper is perfectly acceptable and demonstrates a relaxed and friendly quality. However, the same approach would not have the desired effect if you were writing an application for a job. With the latter, you would have to spend much more time deciding what you wanted to say and how to say it. You might decide that such an application needs to be typed to give it clarity and authority, or you may feel that a handwritten application will allow you to demonstrate your personal writing skills.

Visual language

Artists and designers develop and use visual language, i.e. pictures, to perform functions similar to those of written or spoken language. It allows us to communicate, describe, question, explore, narrate, explain, debate, express emotions, record information and inform. It often allows us to communicate much more effectively and clearly than can written or spoken language by going beyond the limits of the written and spoken word and so giving us access to a much greater audience. You do not need to understand French to appreciate a drawing by Monet, or to be able to read sixteenth-century Italian to see how Leonardo da Vinci was exploring ways to enable man to fly.

Mark-making

The majority of two-dimensional images are created by applying marks to a surface. Whether this is done with pencil (graphite) or charcoal on paper, paint on canvas or even by creating an image on a computer screen, the processes of building an image are fundamentally the same. The range of materials and tools which are available to create these marks is almost infinite. Artists and designers are constantly exploring new ways of expanding their visual vocabulary, finding media and methods that will allow them to express themselves more clearly or effectively.

Drawing

Drawing forms the basis of two-dimensional visual language and allows the artist, craftsperson or designer to explore, examine, understand, record and communicate, irrespective of the particular discipline they are working in. Although it is important to recognise that drawing covers a much broader range of activities than the use of pencil on paper, this is probably the most common and familiar way of creating images. A pencil is convenient and can be used to make a huge range of marks that can be applied to many different styles of drawing: loose, flowing line drawings, dark tonal drawings that deal with light and form, or formal measured scale drawings that might be used by an architect or engineer. The ability to erase marks, not just to remove mistakes but also to create or re-establish lighter areas, extends the pencil's range even further. One of the pencil's limiting factors, however, is the width of the mark it can make, and therefore the scale of drawing it is practical to produce. On the other hand, charcoal is an excellent medium for making large drawings, and is equally suitable for line or tone. However, it can be messy to handle and, even when used in pencil form, fine accurate detail becomes less easy to achieve. It is therefore less likely to be used where measured accuracy is of prime importance.

You can see already that your choice of media will, to a large extent, be dependent on the intended nature of the work being produced.

The creative process of art and design is about exploration and understanding. The more you understand about the media and processes you are using, the more confidently, fluently and appropriately you will be able to apply them. In the exploration of media, you should be prepared for things not always to work as you anticipate. Your creative development will be slow if you only work within the limits of what you already know. The process of testing the unknown is one of the things that makes being an artist or designer exciting.

Line

A line in the context of drawing can probably best be described as a single thin mark made by a particular drawing medium, for instance pencil, charcoal or **conté**. When describing objects with line, we tend to draw around the 'edges', or where a surface changes direction. You can vary the quality of a

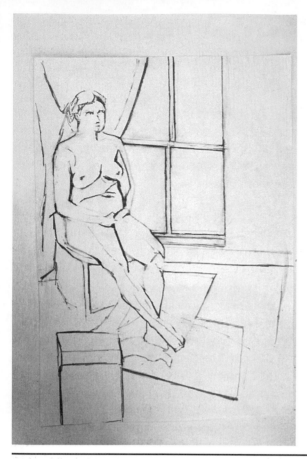
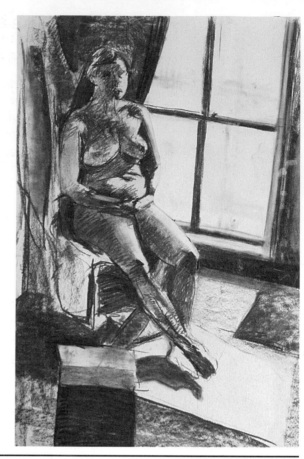

These two drawings of a figure by a window show how differing line quality relates to the tonal changes in the subject

line, making it darker or lighter, thicker or thinner, continuous or broken. If the drawing that you are making is based on direct observation, the quality of line used will often be dictated by the degree of tonal contrast that exists on each side of the 'line' being observed. An object placed in front of a sunlit window, for instance, will exhibit strong tonal contrast, the object appearing dark against a light background and therefore giving a clearly defined outline. Where the object is in front of a darker background, the contrast will be much less, and in consequence the outline will be less defined.

Although line drawings can be very descriptive and will often allow the artist or designer to communicate and record with a clarity and fluency that would be difficult to achieve in any other way, when we look at objects and space around us, we see that lines rarely exist on their own.

Tone

The way light falls on objects and surfaces informs us of their shape and form. By using **tone**, you can create the illusion of form in two dimensions. When using tone in a drawing or painting, you should initially identify where the lightest and the darkest areas appear in the subject matter you are working from and at the direction from which the main source of light is coming. The greater the range of light to dark that is used, the greater the feeling of depth that can be created. An image that has only a mid-range of tones with little or no very light or dark can have a tendency to look flat. Although the

use of photographs as the source material for creating drawings or paintings is rarely preferable to working directly from original subject matter, it is worth examining good-quality photographs, and in particular black and white images, to see how the full range of tones from black to white create the illusion of form, space and depth. You should also note how the varying areas of tone are used in the composition of the image.

Perspective

Two-dimensional visual language has a history dating back to at least 1400 BC, as demonstrated by the Paleolithic paintings in caves at Lascaux in France; see colour plate 1.1. Since this time, our ability to record and communicate through two-dimensional images has become increasingly sophisticated as fundamental principles in the use of this language have been developed.

As with the cave paintings, two-dimensional images are normally descriptions of the three-dimensional world around us. The use of perspective is one of the best ways of achieving this, allowing us to describe form and space just by the use of line. The discoveries and inventions of the architects **Filippo Brunelleschi** (1377–1446) and **Leon Battista Alberti** (1404–72), and the painter **Paolo Uccello** (1397–1475) and others, established the basis of the **Perspective System** which has been used by Western artists and designers ever since.

Although, since Brunelleschi, many artists and designers have invested a lot of time in examining the effects of perspective, and although many books have been written on the subject, the underlying principles have not changed and are basically very simple. Our understanding of the world around us is built up from many visual clues, but one of the most obvious is the recognition that objects that are nearer to us appear to be bigger than similar objects further away. This seeming diminution in size applies not only to one object in relation to another but also to the apparent changes in size within an object or space according to its distance from the viewer. The other main influence on perspective is the relationship between the viewers' eye level and the objects or space being viewed.

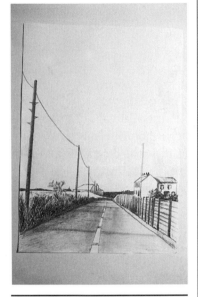

Diminution and eye level

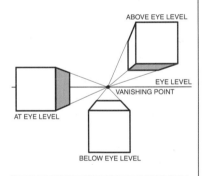

One-point perspective

Diminution and eye level

In this view, we can see the basic elements of linear perspective. The telegraph poles, fence posts and road markings appear bigger the closer they are to us, their size and the distance between them decreasing as they recede towards the horizon. The fence and the road also appear to go up towards the horizon from below our eye level, whilst the tops of the telegraph poles appear to come down towards the horizon from above our eye level. All the elements therefore seem to converge at one point.

One-point perspective

Receding parallel lines appear to converge, meeting at a single point on the eye level, called the **vanishing point**. Only two faces of the cube can be seen, and the front and rear planes remain parallel to each other. The vertical lines remain square to the horizon.

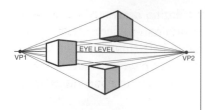

Two-point perspective

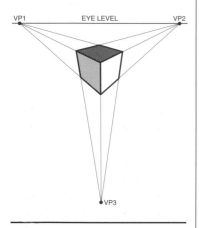

Three-point perspective

Two-point perspective

Two vertical faces of the cube can be seen, with each having its own vanishing point, and again the vertical lines remain square to the horizon.

Three-point perspective

As the eye level is raised and the view of the cube becomes one of looking down as much as looking from the front, a third vanishing point has to be introduced as all lines and faces are receding.

Perspective study

It must always be remembered that linear perspective is very much a simplification and a formalised way of viewing the world. The vertical sides of a cube can never really appear parallel, as in one- and two-point perspective. This is because, wherever our eye level is, the cube's sides will be either above or below our eyes and therefore receding away from us, as in three-point perspective. We also move our eyes when observing the world around us, giving us in effect a constantly changing viewpoint.

Colour

We have seen that light falling on objects and surfaces allows us to recognise and record their three-dimensional qualities in two dimensions. The other major quality that light gives us is the ability to see colour. Most of the time, the world around us is lit by either sunlight or artificial light. This is often described as 'white' light, and it is this white light that colours our environment.

About 200 years ago, **Isaac Newton** (1642–1727) discovered that sunlight can be broken down into the colours of the spectrum, red, orange, yellow, green, blue and indigo, which he termed **primaries**. It was not until many years later when the physicist **Thomas Young** (1773–1829) was examining the effects of combining the individual spectral colours that he realised that white light can be made by adding together just three primaries. He also discovered that all the colours of the spectrum can be recreated by an appropriate mixture of these three primaries. These three primaries of light, each of which comprises approximately one third of the spectrum, are red, green and dark blue.

Additive and subtractive colour mixing

By projecting three partly overlapping beams of light coloured red, green and blue onto a white screen, we can see that the outer patches where there are no overlaps show the individual colours of the three lights; that where two colours overlap, a **complementary colour** is formed; and that the overlapping of all three colours produces white.

It is because white light is made up of all the visible colours of the spectrum that we see our surroundings in colour. As light falls on a surface, the colour that we see will depend on which part of the spectrum is reflected

back to our eyes and which part is absorbed by the surface. A white surface such as this page reflects nearly all the light that falls on it. The lettering on this page absorbs virtually all of the light, allowing little to reach our eyes, so we see it as black. If a surface absorbs the green and blue part of the spectrum whilst reflecting the red light, we will see red. We describe the mixing of coloured light as **additive**; see colour plate 1.2a. The more colours we mix, the lighter the mix becomes, until we get white. We call the mixing of pigment **subtractive** (see colour plate 1.2b) since the more colours we mix together, the less light is reflected. Pigment (see colour plate 1.2c) acts like a selective sponge for light, absorbing parts of the spectrum and reflecting the remainder. Green paint, for instance, absorbs the red part of the spectrum, reflecting the blue and yellow which we see combined as green.

When mixing paint colours, you are using the process of subtractive colour mixing. Mixing two of the **primary-coloured** pigments, red, yellow or blue, will give you a **secondary colour**. Mixing all three will (in theory) give you black. Paint pigments vary in quality and may not always produce exactly the theoretical result anticipated. Practice and familiarity with a particular paint will help you to produce accurate and predictable colour mixes. It is the quality and amount of pigment in paints that most affect the cost, and this is why you will see big variations in the price of apparently similar products.

Colour and space

Whilst we can make very clear and concise representations of three-dimensional form and space using line and tone, it is important to recognise the effect that colour can have on our perception of space. These effects are most noticeable when we view the landscape. As you look from objects that are close to you towards the distant horizon, you will notice that colours that are closer to you are more intense (i.e. more **saturated**), this intensity progressively diminishing, along with the tonal contrast, the further away the objects are from you. The colours will often eventually merge into subdued and subtle greys as they near the horizon. This effect is known as **aerial perspective**.

The temperature of a colour will also have an effect on where it appears to be in space. Generally, **warm** colours will appear closer than **cool** ones if all other aspects such as size and saturation appear uniform.

The examples of work from the sample assignment at the end of the chapter show how students have examined the effects of colour on spatial perception.

Colour and emotion

Colour is a powerful aspect in the creation of an emotional response to a piece of work. It will affect how we read and understand a particular image. The ability of colour to evoke emotion has been explored by many artists as a major aspect of their work. The **Fauve** artists, **Henri Matisse** (1869–1954), **André Derain** (1880–1954), **Maurice de Vlaminck** (1876–1958) and others, at the very beginning of the 20th century, shared an interest in strong, pure colour and flat pattern, taking their inspiration from the **post impressionists**, **Vincent Van Gogh** (1853–90) and in particular **Paul Gauguin** (1848–1903). Although the Fauvists continued to use the landscape and figure as their subject matter, their use of colour was symbolic and expressionistic rather than a

direct representation of the colours of the subject. In the work of **colour field** painters such as **Mark Rothko** (1903–70), the viewer is left to respond to nothing but pure colour; see colour plate 1.3. The large scale of Rothko's work is important, dominating the viewers' visual senses and isolating them from other surrounding influences.

Colour is an important part of the graphic designer's vocabulary. In addition to the emotional responses that colours evoke, many colours have established particular **symbolic** meanings through use and association. Examples are as follows:

- red – has associations with danger, stop or warning
- green – associated with safety or go, and ecological friendliness; olive green is also associated with sophistication and quality, and is often used with gold in this context, as for example with Harrods and After Eight Mints
- black – again, associations with sophistication, but also with despair or death
- white – pure, clean and refreshing, particularly when used with blue or green
- blue – cool, fresh, clean, male
- pink – soft, feminine, gentle
- yellow – sunshine, freshness

Colour is a particularly important element in food packaging, with different colours having particular taste associations:

- Green – vegatables, mint
- Red – tomatoes
- Brown – chocolate, coffee
- Yellow – lemon

Blue is less commonly used, although its associations with freshness is often exploited in the packaging of milk and other dairy products.

A summary of colour terminology

Primary colours (of pigment)	red (magenta), blue (cyan) and yellow (yellow).
Secondary colours	these are formed by mixing two primary colours: red + blue = violet blue + yellow = green red + yellow = orange
Tertiary colours	these are formed by mixing a primary and a secondary colour: red + orange = red-orange red + violet = red-violet blue + violet = blue-violet blue + green = blue-green yellow + green = yellow-green yellow + orange = yellow-orange
Complementary colours	each primary colour has its complementary, formed by a mixture of the other two primary colours: red's complementary = green (blue + yellow) blue's complementary = orange (yellow + red) yellow's complementary = violet (red + blue)
Hue	this is the quality which distinguishes one colour from another, e.g. orange from red.

Tone	this refers to the lightness/darkness of a colour subject to: tint = colour + white shade = colour + black
Chroma	this is the measure of colour purity: there is maximum chroma in primary colours, less in secondary colours, and less still in tertiary colours.
Warm–cold contrast	temperature classifications are often given to colours. On a twelve-hue colour chart, cold colours are considered to be: yellow yellow–green green green–blue blue blue–violet Warm colours are considered to be: yellow–orange orange orange–red red red–violet violet
Successive contrast	this refers to the optical effect of the complementary of a colour appearing at its edges or as an after-image when placed in association with certain other colours.
Simultaneous contrast	this refers to the effect of one colour on another colour when seen alongside each other. The effect of a red area seen against a blue area is different from the effect of a red area seen against a yellow area. Colours can be enhanced by their association.

Defining your aims

With any activity in art and design, it is important to recognise and define your intention and aims. With a language as complex as that used by artists and designers, and with the range of media, techniques and processes available, it is easy to lose the direction and focus of your work. The understanding that every one of your activities should have a purpose is a major element in achieving success. Your aim need not be that complex to be relevant and justifiable: often, simple objectives can lead to exciting discoveries and work. For instance, it may be that you wish to explore the physical qualities and range of a particular medium but with no clear idea of how you might ultimately use this understanding; and a recognition that this is the main aim for your work will free you from being inhibited in the way you carry out this exploration. Or you may feel that you just wish to practise your drawing and observational skills and are looking for a suitable subject matter. Your choice and approach will be different if you are interested in how the light and dark describe form, than if your interest is in pattern and texture. Your drawing will be more successful if it has a focus and a purpose.

If we look at the drawings of different artists and designers, it is interest-

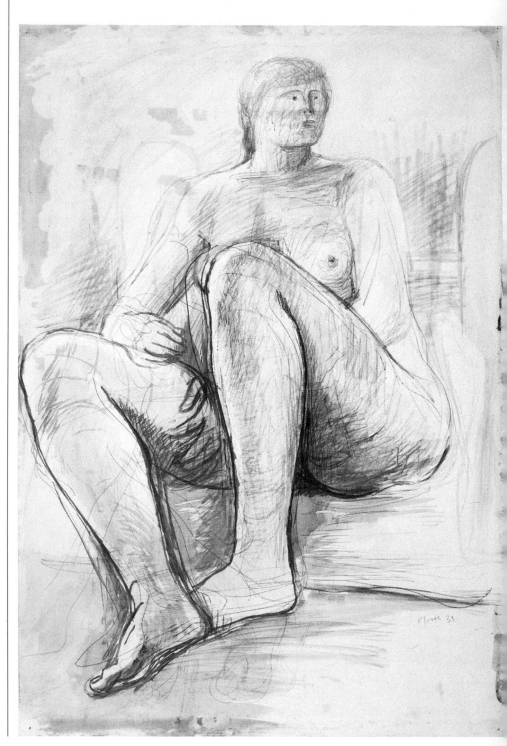

Compare this drawing of Michelle Muller by Henry Moore with the painting by Matisse shown in colour plate 1.4. The two pictures highlight the differing interests and focus of a sculptor and a painter when approaching the same subject

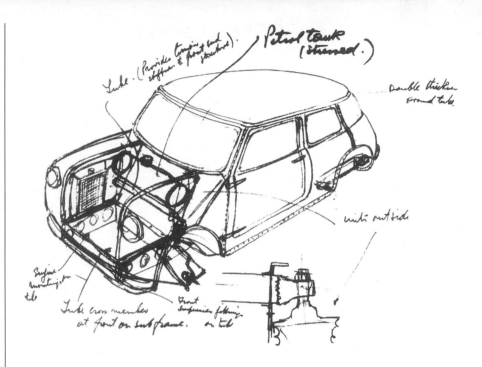

The Mini – an early drawing by Alec Issigonis

ing to see how their work clearly reflects their particular interest. If we compare the drawing made by the sculptor **Henry Moore** (1898–1986) shown on page 10 to the work by the painter Matisse (see colour plate 1.4), it can be seen that although the subject matter of their drawings is similar, it is very clear that one is interested in examining and recording the three-dimensional qualities of the figure (using tone to model the form), whilst the other is much more interested in using line to record the compositional and pattern qualities that exist within the figure and its surroundings.

The drawing above by **Alec Issigonis** (1906–88), the designer of the Mini, is not from observation: it is a visualisation of an idea. Although a simple drawing, it nevertheless clearly and concisely catches the designer's thoughts and vision and contains the fundamental elements that made it such a successful and revolutionary idea.

Using drawing for research

Despite the fact that each of the drawings shown above and on page 10 is dealing with different criteria, what is common to all is the fact that they were initially made as a way for the artist or designer to clarify and resolve thoughts and ideas as part of a process of development. The majority of drawing that we see and admire made by artists, craftspeople or designers were not intended to be works for public attention. They are often private and personal visual notes and enquiries that have only become accessible to us long after their initial purpose has been fulfilled. However experienced an artist or designer is, and irrespective of whether they are working in two or three dimensions, the need to research, examine and develop ideas will nearly always involve some form of two-dimensional enquiry.

Sketchbooks

Sketchbooks are an invaluable aid for any artist or designer, their best quality being their portability, allowing records of observations, thoughts and ideas to be recorded at almost any time or place. Sketchbooks can take many forms, and will be as individual as the person who owns them, reflecting directly the thoughts and interests of that person.

You will find that at any interview for entry onto an art or design course, the interviewer will be very interested to see your sketchbooks. These, even more than finished work, allow them an insight into your everyday thoughts. Rich and exciting sketchbooks full of ideas, observations, experiments, collections and notes that have been developed by someone constantly thinking creatively and visually, will obviously be a clear indicator of commitment and ability.

Students' sketchbooks

The sketchbook pages in colour plate 1.5 are from the work of students on a one-year National Diploma in Foundation Studies and a two-year Advanced GNVQ course in Art and Design.

Worksheets

In the studio, there is no need to research and explore ideas within the confines of a sketchbook. Working on a larger surface is less restricting and offers a greater potential to use a wider range of media and materials. The great advantage of working on **worksheets**, as opposed to sketchbooks, is that this work is immediately accessible both to you and to others. Worksheets are, as the name implies, working documents. They should be pinned up on the wall around you to enable you to constantly refer back to previous thoughts and observations, allowing you to have an ongoing dialogue with your work as it develops towards some form of conclusion.

Student worksheets

The worksheets in colour plate 1.6 are from students who have reached the specialist stage of study on an Advanced GNVQ programme.

Visual communication

The majority of two-dimensional images we are confronted with are in some way intended to **communicate**, whether the image be a painting in a gallery, an image on the television, a map, an architect's plan, or a photograph in a newspaper, magazine or, as you are looking at now, a book. The image, the method chosen to make the image and the way and the context in which it is presented will all affect the understanding of the information being conveyed.

The most common and recurring image that humanity has made, since the

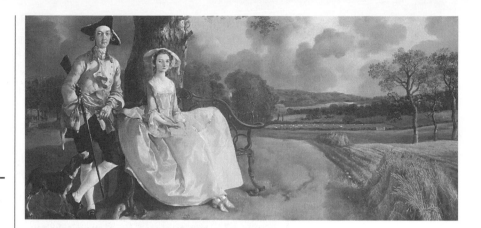

Mr and Mrs Andrews by Gainsborough was commissioned by the subjects. What did the painter want to say about them?

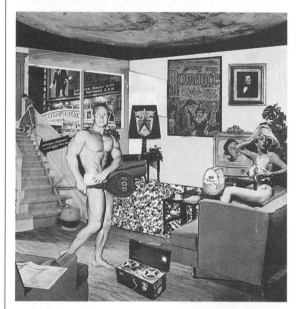

Just what is it that makes todays homes so different so appealing? by Richard Hamilton (1956) is a comment on western consumer society in the late 1950s. Would a similar visual statement look the same today?

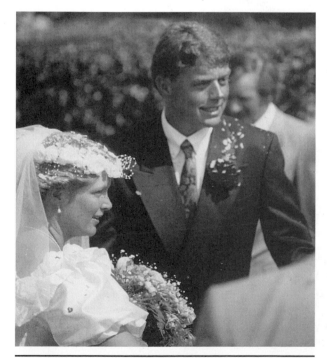

What does this picture say that a more formal wedding photograph might not?

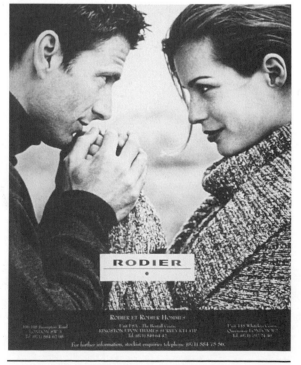

What do you think you are really buying? Perfume?

earliest times, is one of itself. Yet each of the millions of such images made will be communicating often very different messages. The four images on page 13 all have two figures as the subject matter, yet each is communicating a very different message. Apart from the similarity of subject matter, the other common factor here is that there is a **narrative** involved in each image whether actual or implied. It may be interesting to consider what these images convey and why they have been made. What are the different visual elements that have been used to inform us?

When creating two-dimensional work, there are several aspects to such work that need to be clarified and considered before you start: what is the work intended to do? Is it to record information as part of the research for further exploration leading up to a final piece? Will it primarily be for your own use? Is the exploration of media or materials a major aspect of the work? Is it to communicate an idea, thought or message to others, or is the work to be purely decorative? How is it to be used, and in what context will it appear? How is the work to be made, and is it a one-off or will it be reproduced; and if so, how?

Each of the following two images and colour plate 1.7 is based on the same subject matter, the Tate Gallery in St Ives in Cornwall, and yet each is very unlike the others, and has been made for a very different reason and communicates very different information about the subject. The floor plan is intended to help visitors find their way around the building, and the designer here has had to communicate the necessary information clearly and simply. They have also had to take into account the way this information will be reproduced, its size and how it will be printed. The colour image has been made by an artist who is interested in capturing and conveying the atmosphere, and in particular the quality of light, that is particular to the building

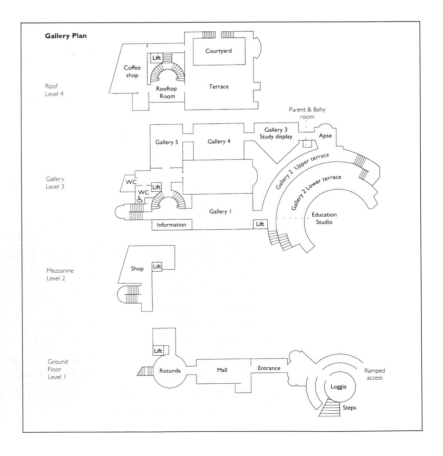

The floor plan at the Tate Gallery, St Ives

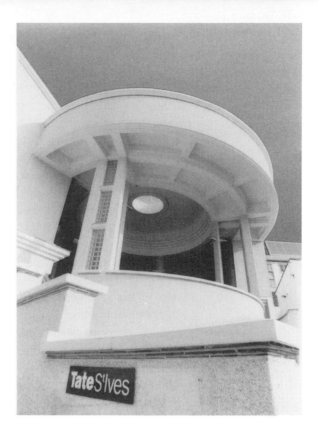

The photographer has chosen this view point, composition and lens to emphasise the strong form of the building

and its surroundings. Finally, this photograph has been taken to capture the dramatic form of the building, emphasised by the strong composition of the image.

Text as a visual design element

One of the main aspects to graphic design work is the combining of text and image. In the context of graphic design, letters and text communicate not just by the meaning of the words used but also, and often more importantly, by how these words are visually presented. The size, weight and style of the lettering used become important visual elements within a design and can send strong messages to the viewer even before the words have been read. There is a wide range of computer programs, such as Claris Works, PageMaker and Quark XPress, that allow a designer to easily explore and manipulate both image and text alongside more traditional methods and media.

You should begin to make note of the way text and images are used in different contexts – magazines, newspapers, books, posters, leaflets, packaging, CD and tape covers, and television. Collect examples and make notes on how and why you think they have been designed in the way that they have. It is interesting to look at how apparently similar contexts and products are presented to different audiences and potential users. The combinations of typeface, image and layout in magazines, for instance, will vary enormously in style to reflect the subject matter, the audience the publication is aimed at and the image it is trying to create. The differing designs of packaging for basically similar products exploit the strength of visual language to attract different consumers.

Technical drawing methods

Designers, although they may use similar media and skills in creating images to those of artists, need to be able to communicate very clear and concise information about ideas and proposals to clients and others they may be working with in the development of a design. Often, the two-dimensional information a designer produces will form the basis on which a product, a piece of graphics, packaging, a piece of architecture, or clothing or some other manufactured item will be produced.

Technical drawing is a formal drawing method that involves making drawings to an internationally recognised format. This method of conveying information about three-dimensional work gives accurate and precise information which others such as model-makers, engineers or builders, can interpret in three dimensions. Whilst these types of drawing are still made using traditional methods of pencil or pen on paper, increasingly, technical drawings are made with the aid of computers (CAD – computer-aided drawing), allowing complex forms to be drawn and manipulated and even rotated. Space can also be explored and examined in a similar way, allowing differing viewpoints and vistas to be presented.

Orthographic drawings are made either at the same size or to scale. Different views of an object or space are accurately presented, and the dimensions of the various different elements involved are also usually included. Conventionally, these views are presented in a way that shows three separate views: the **front view**, the **end view** and the **plan view**. Other views may include sections through the object or space and formalised three-dimensional representations such as **oblique** or **isometric projections**. Whilst this form of drawing communicates clear information to those used to this form of visual language, designers will also often use an orthographic drawing as the basis on which to make a more pictorial representational image, by adding shadows, highlights and colour, which will be more easily understood by a less informed viewer. Making drawings to scale as a design idea is being developed can be a useful way of working, particularly when there are already set physical parameters that have to be accommodated.

Sample assignment

The following assignments and work are from the early part of a two year diagnostic course. The assignments were intended to extend the students' already established drawing skills and to examine and explore a range of issues associated with two-dimensional visual vocabulary and media as a foundation to subsequent work.

Mark Making

T a s k ① As the subject for this drawing assignment, the students were asked to obtain a three-dimensional object that had a rich and varying surface texture. The object also needed to have a clear and definable form, e.g. decaying or eroded man-made objects, or organic forms such as fruit or vegetables. Subjects with repetitive and uniform textures were to be avoided.

The students were then asked to assemble three sheets of A1 cartridge paper, to allow them to produce the largest drawing possible of their object, taking into account the chosen viewpoint that they would take.

They were asked to make a well observed drawing of the object using scenic and compressed charcoal and rubbers. The main criteria of the drawing was to find marks which they felt represented good equivalents to the surface texture of the object. Specific attention was to be given to the edge of the drawing by cutting, tearing the edge in a way that best described the 'edge' of the object.

Mark making drawing using rubbings to create one half of the image

T a s k ② Working from the same or another object with similar qualities of form and texture, students were asked to make a second drawing. They divided an A1 sheet of paper into two equal halves by drawing a light pencil line across it, then made a closely observed drawing of half the object using a range of pencils and graphite sticks and rubber. They were to ensure that the full tonal spectrum from white to black was used, and were advised to divide the drawing along an axis that would give a similar range of textural qualities to each side of the line.

The second half of the drawing was made by closely observing the textural qualities of the undrawn section of the object. A collection of graphite rubbings on newsprint paper was then made from textured surfaces that the student thought best represented those textures. Using these rubbings, a montaged image was built up to complete the other half of the drawing.

Finally a drawing was carried out on top of the rubbings to further define the form of the object. This drawing was limited to no more than 25% of the montaged surface. An example is shown above.

ASSIGNMENT TWO

Colour

These two tasks also offered students from the early stage of a diagnostic course the opportunity to examine and develop an understanding of some of the issues associated with colour and the handling of paint. See colour plate 1.8.

T a s k ① As an introductory assignment to colour, students were asked to paint a colour wheel that examined and demonstrated:

- Primary colours
- Secondary colours
- Tertiary colours

The students were only given paint in the three primary colours to produce the complete wheel. The three secondary and twelve tertiary colours were to be mixed from these. It was discovered that it was not possible to successfully mix a true violet from the paints supplied, due to the nature of the pigments in the paint. A ready mixed violet had to be used.

T a s k ② The second part of this assignment looked at:

- Tonal values – examined by mixing black and white paint.
- Saturation values – examined using the primaries and secondary colours. The paint was progressively diluted with water in eleven stages the final stage being the white of the paper. No white pigment was used.
- Temperature values – examined by progressively mixing complementary colours.

Emphasis was put on even colour change throughout the range.

ASSIGNMENT THREE

T a s k ① For this assignment, students were required to construct a simple model (using card, paper and found objects) based on the inside space contained by three sides of a rectangle. This was then painted white.

T a s k ② With the aid of a viewfinder, the students made a series of line drawings of the model, exploring a range of viewpoints and compositions. From these they selected one. This was used as the basis on which to explore and examine the effects of colour on our perception of space, by making a series of small (A4) paintings:

1 using black, white and three neutral greys.
2 using black, white, warm greys and cool greys.
3 using black, white, warm and cool grey, one area of pattern and one using a textured paint surface.
4 using a range of colour values between two complementaries.
5 using the three primary colours to explore saturation. See colour plate 1.9.

Students used a viewfinder to make line drawings of a simple construction.

The students as a group then put up their worksheets and compared and discussed how the perceived space within each painting was affected by the varying elements of colour, pattern and texture.

T a s k ③ The final task of this assignment required the students to paint the spatial construction using discoveries made from the series of colour studies. The aim was to use colour, tone, texture, pattern and illusion to visually distort the space within the model. See colour plate 1.10.

For these assignments acrylic paint was used, as the exercises offered an opportunity to examine some of this media's range of qualities; see Chapter 3 Media materials and technology, for information on acrylic paint.

ASSIGNMENT FOUR

Transcription

This assignment was intended to give students an opportunity to become familiar with the work of other artists, by examining narrative, composition, and tonal structure within figurative painting. The comparison between a 20th century and pre-1850s painting also allowed students to recognise contextual influences on artists' work. The assignment also continued the development of skills in handling charcoal, and recognition and assessment of tonal values in relation to colour.

The students made a series of studies based on two colour reproductions: one of a 20th century painting, the other pre-1850. In selecting the work for examination they were to choose paintings that placed a figure or figures within a context, and should find two images that had clear similarities such as subject, narrative structure, composition, context or space. Although for practical reasons students were working from reproductions, it was important that these should be as large and as clear as possible to allow examination of marks and paint quality within the painting.

Suggested examples of artists were:

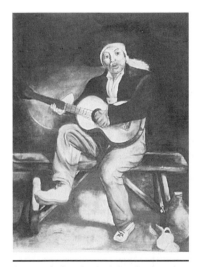

A transcription charcoal drawing based on *The Guitar Player* by Edouard Monet (1859)17

- Pre-1850s – Giotto, Duccio, David, Rubens, Bosch, Rembrandt, Pierro de la Francesca, Delacroix, Raphael, Gericault, Fuseli, Constable, Gainsborough, Goya, Turner, Velasquez.
- 20th century – Seurat, Kirchner, Chagall, Beckman, Matisse, Francis Bacon, Stanley Spencer, David Hockney, Georg Braque, Ashille Gorky, Willem de Kooning, RonKitaj.

T a s k ① Thorough, closely observed studies were made of each of the two paintings, as large as the proportions of the painting would allow, on A1 cartridge paper using a range of charcoal.

To assist in making accurate copies a grid system was used. This system of gridding can be applied to any situation where you need to enlarge an image, for instance transferring a scale drawing for a mural to a wall or a design onto a stage backdrop. The advantage of this simple system is that no measurements are needed.

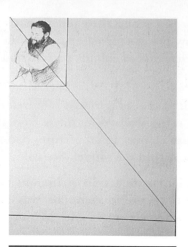

A grid is drawn over the original image. A diagonal line is drawn across the original and is extended to establish a larger rectangle of the same proportions

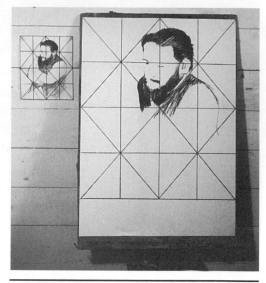

The enlarged drawing can now be developed using the grid for reference points

1 Draw diagonal lines from corner to corner across the image to be enlarged.
2 At the point at which the diagonals cross, draw a vertical line and a horizontal line right across the image. This divides the work into four equal segments of the same proportion as the full image.
3 Now repeat the process in each of the four segments. According to the size and complexity of the work, you can repeat this procedure as many times as you wish.

In this assignment, to avoid marking the work being copied, the grid was drawn on tracing paper laid over the original image.

4 The next stage is to make a grid of a similar format on the surface that you wish to make the enlarged work. The process follows the method described above; the main and crucial thing to ensure is that you start with a rectangle that is exactly the same proportions as the original design. Again this can be achieved without measuring: the original rectangle is placed in the corner of the larger surface lining up the outside edges.
5 A diagonal line is then drawn, extending from the outside corner through the opposite corner and continued until it meets either the bottom edge or side of the larger surface, in this case the A1 paper. By drawing a line at right angles from the edge, you will have a rectangle of the exact proportions of the original work. It is now a relatively simple task to copy the smaller grid using the same process as before.

T a s k (2) Having made the two charcoal studies, students used the image with the strongest structure of dark and light, to examine tonal composition. They made three studies on an A1 sheet of paper. The first study breaking the image down into three tonal values, dark, mid-tone and light. In two further studies they repeated the exercise but swapped the tonal areas around.

T a s k ③ This stage required students to make a study of one of the original images on A1 scale, this time breaking the image down into basic flat geometric shapes such as circles, squares, triangles, crescents, ellipses etc. The drawing was made using line only, paying careful attention to where the flat shapes were within space of the drawing (i.e., how they overlapped).

T a s k ④ The final part of this assignment was to produce the previous drawing, turning the flat shapes into three-dimensional forms. The students needed to make a decision about a directional light source as they were required to change this from the one in the original painting. Through the use of tone, these forms were to look as solid as possible.

Examination of the tonal structure of *The Guitar Player* by Edouard Monet using just black, white and a mid-grey

A line study breaking the image down into simple geometric shapes

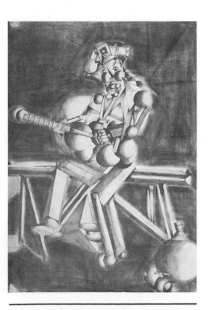

Finally, students developed the flat shapes into forms by shading

2

Three-dimensional visual language

Introduction

In the previous chapter, a broad working vocabulary associated with two-dimensional work, composition, perspective, quality of line and marks, tone, the effects of colour and the perception of space was established. In this chapter, we will examine and explore a three-dimensional vocabulary in a similar way, building on your existing knowledge and understanding to allow you to establish a broad three-dimensional visual language on which to base subsequent three-dimensional work.

We will examine the meaning of form, structure, space, scale, context, surface, colour, dynamics and plane. Throughout the chapter, reference will be made to methods, media, materials and technology used to create three-dimensional work. In Chapter 3, **Media, materials and technology**, you will find comprehensive information on the practical aspects of materials and tools used by artists, craftspersons and designers in the execution of their work. Throughout Chapter 2, reference will also be made to artists, designers, craftspersons and art and design movements etc. These references form the basis of an understanding and recognition both of the work of others and of their relationship to your own work. Chapter 4, **Historical and contemporary contexts**, enlarges on this important area of study.

This chapter will focus on:

- **three-dimensional formal elements**
- **the use of three-dimensional visual language**
- **the use of three-dimensional techniques**

As we saw in the previous chapter, artists, designers and craftspersons spend a lot of time developing two-dimensional skills to allow them to record and

interpret the three-dimensional world around them. Despite this, an equivalent three-dimensional vocabulary is often less developed, explored and understood. Because we live and function in a three-dimensional world, from the earliest age, even before we can walk or talk, our understanding of our environment through sight and touch is extremely sophisticated and well-developed. Our survival depends on this understanding but the ability to relate to our complex three-dimensional environment will for most people remain an unquestioned, unconscious activity. Given that much of the three-dimensional world that we enjoy, use and live in is the result of artists', designers' and craftspersons' work and ideas, it is necessary for us to have a clearer awareness of these qualities that influence our lives.

Formal aspects of three-dimensional work

Just as it is possible to break down, describe and examine the formal aspects of two-dimensional work, so we can also examine the formal aspects of three-dimensional work. It is important to recognise that, although for the sake of clarity, individual aspects are identified and explained, it is very rare that any particular element exists in isolation, and all three-dimensional work will contain and exhibit a range of the qualities examined.

Form

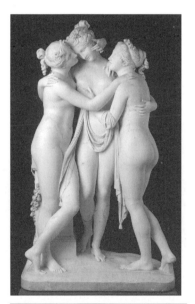

The Three Graces by Antonio Canova (1822) show very accurate reproduction of the human form

Form describes the overall three-dimensional shape of an object. The most easily described forms are the geometric ones, such as cubes, spheres, cylinders, cones and pyramids. The development of a form can take place in many ways. **Figurative** works that take their form directly through the representation of existing forms are possibly the most common among sculptural work. The sensitive and sensual marble carvings of **Antonio Canova** (1757–1822) and of Auguste Rodin demonstrate great precision in reproducing the human form. More recently, the glass fibre casts of the **American realists John de Andrea** (b. 1941) and **Duane Hanson** (b. 1925) (see page 24) accurately reproduce the human figure, although representing the human condition in quite a different way.

Another common way of developing form is to use figurative representation as the subject and starting point of three-dimensional work but then to develop the form through manipulation, distortion or simplification in ways dictated by the particular interests or concerns of the artist. This approach leads to new forms and to the production of exciting work. **Umberto Boccioni** (1882–1916), **Jacob Epstein** (1880–1959), **Henry Moore** (1898–1986), **Amedeo Modigliani** (1884–1920) and **Antony Gormley** (b. 1950) all used the figure as the main subject of their work, but each developed very different forms and qualities as a reflection of their differing interests (see page 24).

The development of form through a response to the function of an object and the materials used in its production was an underlying philosophy promoted by the **Bauhaus** movement. This approach has been a major and

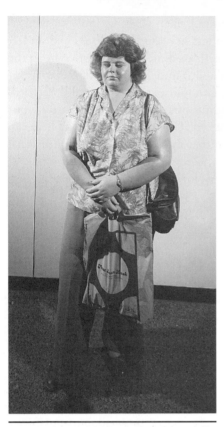

Bus Stop Lady by Duane Hanson (1983). The disconcerting realism of Duane Hanson's figures can make one feel uncomfortable as he offers us the opportunity to examine closely another member of our society

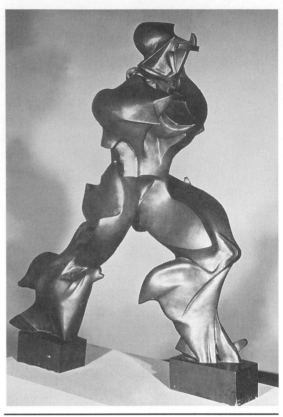

Unique Forms of Continuity in Space by Umberto Boccioni. The artist's interest in exploring and conveying the dynamic quality of movement in a static work, led to the development of this piece

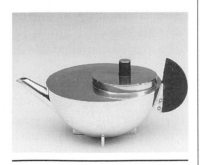

Teapot by Marianne Brandt was developed using simple geometric forms

enduring influence on the form of products and architecture since its inception in 1919. Although this approach began to lose its appeal in the late 1970s, the clean simple forms that typify this philosophy remain a recurring theme. The form of this teapot by **Marianne Brandt** is typical of the use of simple geometric forms in the development of work emerging from the workshops of the Bauhaus; it was made in 1924.

With the fast growth in the use of microelectronics, it has often become difficult for designers to use the minimal shape of the internal workings of functional products as a starting point for the development of the form of the final product. For a period, they resorted to producing anonymous black boxes as a solution to this problem. The deliberate introduction of visual clues as to the product's function, in the development of its form, has more recently become an increasing part of the product designer's visual vocabulary. This approach to the design of a product's form is known as **product semantics**, and it gives the designer the opportunity to make a statement about a product's character and context. Often, visual references will be made to the forms of earlier products that more clearly exhibited, or have, through familiarity, become associated with, the nature of their function.

The development of a form through experimentation and the manipulation of materials and processes can achieve unanticipated and successful results.

Plaster forms, made with balloons, plaster and string

These interesting forms evolved as a response to the assignment on page 110, Chapter 6. Working with the concept of wrapping and tying, these pieces were made simply by filling balloons with plaster and then tying them with string before the plaster set. However, manipulating and combining existing ready-made or found three-dimensional pieces can also lead to the development of exciting new forms.

Although we most commonly associate three-dimensional work with rigid and static materials and objects, fashion design is also an exciting area for three-dimensional exploration. Many designers are exploiting the combination of figure and fabric as a sculptural medium. Designers like **Issey Miake** (b. 1935) are taking full advantage of both the structural and dynamic qualities of natural and man-made fabric.

Space

In the context of making work, **space** is probably best described as the area between objects, surfaces or forms. The scale of a space will largely dictate how it is controlled, its effect and how it is defined. Architects design structures that contain spaces for human habitation, and it is ultimately the function of the space that is contained that will have a strong influence on the architectural form. Spaces for performance, sport, work or living in will all have very different requirements, not the least being size and scale. Space within an object should also be recognised as a visual compositional element, as with the **negative spaces** within a two-dimensional image.

Volume

Volume relates closely to space and can be applied to the space a solid form occupies or the space a form contains – the volume contained by a ceramic bowl or jug, for example.

Structures

A **structure** is a three-dimensional object that has been made by bringing several elements together to make a new 'constructed' form. Buildings are examples of large structures, although structures can be on any scale: pieces of furniture are often structures. Structures do not have to be man-made; we can see structure in natural forms such as plants.

Virtually all designers involved in three-dimensional work have at some time designed a chair, as this particular design problem gives a challenging opportunity to explore both the structural and aesthetic qualities of materials in the fulfilment of a common everyday need. Among the best-known examples are **Marcel Breuer's** (1902–81) tubular steel designs and **Gerrit Rietveld's** (1888–1964) *Red Blue Chair* (1917–18) (see colour plate 2.1) and more recently the designs of **Philippe Starck** (b. 1949) and **Jasper Morrison** (b. 1959).

Scale and context

The **scale**, and the **context** in which a piece of work is placed, have an enormous effect on how we relate to, understand and react to a three-dimensional piece of work. Depending on its size and context, the same form, or even the same object, can be small and precious, e.g. a piece of jewellery, solid and functional, e.g. a piece of furniture, or grand and monumental, e.g. a building.

Many artists use ready-made found objects in their work, and the context in which these are placed, and often their relationships to other objects, force us to question and review what we see. The **Pop Artist Claes Oldenburg** (b. 1929) has used and explored the changing of scale of common consumer products as a major theme in his work. Since 1976, he and his wife **Coosje van Bruggen** have collaborated on public works including a giant baseball bat erected in Chicago in 1977. Designers such as **Achille Castiglioni** (b. 1918), **Ron Arad** (b. 1951) and **Nigel Coats** (b. 1949) have also enjoyed taking ready-made objects from their original context, and by combining them with other objects, they have evolved new and dynamic work. Many of Castiglioni's designs recycle or borrow their inspiration from industrially made objects: everything from bicycle saddles (the *Sella Stool*, 1957) to fishing tackle (*Toio Light*, 1962). Possibly the best known of his designs is the *Mezzadro Tractor Seat Chair* of 1957, which took the 1950s classic but outdated metal tractor seat from its rural environment into an urban one, transforming an industrial object into a domestic one.

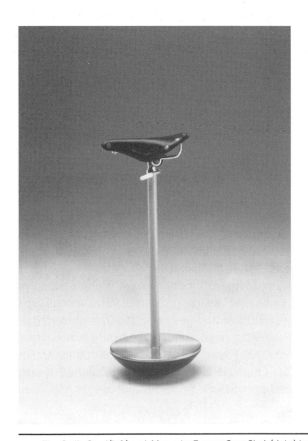 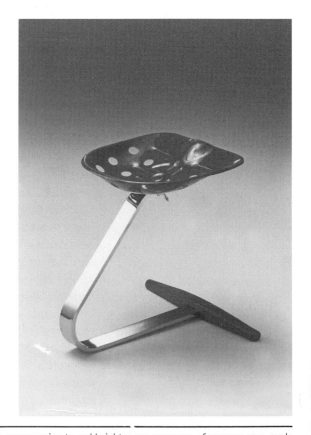

The *Stella Stool* (left) and *Mezzadro Tractor Seat Chair* (right) by Castiglioni give new meaning to and heighten our awareness of common man-made objects by placing them in a new context. They also explore, in a design context, the visual vocabulary of artists such as Duchamp and Picasso who took man-made objects into the Art Gallery

Fashion designers will often develop ideas by changing the context in which a garment is seen, taking inspiration from industrial workwear, military uniforms and street fashion and placing these on the catwalk. They will also take dress from one ethnic context and introduce it into another.

Surface

Surface is an important aspect of three-dimensional work. The surface of an object tells us a lot about the nature of that object. It can tell us what something is made of – plastic, wood, ceramics, glass, metal. It is also important as we can make physical contact with an object through touching its surface, and so extend our knowledge and understanding of that object.

The surface qualities of three-dimensional work can convey the way a piece of work has been made. A hand-thrown ceramic mug will have a different surface from that of an industrially cast mug, and the surface of sculpture made in clay will have a different surface from that of one carved from stone. These surface qualities can affect how we relate and respond to an object. Product designers are very aware of the importance of surface qualities, and often try to give one material the surface characteristics of another as a way of giving an object a particular perceived quality. Commonly, this approach has involved giving synthetic materials the qualities of natural ones. The plastic interiors of most cars have been given the surface texture of leather, and often, synthetic surfaces in domestic and commercial interiors are printed and textured to look like wood or marble.

Decoration in the form of **pattern** and **texture** can also dramatically change the quality of a three-dimensional piece and can often be a major and integral feature of the work. Ceramics works in particular exploit the often-combined qualities of texture, pattern and colour.

Colour

Colour is also an equally important quality in three-dimensional work, and again will affect our response to a piece of work. As with two-dimensional work, colours can create strong responses. Bright saturated colours applied to objects or spaces are likely to convey a dynamic, happy and optimistic feeling, whilst darker subdued colours are likely to convey a more serious mood. Applied to objects or spaces, colour can completely alter our understanding, perception and how we respond and relate to what we see. When used in interiors, colour can dramatically change the feel of the environment, the quality of light and even how the size of the space is perceived.

You should make a point of noticing how colour is used by artists, designers and craftspersons who are working in three dimensions. You should note what sorts of objects and spaces display bright colour and which have more subdued colours, and consider why those particular colours have been used. Why is it unlikely, for instance, that you will see a beige Ferrari?

Movement

Working in three dimensions gives the additional potential of **movement** becoming an element of the work. Clearly, with some functional designs, movement will be an intrinsic part of the work's function, as for example with a bicycle, a pair of scissors, or a wheelbarrow. Likewise, garments will automatically take on a dynamic quality once they are being worn, a quality that needs to be recognised and considered and explored as part of the design process. Non-functional work can equally explore movement. **Marcel Duchamp** (1887–1968) was the first artist to create an artwork that included the potential of movement, *Bicycle Wheel* (1913), although the main reason for making the work was not in fact the exploration of movement. **Naum Gabo's** (1890–1977) piece *Kinetic Construction, Standing Wave* (1920) was a much more specific and influential exploration of movement. Powered by an electric motor, its single oscillating metal rod seemed to transform into a solid volume when in motion. Many artists have subsequently explored movement, and in particular, during the 1960s there emerged, alongside **op art** (exploiting optical effects such as the illusion of movement), a **kinetic art** movement. As with two-dimensional work, horizontal or vertical lines will be perceived as more static and less dynamic than lines at an angle to the vertical or horizontal plane.

Kinetic Construction Standing Wave by Naum Gabo (1920) was the first piece to use movement as a fundamental aspect of the work

It is possible to convey a whole range of qualities, e.g., dynamic, passive, aggressive, friendly, functional, heavy and light, by using and combining these various three-dimensional elements. When examining the work of others, you should try to identify these qualities and consider what aspects of three-dimensional visual language the artist, craftsperson or designer has used to convey this information.

Making work

Making three-dimensional work is fundamental to developing and understanding three-dimensional visual language and the development of ideas. As with two-dimensional work, the ways in which you can make work and the materials and processes available are many. Your choice will be dictated by a range of factors, including the materials and technology available, the creative intentions of the work and your own level of ability in making.

The range of ways to make three-dimensional work can be broadly identified as: **construction**, **modelling**, **moulding**, **cutting** and **shaping**. (Arts relating to moulding or modelling are sometimes referred to as **the plastic arts**.) Different materials are associated with some methods of making more than others. The materials you can use to make three-dimensional work will range from the simple and readily available, such as paper, card and wire, to the more sophisticated and specialist materials like plastics. Within this range, you will also have materials such as wood, clay, metal, textiles and plaster. Recognising and understanding the different working characteristics of the various materials and the technology available to you will allow you to develop a fluency both in making and in the development of ideas.

As with two-dimensional work, you should develop a dialogue with your work and an ability to respond to it as it develops, an openness to discovery and an ability to respond positively to developments that you may not have predicted. You should become curious about how the work of others has been made, and about the materials and processes used in the making of their work. It is important to recognise that sophisticated materials and complex processes are rarely necessary to realise three-dimensional ideas, and often, simple and direct ways of working that allow fluent exploration and development will lead to more successful results. You should also recognise the importance of two-dimensional work in relation to your development of three-dimensional work, and should feel comfortable with exploring, researching and recording three-dimensional ideas through drawing, photography and other two-dimensional methods. The making of simple **maquettes** can be used in a similar way to the sketchbook studies you might make in the development of two-dimensional work, allowing quick and expressive thoughts and observations to be recorded for further consideration.

These drawings made by a student on an advanced GNVQ course clearly show how they have been able to explore initial three-dimensional ideas through drawing before moving on to further exploration using maquettes. These ideas have evolved from observations made when watching sumo wrestlers.

Exploring three-dimensional ideas through drawing in preparation for making maquettes

Construction

Construction is the process of making three-dimensional work by building or combining various component parts. The components may be of the same material or a combination of different materials. Construction has a long history in the making of buildings and furniture, but its use by fine artists as a method of making sculpture is largely a twentieth-century development, this development occurring mainly as a consequence of the availability of mass-produced materials such as steel. The shift at the beginning of the twentieth century from labour-intensive hand-made objects to mass-produced products, constructed from mass-produced parts, also dramatically changed the look and possibilities in the design of both products and architecture.

The work of the **constructivist** artists **Antoine Pevsner** (1886–1962) and his brother Naum Gabo (né Pevsner) were among the first to explore the qualities of construction and of mass-produced materials. **Anthony Caro's** (b. 1924) work of the 1960s and 1970s are also clear examples of constructed work; see colour plate 2.2. Such work need not just be made from rigid materials: many textile artists have chosen to make work that is not limited to flat pattern, and to develop constructed pieces that often combine a wide range of materials. **Barbara Taylor** (b. 1962) uses the processes and skills that she developed during her apprenticeship as a tailor in the making of work. **Janet Ledsham's** (b. 1944) sculptural textile structures combine materials such as fleece, leaves, seeds and tree branches.

Modelling

Modelling is the process of making three-dimensional work by adding and manipulating **malleable** material such as clay or wax to build up the required form. This is often done over a supporting structure (**armature**) of rigid material. Modelling with clay or wax can seem an ideal method of producing three-dimensional work: not only can you build up the form with the addition of material, you can just as easily remove material, allowing a great degree of flexibility and freedom that does not exist when using solid materials such as wood or metal. Unfortunately, the disadvantage of using such flexible and compliant materials is that, until you have become experienced and familiar with the range of qualities and states that the materials exhibit, the materials themselves give you little clue as to the direction a form might take. Modelling therefore requires careful forethought and planning, and you will need to clearly establish your intentions before beginning work. If you do not prepare sufficiently, there is a great danger of ending up with work that is little more than a three-dimensional doodle with an ill-defined form and lacking direction or purpose.

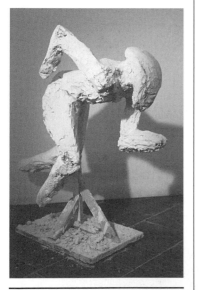

Development of a form based on a sprinting figure, using wood and chicken wire armature

Cutting and shaping

Cutting, chiselling and abrading are methods by which solid materials can be shaped, either to form complete and finished work or to make component parts for constructed pieces. The methods and tools used to shape work will vary according to the material being worked.

The materials being used will also dictate to a large extent the nature of the forms that can be developed. Stone carving is probably the most traditional of artists' methods of producing sculpture. However, working with stone is a time-consuming and skilled activity, and one not particularly appropriate either in the development of ideas or for the early stages of three-dimensional work. Other softer and more easily worked material should be considered if you wish to explore carving as a method of producing a form. Wood offers a wide range of possibilities: blocks of timber offer carving opportunities and can be used to create both intricate and delicate work and bold and simple forms. Styrofoam is a very soft block material that is very easily worked, and is a material that is particularly popular with designers when they wish to produce and explore the potential of a particular form. Styrofoam was used by the design consultants Seymour Powell in the development of their designs for the BSA motorcycle for MZ; see colour plate 2.3.

Barbara Hepworth's (1903–75) carved abstract forms evolved as a response to the Cornish landscape in which she lived. Paul Spooner has to

Carved crows by Claire Guest shows the marks made by the gouge used to carve the work

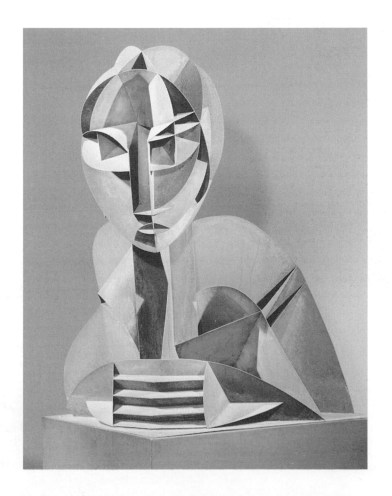

Naum Gabo's *Head* is made from sheets of steel. The edges of the planes are used to define the overall form

cut and shape many small and intricate wooden pieces in the making of his automatons; see colour plate 2.4. Sheet materials such as plywood or hardboard are relatively easily cut with hand or power tools and can be assembled to make more complex forms. **Pablo Picasso** (1881–1973) used cut and assembled flat material in a lot of his sculptures. Although made from sheet steel, *Head,* by Naum Gabo describing form using intersecting planes, could equally well be explored using card (see previous page); this can be seen in the examples of student work on page 34.

Moulding and casting

Moulding is a way of forming materials that can change their state from plastic or liquid to solid. This change of state can take place in a variety of ways: by heating to liquefy or soften (e.g. metals, thermoplastics, wax), returning to solid form on cooling; by chemical reaction (e.g. plaster, cement, resin); or by heating to solidify (e.g. clay, thermoset plastics). **Casting** can be used to reproduce work in a different, usually more durable material, for example making a bronze casting of a clay or wax original, or it can be used to make a number of identical pieces. **Rachel Whiteread** (b. 1963) has used casting as the main process in the making of her work. She has used this method to record, and literally make concrete, time and space. *House* (1993)

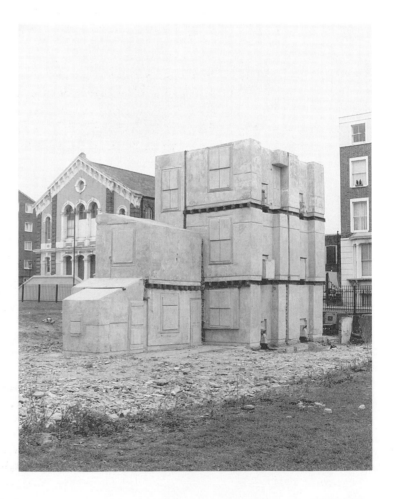

In 1993 Rachel Whiteread used concrete to cast and define the inside surfaces and space of a terraced London house before the house itself was removed. Sadly, after a lot of controversy the local council had the work, *House,* demolished as well

is her most well-known work. This was the cast of the inside space of a whole house scheduled for demolition, and it was intended to capture the memories and feelings of the people who once lived there.

Sample assignment

This assignment and associated work is from first-year students studying on a two-year diagnostic course. The assignment was intended to offer the opportunity to examine and explore a range of issues associated with three-dimensional visual vocabulary and work. The students were asked to follow a progressive series of tasks. Each task is a development of the previous one, and the whole is a demonstration of how ideas and work develop and evolve as part of a progressive process. As well as the practical studio work, students were also asked to reinforce their understanding of the issues being examined by researching the work of three artists, craftspersons or designers whom they thought explored three dimensions in an interesting way.

T a s k ① Preparation

As a starting point for the assignment, students had to prepare the subject material that would form the basis of subsequent work. This was a portable, man-made object which had a complex form, e.g. an electric drill, iron or telephone. As a simple way of introducing a less formal and predictable element into the form, about a third of the object was wrapped in a piece of cloth.

T a s k ②

The students made a series of two-dimensional observational studies that explored and clearly recorded the three-dimensional form of the subject. They used a variety of drawing methods, of their choice. Since these studies were to form the basis from which the rest of the assignment developed, these drawings needed to be as rich, descriptive and comprehensive as possible.

T a s k ③

Working from the drawings, a series of maquettes were made that:

1 explored and described the form using line (wire);
2 explored and described the form using intersecting planes across the form;
3 combined elements of both 1 and 2 in a third structure. A 'skin' (using masking tape, for example) was then to be introduced over parts of the structure to re-establish solid or partially solid forms within the structure.

T a s k ④

Working from the three maquettes, the students produced a series of worksheets that explored the possibility of these being maquettes for:

1 an architectural form or space;
2 either a chair, a desk lamp, a toaster, a telephone or a hi-fi system;
3 a wearable structure that contained most of the figure.

A wire maquette

An intersecting planes maquette

A combined maquette

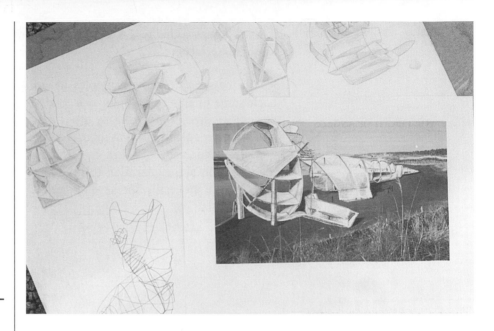

Designs for architectural space

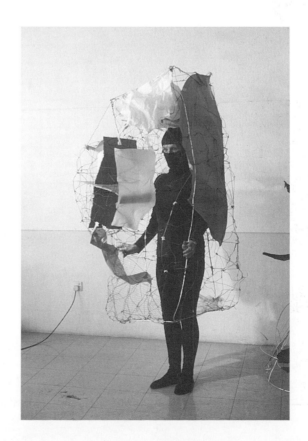

A wearable structure

T a s k ⑤ **This task was to make a wearable structure using card, paper, wire, packaging materials etc.**

As can be seen from the examples of work on the previous pages, although each stage of this assignment is a relatively small development, it would be difficult to predict or evolve by other means the exciting and dynamic forms and structures that have emerged.

The development of work by progression from visual research through manipulation and exploration to rationalisation and resolution is a basic and fundamental process in the development of successful work in all areas of art, craft or design.

3

Media, materials and technology

Introduction

In the previous chapters, we examined visual language in both two and three dimensions, the various ways we use this language, its formal aspects, and briefly how work is made. This chapter looks more specifically at the practical aspects of producing work in both two and three dimensions.

This chapter will focus on:

- **media, materials and their working characteristics**
- **processes and techniques**
- **technology, tools and equipment**

Because of the vast range of materials, media and technology used in the development and production of art, craft and design work, it is only possible to cover a limited range within this chapter, and those that have been included are only described briefly as an introduction to further study and exploration. There are many excellent books available, dedicated to most of the individual media, materials and processes outlined, which may be used to support your own practical work. Personal direct experience and experimentation, along with tutor support, is always a good way of developing your understanding.

This chapter is divided into two sections:

1 two-dimensional media, materials and technology;
2 three-dimensional materials and technology.

The most common and familiar materials and processes are examined at the beginning of each section. Media, materials and technology that are more specialist and may not be available to you at this stage of your art and design edu-

cation, or that involve industrial processes that artists, designers and craftspersons may need to understand in order to have their work produced, are examined towards the end of the section.

As we saw in Chapters 1 and 2, the choice of materials and the way that they are used are often dictated by the intentions of the work being produced. However, your choice will also be made on personal preference. To be able to make such choices, you need to be aware of the variety of technologies available, and to have a working knowledge of the particular characteristics of the different media and materials.

Two-dimensional media, materials and technology

Drawing media

Drawing media have many properties in common, but each also has qualities that will allow you to produce marks of differing character. The more you draw and explore the range of media available, the more apparent these differences will become and the more discerning your choice will be when producing work.

Pencil

Although we most commonly use the word 'pencil' to describe a wood-cased lead or, more correctly graphite, core, pencils that have charcoal or coloured cores with varying characteristics are also widely available.

Graphite pencils are graded (from the hardest to the softest) as follows: 8H, 7H, 6H, 5H, 4H, 3H, 2H H, HB, F, B, 2B, 3B, 4B, 5B, 6B, 7B, 8B. The softer grades give a darker mark and are therefore more responsive, allowing a greater range of marks to be easily made when making sketches or visual notes. The harder grades give much lighter marks and have the advantage of holding their point, giving consistency in line quality. These harder grades are often used when making accurate technical or measured drawings.

There are several types of **coloured pencil** available, and in a wide range of colours. Some have soft 'leads' and give a dense mark, whilst others are harder, allowing fine-detail drawings to be made. There are also coloured pencils that have water-soluble 'leads', allowing them to be used in a similar way to watercolour paints. Pastel is also available in pencil form.

Charcoal pencils come in four grades, which gives them a predictable consistency of tone. They can also be easily sharpened, making them ideal for fine detail, and they have the advantage, over stick charcoal, of being less messy to handle. Using the pencil form only does, however, limit the range of marks you are able to produce, and it is therefore often a good idea to use pencil and stick charcoal in combination.

Charcoal

Probably the oldest drawing media, but its enormous versatility means that it is still one of the most popular, particularly with artists. **Stick charcoal** is the most common form of charcoal, and is literally burnt (or carbonised) sticks of wood, usually willow. It is available in different sizes: thin, medium and large. The large size is often called **scenic** or **scene painters charcoal**, as it is ideal for large-scale drawing either as finished work or as an outline for a painting.

Compressed charcoal is a stick of compressed charcoal powder held together with a binder. This gives a very dense mark that tends to adhere to the paper more than stick charcoal and is therefore difficult to fully erase.

(**Charcoal pencils** have already been discussed above.)

On completion, charcoal drawings should be fixed to avoid their being smudged (see the next section).

Pastel

Pastels are made from powdered pigment which has been mixed with a binder to make a paste (the word 'pastel' comes from the word 'paste') which is then formed into sticks. The main characteristic of pastel is its purity and richness of colour. Pastel sticks come in three grades: soft, medium and hard. The softest give the richest and most brilliant colours, whilst the hardest, although losing some of the vibrancy of the soft pastel, allow the production of more detailed work. This medium has many of the working characteristics of charcoal. For practical reasons, it is best to fix pastel drawings as they will otherwise soon get damaged, particularly if kept in a portfolio. Unfortunately, fixing means that the drawing will lose a little of its brilliance and appear slightly darker in tone.

Oil pastel is made from powdered pigment which is mixed with an oil-based binder, giving qualities very similar to oil paint. Like paint, it is possible to blend and mix colours on the drawing surface. Oil pastels do not need fixing.

Some of the best examples of pastel drawing are by the **French impressionists**, in particular **Edgar Degas** (1834–1917).

Fixative is a clear varnish which is sprayed thinly onto charcoal or pastel drawings. It acts as a glue to fix the particles of the charcoal or pastel to the paper, preventing them from getting smudged. There are several proprietary brands available which can be used for your best work. A less expensive alternative which is satisfactory for general use is one of the cheaper hair sprays, although this might mean that your portfolio has a rather strange smell!

Health and safety note
As when using any aerosol, avoid breathing in the spray, and use in a well-ventilated space away from naked flame or any strong heat source.

Pen and ink

Pen and ink has a long history dating back over 2,000 years. The style and quality of drawings made with this medium are as diverse as the artists that have made them. Essentially, pen and ink is a line medium, the quality of line being largely dictated by the type of pen used.

The function of a pen is to hold a supply of ink which can then be deliv-

ered to the drawing surface in a consistent and controlled way. The earliest pens were made from reed and, along with bamboo and quills, are still used by artists today. Steel nibs were introduced in the nineteenth century, and the later introduction of fountain and reservoir pens led to the many and varied types of pen available today.

Drawing ink is waterproof when dry and tends to have a slightly glossy finish. The ink's waterproof quality allows the artist to lay one set of marks or colour on top of previous ones without the underlying work being affected. Drawing inks come in many colours; black is often referred to as **Indian ink.**

Non-waterproof ink is also available, and as with drawing ink can be obtained in a range of colours. It has many of the qualities of watercolour paint, and dries to a matt finish.

Markers

Markers are the most recent development in the long history of the pen. They come already filled with ink and are available with many different types and sizes of tip. The ink can be either spirit-based or water-based. Drawing tips can be felt, fibre or a very small rolling ball.

Painting media

The characteristics of different **paint media** will depend not only on the type of paint being used but also on how the paint is applied and on the type of surface or **support** on which it is being used.

Acrylics

Although **acrylic paint** has been available since the 1950s, it is a new media in comparison to other common painting materials such as oils, watercolours, and tempera. Contemporary artists with diverse styles of painting, such as **Frank Stella** (b. 1936) and **David Hockney** (b. 1937) have exploited the potential of acrylic paint, which is very versatile and has many of the characteristics of several of the more traditional painting media; see colour plate 3.1. Acrylics can also be exploited in less traditional ways such as in airbrushing, **stencilling** and silk-screen printing. Acrylics have good adhesive qualities and are very flexible, and are therefore ideal for **collages** and for applying to a wide range of surfaces.

Acrylics can be thinned with water, but unlike watercolours, gouache or tempera, acrylic dries to give an insoluble film. The speed of drying will enable you to work quickly, place one colour over another or side by side, without affecting previously applied colours.

The most common way of applying acrylics is with the same types of brushes and **palette-knives** as those used for oil paints, or, when used diluted and on a small scale, watercolour brushes should be used. It is important that you wash the brushes thoroughly after use, as any pigment that is allowed to dry on them will not be easily removed.

Glazing (laying transparent layers of paint one on top of the other) is easy to carry out with acrylic, either by mixing with water or by the addition of **glaze medium.** Media available to extend the versatility of acrylics even further include:

- texture paste – for heavy **impasto** applications
- **water tension breaker** – to increase flow and reduce brushmarks
- **gel retarder** – to slow the drying time

Oil paint

Oil paint has, since the sixteenth century, been the most commonly used painting medium and, even with the introduction of acrylics, is still the most popular. Oil paint is made of coloured powdered pigment mixed with vegetable oils, usually either linseed or poppy oil. One of oil paint's most important qualities is that it dries very slowly compared to other paint media, and this allows time to develop and change the image being created: if you are unhappy with part of the painting you are making, you can scrape it off and repaint it. Oil paint has further qualities which have maintained its popularity with artists. The artist can not only change and mix colours, they can also control the physical characteristics of the paint by varying the proportions of oil and thinners, such as turpentine, which will give the paint a wide range of qualities: transparent, opaque, gloss or matt. The enormous variety of ways oil paint can be used has affected the way artists have developed their work.

It is very important that, as a developing artist, you take as many opportunities to visit galleries as you can. However much you learn about artists and their work from books, it is not until you see their work first-hand that you can appreciate the different qualities of paint surface and the way the artist has applied the paint. If you look closely at many paintings by well-known artists, it is interesting to see evidence of the artist having changed their mind or made mistakes and repainted areas of their work. You will also recognise much more clearly what they have achieved, and you may even see features in common with your own work. It is certain that you will get ideas about your own way of working from this first-hand contact with others' work.

Tempera

From the beginning of your schooling, your experience of painting will have been either with paint made from powder mixed with water or with a pre-mixed water-based paint. These are **tempera** paints, and although the quality of the pigment and the range of colours is not that good, the low cost of these paints allows uninhibited experimentation with the process of painting. Additionally, powder paint can be mixed to a thick paste, giving the opportunity to explore some of the textural surface qualities of painting.

Tempera paint is one of the earliest paint media. The word 'tempera' literally means a substance that is used to bind powdered pigment. Traditionally, tempera paint is made using the yolk of egg as the binding agent. Although water is used as a medium, tempera paint, when dry, hardens to give a very permanent and stable surface. It is this quality that has allowed many examples of early tempera paintings to survive, **Sandro Botticelli's** (1444–1510) *Birth of Venus* (1483–4) being one of the best known. Although artists that use egg tempera often mix their own paint, it is possible to buy egg tempera paint based on a nineteenth century formula that is of a high quality and is ideal if you wish to explore this medium.

Watercolour

The main characteristic of **watercolour** is that it is a transparent pigment. Other paint media allow light colours to be painted over darker colours and white highlights to be the last pigment to be applied, but you cannot take this approach with watercolour. Instead, the construction of a painting has to be carefully organised as you can only work from the lightest tones to the darkest. The lightest tones, highlights, clouds and light skies rely on the whiteness of the unpainted or only lightly tinted paper. Any paint mark will become permanent, and even a very light tone painted over a darker one will darken it still further.

Watercolour is normally associated with landscape painting. **J. M. W. Turner** (1775–1851), **Van Dyck** (1599–1641), **Thomas Gainsborough** (1727–88) and **John Constable** (1776–1837) all developed a fluency with watercolours which allowed them to record the changing light and shape of land, sea and sky. They would also use this ability to make notes for larger oil paintings, as well as to produce finished paintings in their own right. As with any other medium, you should not feel you are restricted in the way you exploit the paint's qualities. **Paul Klee** (1879–1940) used watercolour in a much more abstract way in his exploration of colour and composition; see colour plate 3.2.

Gouache

Gouache is basically watercolour but with the addition of white pigment to make it opaque. This opacity allows you to paint light tone on top of dark, as you can with oils, acrylics and tempera colour. The particular quality and luminosity that is achieved with watercolour is to some extent lost, but the opportunity to work in much greater detail makes it particularly useful for fine illustrative work. Because of this, gouache is often called **designer's gouache**. Gouache can be applied with a brush, pen or airbrush.

Airbrush

Although the **airbrush** is not a medium but a tool, it seems appropriate to introduce it at this stage. Airbrushing is a way of applying wet pigment to a surface by spraying, rather than by painting with a brush or drawing with a pen; see colour plate 3.3. Although airbrushes have been in use since the beginning of the twentieth century, they were for a long time mainly used by commercial artists for retouching photographs. More recently, however, the airbrush has been used as an art tool in its own right. The ability to produce soft graduated tones, flat areas of solid colour and fine lines allows a skilled airbrush artist to produce images that have a very particular and almost photographic quality. Until relatively recently, airbrushes have been an expensive and specialist piece of equipment. The need to buy not only the airbrush itself but also a compressor to provide an air supply has meant that access to this process has been limited. However, it is now possible to buy relatively inexpensive airbrushes and aerosol propellant canisters from most art or model shops, which, although not as sophisticated as professional equipment, will allow you to experiment with this way of producing images.

Gouache, watercolour, inks, oils and acrylic paint can all be used in an airbrush. It is important to make sure that the medium you use has fine pigment

particles and that you mix the paint or ink to the right consistency, using the appropriate thinners: too coarse a pigment or too thick a mix will cause splattering and clogging. Always be meticulous in cleaning the airbrush both for colour changes and particularly after use, as the fine nozzle and delicate needle tip can become easily clogged, and a build-up of dried pigment can cause permanent damage.

Printing

Printing can take many forms, from the simplest potato print to the very sophisticated commercial offset lithography used in the printing of this book (see the 'Commercial printing' section below). However, although there are many different printing methods, the basic underlying principle of all printing is the same: to transfer an ink image from a plate, block or screen to another surface such as paper, card or fabric. Some of the simplest printing processes can produce very exciting images that you would not be able to make in any other way. You should always consider printing as part of your visual vocabulary along with drawing and painting.

Mono printing

Mono printing is the simplest and most direct form of printing and, as the name suggests, only allows one (mono) print to be made from a plate. Despite this limitation, the range and quality of unique marks achievable by this process, and its simplicity, make it an exciting process well worth exploring. To make mono prints, you will need a smooth flat surface – a piece of perspex is ideal. Using a roller, apply a thin, even coating of printing ink to the plate. While still wet, draw directly into the ink, making marks through to the surface of the plate. Having made the drawing you want, lay a piece of paper over the plate, and using firm, even pressure, with your hand, rub the paper down onto the inked surface, making sure you have covered the entire surface right out to the edges. Carefully peel off the paper, and, with luck, you will have a good print. As you will see, you have an image where the drawn marks leave exposed areas of paper, with the ink covering the rest. You should experiment with different ways of removing ink from the plate's surface. You can also lay pieces of paper onto the inked plate to act as masks.

The best prints using this process will be achieved if you can use an etching press, which will give you sharper and more controlled prints. Colour plate 3.4 shows a colour monoprint, and another example is shown opposite.

An example of a monoprint, see also colour plate 3.4

Relief printing

Relief printing describes a range of methods of printing in which areas of the printing plate or block are raised. These raised areas are inked, and then under pressure, the ink image is transferred onto paper or fabric. A **potato print** is the simplest example of this process.

Lino cut

Lino cut has been a popular process, used by many artists including Henri Matisse and Pablo Picasso. Lino's flat, smooth surface can be easily cut in any

direction, and makes it ideal for cutting relief blocks. To make a lino cut, you will need a piece of lino, ideally 6 mm thick. A soft or medium-soft grade will be easiest to cut, and you should start with a relatively small piece, 150 × 100 mm or so: larger prints will take quite a long time to cut, so it is worth getting to know the process before you become too ambitious. You should first draw your design onto the lino with pencil or felt tip pen. It will help to shade in the larger areas that you want to remove, so that you don't start cutting away on the wrong side of the line you have drawn. Remember, it is the raised areas that will print: any cut-away lines or areas will remain as unprinted areas of paper. If you print with black ink on white paper, lines cut in the lino will appear as white on a black background in your final print. Special lino-cutting gouges are used to cut the block. Make sure you always cut away from the areas you wish to keep, in case of slips. You must also always make sure that the hand that is not holding the gouge is never in front of the cutter when you are cutting; working away from you, with the lino pushed up against a vertical stop, will help you to avoid this. If you find the lino too hard, gently warming it will make it softer.

Once the design has been cut, oil-based printing ink is applied evenly, with a roller, over the surface of the lino. The paper to be printed is then placed on the inked surface. Now, using firm, even pressure, rub the back of the paper with a hard rounded object such as a spoon. If it is available, and particularly if you are making larger prints, a **printing press** should be used.

Cutting the design with a gouge

Inking the block with a roller

Making a print by rubbing the back of the paper with a spoon

Peeling the print from the lino block

Collographs

As the name might suggest, **collographs** are prints taken from a printing plate that has been made by **collageing**. Very rich prints can be achieved easily and simply using this method; see colour plate 3.5. By applying printing ink to virtually any surface that has a shallow relief texture and then placing paper over this and putting it through a printing press, a print will be achieved. Complex images can be built up by combining different textured materials or even objects. Coarse fabric such as hessian, corrugated card, sandpaper, string and grains of rice sprinkled into wet glue and allowed to dry will all give a surface suitable for printing. Objects such as matchsticks, washers and paper clips can also be tried. The finished plate should be sealed with a good coating of PVA and allowed to dry thoroughly before you start printing.

Woodcuts

Principally, **woodcuts** use the same techniques and processes as lino cuts. Most types of wood can be used as long as they have a flat, smooth surface and are free of knots. Plywood or block board are good in this respect. Whilst the natural grain of the wood can give the finished print a quality that is particular to this process, it is less easy to cut than lino, and more care will be needed to achieve a sharp image.

Woodcuts are the earliest form of printing. The Japanese were making prints using this process as early as the eighth century. The first mass-produced fabrics and wallpapers were produced using wood blocks, often with the introduction of strips of metal to allow thin lines to be printed that would be too delicate in wood. **William Morris** (1834–96) produced some of the best-known designs using this process, examples of which are still being made today. Many of the rich fabrics that are imported from India are still printed by this method.

Wood engraving

Wood engraving differs from woodcuts in that the image is made by cutting or engraving into the end grain of the wood as opposed to the long grain. It is usual to use finer-grained hardwoods such as maple, pear or boxwood. Wood engravings tend to have finer detail than woodcuts and are made using engraving tools similar to those used for metal engraving. Wood engraving was, from the fifteenth century until the introduction of photo reproduction, the commonest method of creating printed images in books and newspapers.

Screen printing

Screen printing is basically a sophisticated form of stencilling in which a fine mesh screen is used to support the stencil, the ink then passing through the screen but not through the stencil. Silk was originally used to make the screen, although nowadays man-made fibres such as nylon and terylene are the most commonly used.

1 The mesh fabric is tightly stretched across a wood or metal frame. Stencils are then used to block off areas of the screen, and the image is then printed.

Paper stencils are laid out to create the design

Ink is poured along the edge of the screen

A squeegee is used to force the ink through the screen

The final print

2 A print is made by forcing ink through the mesh and onto the paper or fabric being printed, using a rubber-bladed squeegee.

3 There are several ways stencils can be made, the simplest being those made from paper. Thin paper such as newsprint is best: thicker paper will tend to hold the screen off the surface being printed, leading to a less defined image. The cut stencils are first laid out on a piece of paper in the position you want them to be on the screen.

4 Place the screen over the paper and pour a small amount of printing ink along the edge furthest away from you. Using a squeegee, and applying even pressure, draw the ink over the screen, forcing it through the mesh onto the paper.

5 On lifting the screen from the paper, you should have your first print, and the paper stencils will now be attached to the screen by ink, allowing you to repeat the process.

6 If you are using oil-based ink, you can paint designs directly onto the screen with gum arabic or one of the specially made liquid stencil materials. These can be washed off the screen using water once you have finished printing.

Photo-silkscreen is a method that allows much more complicated images to be printed and also gives the opportunity of printing areas of tone. A photo-silkscreen is created either by coating the screen with a photo-sensitive emulsion or by using a photo-sensitive stencil film. When the emulsion or stencil film is exposed to ultraviolet light through a positive film image, areas exposed to the light will become fixed, allowing the non-exposed areas to be washed away, leaving a stencil.

Although primarily a commercial printing process, photo-silkscreen became a popular fine-art process in the 1960s and was used extensively by artists such as **Andy Warhol** (1930–87), **Roy Liechtenstein** (b. 1912) and **Robert Rauschenberg** (b. 1925); see colour plate 3.6.

Intaglio printing

Engraving and etching are names of printing processes that are probably more familiar than the name **intaglio**. Intaglio refers to a number of printing processes, including engraving and etching, that share the common characteristic where an image is cut into the surface of the printing plate. It is this cut image that will retain the ink that is then transferred to the paper (the reverse of **block printing**). As it is the mark that is made in the plate that is printed, the final print will have greater similarities to a drawing than to a block print where it is the flat spaces between the cut areas and marks that are printed.

Line engraving is the simplest and oldest way of producing an intaglio print. As with most intaglio printing, a metal plate is normally used, although it is possible to make line engravings using other flat, smooth surfaces such as perspex. In this process, the image is cut into the plate using an engraving tool. Unlike a pencil or pen, the tool is pushed across the surface of the plate, removing a thin strip of metal, to leave a groove in the surface. It is this groove that will hold the ink for printing. A similar process to engraving is **dry point**, where the edge of the groove being cut is deliberately left with a slight ridge or burr which will also hold some ink, giving the resulting print a softer quality than a line engraving.

Etching is the most versatile of the intaglio printing processes, allowing an artist to work much more freely and fluidly than with engraving. The cutting of the image here is made by using acid to etch into the surface of the metal plate, the most commonly used metals being copper, zinc or steel.

1 With a roller, a thin coating of wax is applied to a heated plate.
2 The wax is left to cool and hardened, and the design is drawn into the wax using a sharp instrument. This process is known as **hard ground**.
3 When the design has been drawn, the back and edges of the plate are painted with varnish to protect them from the acid. The plate is now immersed in an acid bath and is left there until the lines, where the wax has been removed to expose the metal, have been sufficiently bitten into the plate. This process of drawing and biting can be repeated as many times as you like. Nitric acid, hydrochloric acid and perchloride of iron are the most commonly used acids, each of which bite into the plate in slightly different ways, affecting the quality of line produced.
4 The plate is then removed from the acid and washed and dried, and the wax is removed with turpentine.

Wax is applied to the heated plate

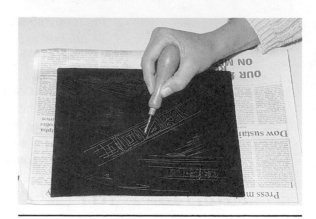

The design is drawn into the wax to expose the plate

The plate is immersed in an acid bath

The wax is removed from the etched plate using turpentine

The plate is inked by hand

A print is made using an etching press

5 With the plate thoroughly cleaned, it can now be inked and printed using an etching press.

The process for printing intaglio plates is as follows:

1 The plate is warmed and ink is worked into the image using a cloth pad. The surface of the plate is then cleaned, leaving only the ink in the cut or bitten areas.
2 Printing is carried out on dampened heavy paper using an etching press. The inked plate is placed face up on the bed of the press, and the dampened paper is placed on top. It is then covered with a thick blanket and rolled between the rollers of the press, which forces the dampened paper into the inked recesses of the plate.

Other methods of producing images on the plate include the process known as **soft ground**. This process uses a wax that remains soft, allowing impressions to be made in its surface that expose the metal below. The variety of textures possible with this process are almost limitless, as almost any texture or even object can be used to impress its pattern in the wax.

Aquatint is a process by which areas of fine texture can be etched into the plate, allowing blocks of tone to be printed. Resin powder is dusted onto the surface of the plate and fixed by gentle heating. The particles of dust resist the acid, leaving the bitten plate with a fine granular surface which will hold ink.

Health and safety note
Intaglio printing, and in particular etching, can only be carried out in an environment that has been prepared for this process, as specialist equipment will be needed. Acid can only be used in strictly controlled conditions as it is highly corrosive and the fumes given off during the process are toxic and will require good ventilation facilities. The disposal of used acid must be done in a way that adheres to health and safety requirements. Etching presses work using very high pressure, and care must be taken to ensure that your own, or other students', hands, hair or loose clothing do not get close to the rollers when you are using the press.

Lithography or planographic printing

Lithography was invented in 1797 by a German typographer **Aloys Senefelder** (1771–1834) and means printing off stone, although today stone has in most cases been replaced by sheet metal. As well as being the most common commercial printing method used in the printing of books, magazines, newspapers, packaging, posters and letter headings, lithography is a simple method for artists to use to create a printed image. The principle by which both hand-made and commercial prints are made is the same, both being reliant on the fact that a greasy surface will reject water whilst a damp surface will reject grease.

The process for **hand printing** is as follows. Working on either the flat surface of a prepared **litho–stone** or a specially grained metal **litho plate**, the artist draws an image with greasy ink or chalk. The grain of the stone or plate will hold the greasy marks made. The grain will also hold water when this is washed over the surface, but only where there is no grease. If a greasy ink is now applied to the stone or plate with a roller, the ink will only adhere to the

greasy image previously drawn. This image can then in turn be printed by lay-ing paper on top of the stone or plate and placing it all in a press.

Although the principle for **commercial printing** is the same as that for hand printing, the technology used for the former is far more complex and sophisticated, enabling incredibly fine-detailed, full-colour images to be reproduced at high speed. To allow continuous printing to take place, com-mercial machines use metal litho plates which are continuously inked and dampened as they rotate against **inking rollers** and **dampening rollers**. Instead of the ink image then being transferred directly on to the paper, which is being fed through the machine, the image is transferred to a second rubber-faced (**blanket**) roller, and it is from this roller that the image is trans-ferred onto the paper. Using a rubber roller gives a clearer impression than is achievable by printing direct from the metal plate. This method involving a second print roller is called **offset lithography**.

Paper and card

Paper is an enormously versatile material, available in many forms from thin delicate tissue through to thick glossy card. It can be used as a surface to draw, paint and print on, or to construct three-dimensional work, or, as in the case of hand-made paper, it can become the work in its own right.

Mass-produced paper comes in standard sheet sizes. The international 'A' size-classification system begins with 'AO', the largest sheet size which mea-sures a square metre. The proportions of the other paper sizes are then calcu-lated by dividing the size above into two equal parts, 'AO' divided giving two 'A1' sheets; 'A1' divided giving two 'A2' sheets.

Cartridge paper

This is one of the most commonly used kinds of paper. Its plain smooth sur-face makes it ideal for drawing with pencil, charcoal, pen and ink, as well as for painting in acrylic, tempera and gouache.

Watercolour paper

The most common support for watercolour painting is paper whose surface plays an important part in the quality of the final image. There are many papers that are made primarily for this purpose, and their surface qualities can also be exploited when used with other media. **Watercolour paper** is generally thicker than cartridge and, depending on the make, has a particular textured surface.

Newsprint

This is a thin, off-white paper that gets its name from one of its main uses, newspaper production. Its thinness makes it ideal both for making rubbings and as stencils in silk-screen printing. Its low cost also makes it a good paper for experimentation and for making trial prints.

Tracing paper

This is useful for copying and transferring images and designs. The smooth surface will take fine detail in pencil or ink and is often used by designers when making accurate scale drawings.

Layout paper

This is a white paper that is also see-through. It will take a wide range of media and is particularly useful in a pad, allowing the quick development of a design where a particular layout or outline is being explored in different ways.

Ingres paper

This paper has a distinct grain, is available in a wide range of colours and is particularly suitable for pastel drawings.

Hand-made paper

Whilst it is possible to buy **hand-made paper** in a wide range of finishes, and made from a wide range of fibres, making your own paper opens up possibili-

Using a liquidiser to break the paper down into pulp

The mould (flat part) and deckle (frame part) are lowered into and then carefully lifted out of the pulp mixture, to leave an even distribution of fibres

The deckle can be removed

When completely dry, the paper can be removed from the mould

ties not just for interesting surfaces on which to draw write or paint, but also as work in its own right.

Making paper is an essentially simple process needing little in the way of special equipment. The raw materials from which paper is made include plant and other fibres such as silk or wool. The easiest thing to do when first making paper is to recycle existing paper. Almost any paper can be used, although you should avoid those with a shiny surface.

1 You will first need to turn your raw material into a pulp. Break down the paper by tearing it into small pieces and soaking these in water overnight. Boiling them for about half an hour if you have a suitable large container, will speed up the process, instead of soaking. You then use a liquidiser to fully break down the paper. Do this a little at a time to avoid overloading or even permanently damaging the machine. Begin by liquidising for no more than 15 seconds, repeating this until you achieve a smooth, creamy consistency. Do not continue once this consistency is achieved as you will break down the individual fibres and so weaken the finished paper.

2 The next stage requires a **mould** and **deckle**. These are a pair of simple rectangular frames that can easily be made if they are not already available. One frame will require mesh to be stretched over it (the mould), whilst the other, of identical size, is left as an open frame (the deckle). For early experiments, frames with the inside dimensions of A4 paper, i.e. 297 mm × 210 mm, are ideal. The mesh of the mould can be made of synthetic fabric such as silk-screen mesh or curtain netting; brass or aluminium mesh are particularly good if available. It is on the mould that the paper sheet is formed. The coarseness of the screen material used will therefore dictate the surface of the finished paper.

3 You should first pour the pulp into a large container such as a rectangular washing-up bowl. You will need enough pulp to fill the bowl so that you can immerse the mould and deckle. Stir the pulp to evenly distribute the fibres. Then, holding the mould and deckle firmly together with the mesh sandwiched between them and with the deckle on top, smoothly immerse them in the pulp. Again slowly and smoothly, lift the mould out, keeping it horizontal, and once it is clear of the bath, give the mould a quick shake to evenly distribute the fibre on the mesh. Let the excess water drain back into the bath.

4 Place the mould down on a flat surface and carefully remove the deckle. You will now need to leave the mould to stand on a pad of newspaper. To soak up moisture from the pulp, you will have to change the newspaper a few times until the excess water has been removed. The moulded paper should now be dry enough to allow the mould to be leant against a wall for final drying.

5 When completely dry, the paper can be carefully removed from the mould by slipping a palette knife between the mesh and the moulded paper sheet.

There is no limit to the materials you can use to make, or incorporate into, paper, particularly if you are intending the result to be a piece of work in its own right. Plant material in particular can be broken down in the blender and mixed into the recycled paper pulp, or you can sprinkle unblended petals, small leaves or stems on the surface of the pulp. These types of paper will be most successful if they are dried by being pressed between **couching cloths**.

Lens-based media

Photography

Photography is a process that has many uses for the artist, craftsperson or designer. It can be used along with other methods as a means of capturing and recording information in the form of visual notes for research and for the development of ideas. It can be used for recording work in progress that may otherwise be lost as the work develops, or finished work, particularly large or three-dimensional work that may be difficult to record or keep or present to others. Or a photograph may become a work in its own right, either in the context of a piece of graphic design or illustration, or as a free-standing image.

Cameras

Whilst there are several different types of camera available, from the inexpensive fixed-focus compact cameras through to the very expensive large-format professional studio cameras, the 35 mm **single-lens reflex** camera is by far the most popular with both the serious amateur and the professional photographer. It is versatile, light enough to carry anywhere, allows fine control, and is relatively simple and easy to use. With the single-lens reflex (SLR) camera the image that is seen through the viewfinder is identical to the one that will be recorded on the film. This type of camera thus allows great control when composing and taking a photograph, since the effect of any alterations made to the camera, such as changing the focus setting or fitting a different lens, can be seen through the viewfinder.

Although different makes of camera will have slightly different layouts both for the controls and in the way information is presented in the viewfinder, all will have similar functions and features.

Focusing

To archive a sharp image, you need to **focus** the image on the film. To do this, the lens needs to be moved forwards and backwards to change its distance from the film. This is achieved by turning the wide textured focusing ring. You will be able to see the effects or rotating this ring through the viewfinder. To help you achieve accurate focusing, the centre spot of the image, seen through the viewfinder, appears split, and only when both its halves are aligned is the image accurately focused.

Exposure

To successfully record an image, it is necessary to expose the film to the amount of light that matches the film's range of sensitivity: too much light and your image will be overexposed and will appear too light when developed; too little light and the image will be underexposed and the resulting image will be too dark. You have two ways by which this amount of light can be controlled:

1 *shutter speed.* The **shutter** in a camera is situated behind the lens and prevents light from reaching the film, except when you open it by pressing the shutter release button whereupon the shutter will rapidly open and almost instantly close again, so allowing light to reach the film for, usually, a fraction of a second. The amount of time the shutter is open, i.e. the shutter speed, can be adjusted either manually or, in the case of an automatic

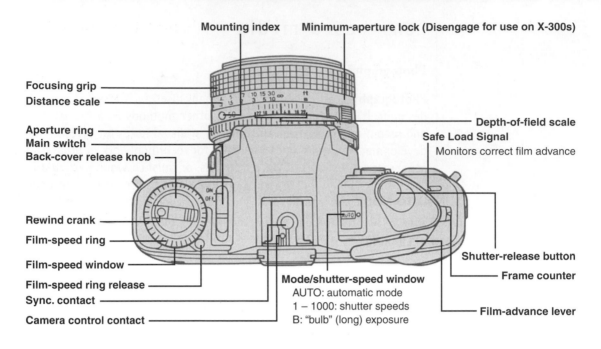

Mounting index Minimum-aperture lock (Disengage for use on X-300s)

Focusing grip

Distance scale

Aperture ring

Main switch

Back-cover release knob

Rewind crank

Film-speed ring

Film-speed window

Film-speed ring release

Sync. contact

Camera control contact

Depth-of-field scale

Safe Load Signal
Monitors correct film advance

Shutter-release button

Frame counter

Film-advance lever

Mode/shutter-speed window
AUTO: automatic mode
1 – 1000: shutter speeds
B: "bulb" (long) exposure

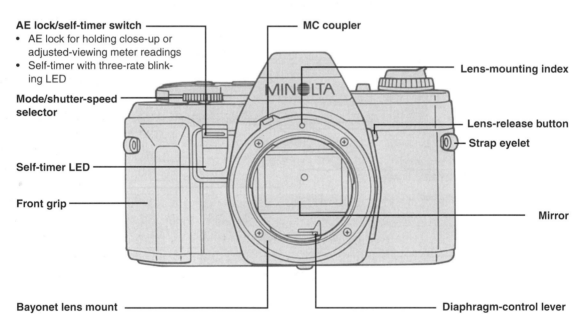

AE lock/self-timer switch
• AE lock for holding close-up or
 adjusted-viewing meter readings
• Self-timer with three-rate blink-
 ing LED

Mode/shutter-speed
selector

Self-timer LED

Front grip

Bayonet lens mount

MC coupler

MINOLTA

Lens-mounting index

Lens-release button

Strap eyelet

Mirror

Diaphragm-control lever

The layout of a 35 mm camera

camera, by the camera itself in response to the amount of light it has recorded entering the lens. For a sharp picture, the fastest practical shutter speed is the safest to use because the less time during which light from an image falls onto the film, the less time there is for any subject movement or camera shake to blur the photograph. The safe working shutter speed for hand-held shots with a normal lens is 1/125 of a second.

2 *aperture*. Just like our eyes, the lens of a camera contains an iris that opens and closes, making a bigger or smaller hole through which the light from the image you are recording passes. The smaller the hole, the less light that reaches the film; the larger the hole, the more light that reaches the film.

To ensure that the correct amount of light reaches the film, a balance between shutter speed and aperture size has to be made. If the speed of the shutter is increased, the aperture will have to be widened to compensate for

the reduced time for which the film is exposed. Likewise, if the aperture is made smaller, the shutter speed will have to be slower to allow the film to be exposed for a longer time.

The decision as to whether you have a fast or a slow shutter speed or a small or a large aperture will depend on several things:

- the lighting conditions
- whether you are photographing a static or a moving subject
- whether you want as much as possible of your image in focus, or whether you would like to have some part in focus and other parts out of focus

A small aperture will bring more of the image (both in front of and behind the point you have the focus on) into focus than a large aperture. The amount of image in focus is known as the **depth of field**.

Films

There are principally three types of film:

1 **black and white negative film**, used to make black and white prints;
2 **colour negative film**, used to make colour prints;
3 **colour transparency or reversal film**, used as slides (these can also be made into prints, although this is a more costly and less readily available process than using colour negative film).

All commonly available colour film is designed to be used in daylight or flash-light. Using these films in ordinary artificial light (tungsten or fluorescent) will produce disappointing and inaccurate colours. Using a blue filter will help to compensate for this if you have no alternative light source.

Films are most commonly available in 24 and 36 exposures and in a range of film speeds. The speed of a film dictates the range of situations in which you can successfully take photographs. The speed is indicated as an ISO (International Standards Organization) number: the higher the number, the more sensitive the film is to light. 100 ISO film is suitable for well-lit situations. It has a fine grain which allows you to make enlargements without losing sharpness or definition. 200 ISO film is a good general purpose film. 400 ISO film will be needed if light levels are low or you are taking action shots that require fast shutter speeds to capture the action. When loading a new film, it is important to remember to set the correct film speed on your camera.

Video

The ability to record movement and time using a **camcorder** or **video camera** opens up a range of exciting possibilities. A camcorder, like a stills camera, can be used to record research information for the development of other work, to record work as it develops, to record or make presentations, or to make work in its own right, graphics, animation, documentaries or time-based fine art.

Camcorders have a lot of functions in common with stills cameras.

Camcorders also allow you to immediately play back and view, through the viewfinder, what you have just recorded. This instant replay gives you the opportunity to review your work and rerecord it if you are not happy with your first attempt. The main functions of focusing and exposure are usually

automatic on most camcorders, which makes them very easy to use for basic recording, although the ability to override these automatic controls gives greater creative scope.

Although it is possible to achieve good results with just a camera, any serious work with video will need some form of **editing** facility. Editing allows you to rearrange the order of recorded pieces, discard shots, bring together recordings from different tapes, and refine loose shots to allow you to build a sequence and give shape to the video. It will also allow you to introduce and control the very important aspect of sound.

If you are interested in exploring time-based work, you should make a point of watching television and films with the specific intention of noting how the work has been created. Become aware of the fact that you are seeing from the viewpoint of the camera. Recognise its position in relationship to what is being recorded. Is the camera near or far, high or low? How long does it hold its position, and why was this particular view chosen? You will soon recognise that apparently simple situations such as two people having a conversation over a dinner table require much more than just recording a conversation as it happens in real time. Often, shots of each person will appear face on, as if seen from the other's viewpoint; the shots will also quickly shift from one to the other; and there will be yet other shots that include both parties. To achieve this, a careful scripting both of the peoples' conversation and of the camera positions will have to take place, followed by further editing once the shots have been recorded.

Animation
In principle, **animation** is a simple process that allows you to create the illusion of movement in inanimate objects or images. An object or image is recorded for a few seconds, the recording is then stopped and the object is moved a little or the image is altered slightly, a further few seconds of recording is made and the process is then repeated, changing the subject slightly every time. Although simple in principle, animation requires careful preparation and can be a lengthy process, requiring patience if good results are to be achieved.

You should not be too ambitious in your first attempts at animation. You can start just by developing the basic principles and techniques. One or two pebbles, matches or other similar simple objects are all you need to experiment with the relationship between the amount of change you should make and the length of recording time made to achieve a smooth and effective illusion of movement. You will need to set up the camera so that it is held completely rigid: any movement of the camera during filming will distract from the movement of the animated image and give a jerky finished video. For similar reasons, you will also need to ensure that the lighting remains constant throughout the filmed sequence.

Photocopying

Photocopiers are useful for copying both text and images as a way of recording information from books and documents. But photocopiers have much greater potential than this. Their ability to enlarge and reduce images and even to copy three-dimensional objects allows them to be used as a creative tool. Images can be copied both onto coloured paper and onto transparent film. (Always ensure, however, that the paper or film you are using is suitable

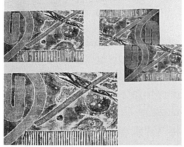

A worksheet exploring repeated patterns using photocopied images. The original image was made by collograph printing

for photocopying as expensive damage can be done to the print drum if the wrong materials are passed through a machine.)

Copying onto transparent film in particular offers a range of possibilities. You can make **transparencies** to be used either for presentation by an overhead projector, or as negatives for making photo-silkscreens, or as **overlays** when producing graphic design work. Overlays give you the opportunity to quickly and easily try out a range of design possibilities. Creating titles and text, on a computer, which can be transferred to transparent film and then laid over artwork, photographs, paintings, drawings or other photocopied images, means that you can test several layouts combining text and image without having to constantly recreate the pictorial images.

The ability to enlarge, reduce and make multiple copies offers great potential when exploring repeated patterns for fabric designs. Again, you can quickly and easily experiment with different layouts, and accurately resolve how each individual print will relate to those around it before you start to print on the fabric.

Textiles

Tie dying

Tie dying is a traditional technique by which fabric can be patterned using dyes. It is a simple two-stage process. First, the fabric being patterned is bunched up and tightly tied. It is then immersed in dye and left for the required time before being taken out and thoroughly rinsed in water. Having been left to drain, the fabric is then untied. Where the fabric has been tightly tied, the dye will have been unable to penetrate and will be left uncoloured, leaving a distinct tie-dyed pattern.

Whilst it is easy to make arbitrary patterns by this method, the real creativity comes by exploring and controlling the patterns achieved by careful consideration of the way the fabric is bunched. Various different ways of preventing the dye from reaching parts of the fabric should be tried out. Folding into pleats and tying in bands, folding into packages, tying the fabric around pieces of wood, dying in one colour then re-tying and dying in a second colour are just some of the infinite possibilities here; see colour plate 3.7.

Batik

Batik is another method of creating patterns on fabric using dyes and a method of resistance, in this case wax. The wax is used for drawing the required design on the fabric, which is then dipped into the dyebath. The parts that are covered with the wax resist the dye. The wax is removed at the end of the process. During the dying, cracks occur in the wax which let in specks of dye. This produces the fine veins that are characteristic of batik work.

This initial design should then be transferred to your fabric using a charcoal pencil. If you are using a transparent material such as silk, you can simply place the fabric over your initial drawing and then, with the charcoal pencil, trace the lines of the design onto the fabric. With thicker fabrics, a **light box** can be used.

Having transferred your design onto the fabric, you will now need to stretch it over a simple frame so that the wax can penetrate right through.

The wax that is used for creating the design needs to be melted, and this is best done in a special electrically heated wax pot. (Wax should never be heated on an open flame as it is highly flammable. Hot wax is dangerous, so never leave the wax-heating process unattended even for a short time.) See colour plate 3.8.

Once the wax has been heated, there are two principal ways of applying it to the fabric. Where bold lines or large areas are to be covered, the wax can be applied using a **bristle paintbrush**. However, the more usual method, and the one that allows detailed and delicate designs to be made, is to apply the wax using a **tjanting**, which is the traditional tool for applying wax and an essential part of batik work. This comprises a small reservoir made of copper or brass from which protrudes a thin tubular spout. This reservoir is attached to the end of a wooden handle. The tjanting is used as a drawing implement. The reservoir is filled by dipping it into the liquid wax, and the wax is then trailed or drawn onto the fabric via the spout. Various spout diameters are available, the finest being 0.5 mm. See colour plate 3.9.

The choice of fabric to a large extent depends on what you are going to do with the final piece. Some of the most suitable materials for batik work are white or light-coloured fabrics such as cotton, linen, silk or rayon, all of which take dye well. Generally, the coarser the fabric, the bolder the design needs to be.

Weaving

Weaving involves simply interlacing two sets of threads, yarns or fibres in order, in most cases, to make fabric. In the case of constructed textiles, weaving may be used as a method of making work that takes on other forms. When weaving fabric, the threads that run the length are known as the **warp threads**. Those that run across the width and usually at right angles to the warp are known as the **weft threads**. the simplest weaving consists of threading the weft over and under every other warp thread, with each adjacent weft thread starting alternately under or over the first warp thread. See colour plate 3.10.

It is very difficult to successfully weave without the warp being held taut, and to achieve this, some form of **loom** will be needed. This need not be particularly complex: a successful exploration of this process can be made on a very simple frame. See colour plate 3.11.

The variations on the weaving process are enormous: you can vary the weave so that it is not just over-one under-one; and the materials used in weaving need not be restricted to thread or yarn: anything that can be interlaced can be used, from strips of fabric, as in the making of rag rugs, to plastic bags or plant materials such as stems twigs or leaves.

Three-dimensional materials and technology

Wood

Wood is one of the most versatile of materials. It has been used by artists, craftspersons and designers for an almost infinite variety of work, from jewellery to architecture. Used for its mechanical properties or purely for its decorative qualities, it is a material that is easy to work, needing only relatively simple hand tools to cut and shape it.

Different woods show widely differing qualities both in their appearance and in their mechanical properties. There are woods, such as oak, that are strong, durable, hard and tough but expensive, and woods that are extremely light and soft like balsawood. The most commonly available wood, that is mainly used for constructional work and joinery, is Scots pine, which is straight-grained, fairly strong, easy to work and inexpensive.

Manufactured boards

Boards manufactured from wood greatly extend the versatility of this naturally occurring and renewable resource. Man-made boards have the advantage of being available in large, standard sheets of uniform thickness and quality. They are much more stable than timber and have a uniform strength and finish. There are a range of differing manufactured boards available, each having particular qualities making them more or less suited to given situations.

Plywood

Plywood is made by laminating an odd number of thin layers (**veneers**) of wood approximately 1.5 mm thick, with the grain of each running at right angles to its neighbour. This alternating direction of grain gives the plywood high and uniform strength once the veneers have been bonded under pressure with glue. Plywood is available in thicknesses from 0.8 to 18 mm, and in different grades of appearance, quality and durability, the least durable being INT (interior use only) and the most durable – suitable for exterior use and boat building – being WBP (water and boil proof).

Blockboard

Plywood is expensive to manufacture over 12 mm thickness. **Blockboard** is made more economically by substituting strips or blocks of solid timber for the core of the board. These softwood strips are laid parallel to each other, with the grain running at right angles to the grain of the facing veneers.

Chipboard

This board is made in large flat sheets and is available in a range of sizes and thicknesses. It is made by bonding wood particles, including chips, flakes and

shavings, under heat and pressure, with synthetic resin. These boards are not as strong as either plywood or blockboard, and apart from some boards that are manufactured for specific building purposes such as flat roofing, they should only be used for interior use. Boards are available covered with a variety of decorative and durable surfaces and veneered with hardwood, decorative plastic or **melamine** which is commonly used for kitchen worktops.

Hardboard

Hardboard is a cheap sheet material, which has less strength than the equivalent thickness of plywood. It is made from wood fibre, obtained from wood chips or pulp, which is pressed between steam-heated plates to give large sheets with one smooth and one textured face. Although its lack of strength or rigidity requires large areas of it to be supported by a framework, hardboard is an economical way of constructing large, lightweight, flat or curved planes such as those used in theatre sets.

MDF (medium density fibre board)

Also made from wood fibre, **MDF** is thicker and denser than hardboard, with both faces having a smooth finish that takes paint or other finishes very well. It is a very stable material that is easy to machine, leaving a fine finish, and is used extensively in mass-produced painted furniture.

Woodworking tools

Hand tools

Saws
Although a wide variety of saws are available, these can be divided into three main groups according to the job they do:

1 large **handsaws**, for roughly cutting large lengths or sheets of timber to size, the most useful here being a **panel saw**;
2 saws for cutting joints and for other exact work – **tenon** or **dovetail saws**;
3 saws for cutting curves and other special shapes – **coping saws**, **bowsaws**, **padsaws**, **fret saws**.

Planes, surforms and rasps
This group of tools are all used in the shaping and finishing of wood.

There are many types of **plane**, each designed to cope with special jobs. The basic planing job, however, is to reduce wood to exact dimensions, and to leave also a flat smooth surface. The best all-round plane for this purpose is called a **jack plane**.

Surforms are light, easy-to-handle shaping tools with replaceable, open, rasp-like blades. They come in a variety of shapes, including curved blades and circular ones for enlarging and shaping holes. These tools will also shape most materials that are softer than metal, including plastics and plaster.

Rasps are another shaping tool, are similar to surforms in the tasks they can carry out, and again come in a variety of shapes. Depending on the fineness of the teeth, they can tackle the shaping of wood, plastics and even soft metals such as aluminium.

Planes, surforms and rasps; clockwise from the left flat rasp, curved rasp, circular surform, small flat surform, large surform, smoothing plane and jack plane

A band saw

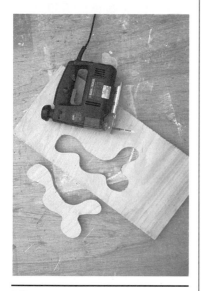

A jigsaw

Chisels and gouges

Chisels are mainly used for **pairing**, joint cutting or cutting out small recesses. **Gouges** are used for carving and shaping wood. Special chisels and gouges are also used when shaping wood on a wood-turning lathe.

Power tools and machines

Band saws

These are versatile powersaws that use a narrow flexible blade that is tensioned over two or three large diameter wheels. The narrow width of the blade allows them to cut curved as well as straight lines. Special blades are available for cutting materials other than timber.

Jigsaws

These are an ideal tool for cutting curved lines and shapes in timber and sheet material where it would be impractical to use a band saw. The saw's power and the length of the blade limits the thickness of material that can be cut, but it is possible to cut holes and shapes in the middle of a sheet of material, which is not possible with a band saw.

Fret saws

These saws use thin fine-toothed blades intended to cut intricate curves in thin material. Blades are available to cut wood and thin metal as might be used in jewellery-making. These saws are also available as a hand tool.

Lathes

Wood-turning lathes are used to make circular or cylindrical shapes by rapidly turning the wood to be shaped against a chisel or gouge which is held on a **tool rest**.

Circular saws

These allow quick and accurate straight cutting in both timber and sheet manufactured boards. Angled cuts can be made by tilting either the blade or the **saw bed**, according to the type of saw being used.

Disk sanders

The main use of these is for producing smooth and flat surfaces. Work is rested on an adjustable platform, and although the platform is fitted across the full diameter of the disk, you should use only the half on which the disk is rotating downwards towards the platform: sanding on the other side is dangerous as the work is very likely to be caught and thrown up by the friction of the abrasive surface. By adjusting the platform, any desired angle can be accurately sanded.

Belt sanders

Instead of a rotating disk, these use a continuous belt of abrasive material which travels over and is supported by a flat metal bed. The belt is held in tension by rollers.

Pillar drills

These are either bench- or floor-mounted. They have a range of speeds which allows them to drill accurately a variety of materials. The **drill bit** is lowered by a lever to the work which is held on an adjustable table.

Portable power drills
These drills allow the drilling of holes in work that cannot practically be accommodated in a pillar drill.

Metal

Casting

The **casting** of metal has a long history, and in particular bronze casting which has evolved over a period of about 4,000 years. Yet over this time the basic principles have remained unchanged. There are two basic methods of making a piece of work in cast metal: direct or 'lost'; and indirect, using a reusable pattern.

There are examples of the lost wax method dating from around 2000 BC. The process involved a wax pattern of the shape to be cast. This wax pattern was coated in clay and buried in sand. The sand was then heated until the wax could be poured out, and the molten metal could then be poured into the cavity that remained. The fact that the pattern is only used once means that how the pattern is removed from the mould does not have to be considered. This gives great freedom in modelling, allowing complex and textural forms to be made.

The process using reusable patterns needs greater preparation and planning than using wax patterns, and this restricts the complexity of form achievable. It does however allow large numbers of castings to be made relatively quickly. Wooden patterns are commonly used, and in their making, consideration has to be given to the fact that they will have to be removed from the mould without damaging it. This will mean designing in tapering surfaces and avoiding undercuts. Internal and external sharp corners should also be avoided as these will leave delicate and vulnerable points within the sand mould. If you look at the casting used for the engine block of cars, you will see this type of detail (i.e., no sharp corners) along with the slightly rough surface which has come from the impression left by the sand of the mould.

Aluminium casting
As aluminium has a much lower melting point than bronze and is a cheap and easily obtained material, it is possible that you may be able to explore metal casting using this material.

Joining metal

Heat processes

Soft soldering
This is a method of making joints in copper, brass, tin plate and steel. It is a relatively easy and quick process but is best confined to light fabrication work where strength is not a requirement. The jointing process relies on melting **solder** (an alloy of tin and lead) between the surfaces to be joined. The effectiveness of any soldering depends on the joint area being thoroughly clean. Flux is applied to the cleaned surfaces to aid the soldering process by preventing **oxidisation**.

A **soldering iron** or **gas torch** is used to provide the heat. It is essential that the surfaces that are being jointed be close fitting so that **capillary action** can draw the solder in to cover the mating surfaces completely. There are several ways of applying the solder. One method is to assemble the fluxed joint onto which small pieces of solder are then laid. The work is then heated, melting the solder which runs around and into the joint.

Hard soldering

Hard soldering involves higher temperatures than soft soldering, though the principle is the same as for soft soldering. Soft solder melts at around 200 °C, whereas the lowest melting point of hard solder is 625 °C. This means that heat cannot be applied by a soldering iron: a gas torch must be used instead. Hard solder joints are much stronger than soft solder ones.

Silver solders

Silver solders are alloys of silver, copper and zinc. There is a range of silver solders with differing melting points from 625 °C to 800 °C. This enables work to be joined in several stages, using the high-melting-point solders first and then the lower-melting-point solders, so avoiding the risk of the early joints coming apart while applying the heat for the later ones. A typical application for silver soldering is the making of jewellery.

Brazing

Brazing gives the hardest and strongest of all soldering methods. Here, joints are made at temperatures around 875 °C using a **brazing rod** which is made from an alloy of copper and zinc. Working at this temperature makes it too hot to use with brass or copper, but it is ideal for mild steel.

Welding

Welding is the process by which pieces of metal to be joined are melted and fused together forming a joint that is as strong as the metal being joined. It involves extremely high temperatures, and the main ways of achieving these temperatures are oxyacetylene gas welding, electric-arc welding or MIG welding.

In oxyacetyline gas welding, a very hot flame is produced by burning acetylene gas in oxygen. The gases are mixed in a **welding torch,** and the flame, once ignited at the end of the nozzle, burns at a very high temperature. Then, to join pieces of metal together, a pool of molten metal is created by the hot flame, and a **filler rod** of the same metal as that being joined is continually fed into this. The filler rod melts into the joint, filling it and so fusing the metal together.

In electric-arc welding, the heat needed to melt the metal is produced by creating an **electric arc**. Here, a large electric current is produced by passing mains electricity through a **transformer**. The current flows from the transformer to an **electrode**, across a small gap to the workpiece, and returns to the transformer via an **earth clamp** attached either to the work or to a metal-topped **welding bench**. The electrode, as well as carrying the current is a flux-covered filler rod. The rod is consumed in filling the joint, like the filler rod in oxyacetylene welding. Not only does the arc generate great heat, it also produces an intensely bright light which is strong in **ultraviolet (UV) radiation**. It is therefore necessary to protect the skin from the **carcinogenic** effects of the glare and to protect the eyes from both the UV radiation and the intensity of the light. A **welding mask**, not just goggles as in gas welding, will need to be worn.

Small pieces of silver solder are being heated to melting point using a gas torch. Capillary action draws the solder into the fluxed joint

Health and Safety Note
As well as very high temperatures, oxyacetyline welding produces an intensely bright flame. It is essential that special, dark protective goggles are worn when using this equipment.

MIG (metal inert gas) welding is also an electric-arc welding process but is much more versatile and easier to do than basic arc welding. Here, the arc is struck between the workpiece and a continuous wire electrode that is fed by motor through a torch. An inert gas flows through the torch, forming a shield around the arc which prevents surface oxidisation and slag from forming. The continuous wire electrode provides the filler rod. By using different gases and filler rods, most metals can be welded by this process, including aluminium, copper, carbon and alloy steels.

Spot welding is the main process that is used to join the steel panels in the production of motor cars. It is an ideal method for joining thin sheets of steel or wire. The process relies on the fact that if an electric current meets any resistance to its path, heat will be generated at that point, and with a sufficiently strong current, heat for welding can be produced. A spot welder has a pair of electrodes. The work being joined is sandwiched between these, and as a current is passed through both the electrodes and the work, resistance at the point where the pieces touch produces enough heat to form a localised **spot weld**.

Pop riveting

This is a quick and easy process ideally suited to jointing thin sheet material. Although mainly used for sheet metal, the process can also be used to join ridged sheet plastic and plywood.

Pop riveting allows fixing where access to both sides of the joint is not possible. Special **pop rivet pliers** are needed for this process. A hole, of the correct size for the rivet being used, is drilled through both sheets to be joined, and a pop rivet is then inserted. The rivet pliers are located on the rivet, and the plier handles are squeezed together. The head of the pin causes the rivet to swell on the inside of the joint, pulling the surfaces tightly together until the centre pin of the rivet snaps off.

Equipment for pop riveting

Plaster

Plaster is a very versatile material that has been used by artists and craftspersons for thousands of years, and as early as 2400 BC, the Egyptians were using it to make death masks. The plaster used for sculptural and three-dimensional work is **plaster of Paris**, also known as **dental** or **superfine casting plaster**. Plaster comes in the form of white powder which, when mixed with water, will set irreversibly within 15 to 20 minutes.

There are several ways plaster can be used:

Taking casts

The fine texture of plaster means that it is capable of reproducing great detail and will even pick up fingerprints when casting from a hand. Casts can be used as pieces of work in their own right or, more commonly, as a mould to make reproductions of the subject that the cast was made from. A simple way to explore the qualities of casting is to carefully press different objects into clay and then fill the depression made with plaster.

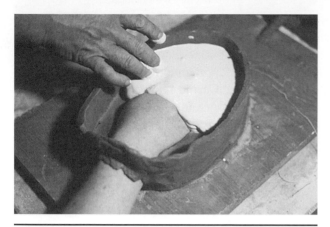

First a base and wall of clay are built up around the hand. Then plaster is poured over the hand to make the first half of the mould. To make the second half of the mould the process is repeated, with the hand the other way up

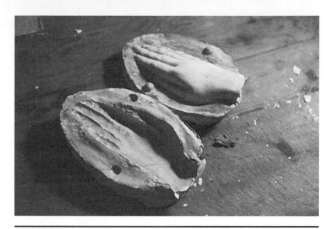

The two halves of the mould are treated to prevent sticking and are brought together and can be used to make casts. Here the two halves of the mould are opened to remove the finished cast

To take a mould from a hand:
1 First, you should thoroughly grease the hand with **petroleum jelly.**
2 Place the hand onto a clay bed and build up the clay surface so that it follows the contour of the hand at its widest point, ensuring that you have left no undercuts or gaps.
3 Build a wall around the hand either in clay or in already prepared wood, and ensure that you seal any gaps.
4 Pour thin plaster over the hand. Do this slowly to ensure that no air pockets are trapped which will spoil the finished cast.
5 Once the plaster has set, remove the wall and carefully release and lift away the cast.
6 Clean off any clay from the cast and make three or four location dimples in the plaster. Then apply either a thin clay wash or soft soap to the mould face to prevent the second half from sticking.
7 Turn over the mould and replace the hand, ensuring that it fits snugly, with no gaps. Remake the wall.
8 As for the first half, carefully fill it with plaster.
9 Once the plaster has set, remove the wall and gently prise the two halves of the mould apart.
10 The mould can now be used to make casts in plaster or **ceramic slip.** Large elastic bands made by cutting across tyre inner tubes are ideal for holding moulds together.

Modelling

The successful **modelling** of plaster is dependent on building a suitable armature. Square-sectioned aluminium wire or rod is good for this as it is easily bent to shape and there is no risk of staining the plaster. For large pieces, it may be necessary to use a mild steel rod to provide adequate strength and support. It is advisable to protect this steel with paint, as contact with the damp plaster quickly rusts the surface, leading to rust stains in the plaster. Building up the form with **chicken wire** will help to reduce the amount of plaster needed and will make the final piece much lighter. It is worth spending time carefully shaping the chicken wire as this will make the subsequent plaster work much easier; see page 34.

Expanded **polystyrene** can also be used as the underlying structure for

plaster modelling. This is easily carved, and pieces of it can be stuck together using plaster. Once you have constructed your armature, you can now start to cover the surface with plaster. This is best done, initially, with strips of **plasterers scrim** soaked in plaster. You should cut up strips of scrim in preparation before mixing the plaster, and should avoid mixing more than you can comfortably use before it begins to set. Once you have built up a complete surface using scrim, you can then continue to build and model the final form with plaster on its own. Avoid letting the plaster dry as you do this, and until you come to the final finishing, you should keep the surface rough to ensure that the layers adhere to each other.

The final finishing of the work can be done using surforms, rasps and scraping tools. If you wish to achieve a smooth finish, sandpaper can be used when the work is fully dry, or wet and dry paper can be used whilst the plaster is still damp.

Health and safety note
You should avoid creating unnecessary plaster dust, and should avoid breathing this in. If you are sanding dry plaster, you should wear a dust mask. Furthermore, plaster dries out the natural oils in the skin, and prolonged contact can cause serious skin complaints. You should therefore apply a **barrier cream** before starting work.

General comment
Plaster can be a very messy material to use. You should therefore fully prepare the area you are to work in and carefully plan the work. Wash out mixing bowls after each mix, and thoroughly clean all tools as soon as you have finished using them.

Clay

Clay is one of the most commonly available materials, and has been used since the earliest of times both as a sculptural material and as a way to make functional pieces such as bowls and jugs. Many of the techniques for manipulating clay have remained unchanged for thousands of years, needing little or no sophisticated tools or technology to make successful work. A recognition and understanding of the different qualities and states that this material can take will take one a long way towards achieving good work.

There is a wide range of types of clay available for sculpture, pottery or ceramics, each having its own particular characteristics making it more or less suited to particular types of work. Clays can be smooth and finely grained or rough, and containing sand or **grog** (fired clay that has been ground up). Different clays will also vary in colour from white **China clay** to the red of **earthenware** or the blue of **ball clay**. The types of clay that are available to you may be limited by cost as some clays are much more expensive than others.

Working with clay

Sculpting
There are two main ways in which clay can be used as a sculptural material, one where the modelled clay piece will be fired and become the finished work, and the other where a mould is cast from the clay sculpture which is then used to make castings in other materials such as metal, plaster, plastic

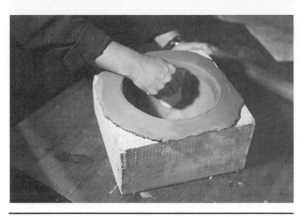

Pressing a slab of clay into a plaster mould

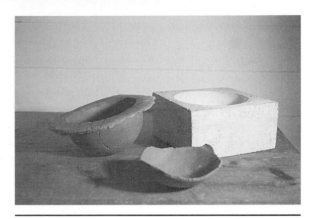

Press-moulded forms

Slab building – a rolled slab of clay is cut to the required shape using templates

The cut shapes are assembled using clay slip as an adhesive

The final slab-built form

resin or **clay slip**. Whilst the actual modelling of the clay will be the same for each process, it is important to take into account that if the work is to be **fired,** any armature that is used will have to be removed, and that large solid forms will have to be hollowed out to leave a thickness of clay of no more than 25 to 35 mm. With fired work, you will also need to ensure that you do not contaminate the clay you are working with. Foreign matter trapped in the clay, especially plaster, may cause small explosions as the work is fired. Not only will this ruin your own work, it is also likely to damage other pieces in the kiln, or even the kiln itself.

Casting and moulding

Making plaster **moulds** from which a slab of clay can be **press-moulded** or in which liquid clay or **slip** can be cast, will allow a number of identical pieces to be made quickly and easily once the mould has been made (see page 67). Although this way of making is more often associated with mass production, the ability to make several identical pieces which in turn can be manipulated through other processes such as cutting or assembling offers some exciting possibilities.

Slabbing

Working with slabs of clay is a simple but versatile way to build both functional containers and non-functional sculptural pieces, and it can produce some strong and exciting work (see page 67).

1 A lump of clay is placed onto a damp cloth and, using a rolling pin, rolled out to make a slab. Thin wooden strips can be laid along each side of the clay to act as guides to ensure uniform thickness of the slab.
2 The slab is then cut to the required size and shape. The use of a paper or card **template** will help to cut accurately.

Throwing – a ball of clay is thrown onto the wheel and centred

A thumb or finger is pressed into the centre of the clay

Even pressure on the sides of the clay encourages the sides of the pot to rise

3 Once you have cut all the pieces you need, the work can be assembled, paying careful attention to the joints to ensure a good bond. Roughen the mating surfaces by scoring them, and apply clay slip to act as an adhesive.

Throwing

Possibly the process most commonly associated with making functional ceramic pieces, **throwing** is a skill that needs patience and practice to master.

1 A ball of thoroughly wedged clay is thrown down onto the centre of the wheel. With the wheel rotating, and using wetted hands, the clay is centred.
2 Once centred, the thumb of one hand is pressed down into the centre of the clay.
3 Both thumbs are then inserted into the indent. With the fingers supporting the sides of the rotating clay, light thumb pressure is applied to open out the clay. Even pressure between thumbs and fingers will encourage the sides to rise, and the basis of a thrown form will begin to take shape.

Plastics

Plastics are one of the most common materials used in the manufacture of products. The range of qualities plastics exhibit is vast, from thin transparent film and fabrics to extremely hard precision-moulded forms that exhibit qualities similar to metals. The large majority of plastic objects have been produced using costly and sophisticated mass-production methods which are dependent on thousands of pieces of work being produced to make them economically viable. As a material for use in hand production, plastics are much more limited, although they do still offer some unique possibilities here.

Plastics are relatively easy to work using basic hand tools: they can be sawn, drilled, filed and sanded. Most can also be joined using solvent adhesives which in effect produce a weld.

Rigid plastics

Rigid plastics come in a variety of forms and finishes – sheet, blocks, rods or tubes, clear, tinted or opaque – and in a range of colours.

Rigid sheet plastics

Virtually all **rigid sheet plastics** are made of material that, when heated, will soften and, on cooling, will again become rigid. These materials are known as **thermoplastics**. Probably the best known of these is acrylic (ICI trade name 'Perspex') polystyrene and **ABS (acrylonitrile–butadiene–styrene)**. Heating these plastics will allow them to be bent and formed into three-dimensional shapes. **Hot air guns, strip heaters** (designed specifically to provide localised heating for bending along a line) and ovens can all be used. Different plastics will soften at different temperatures. Some experimentation may be needed to achieve the right heat required to soften the sheet sufficiently for it to be formed yet not to burn, melt or blister. Acrylic becomes flexible at 120 °C, and is ideal for most forming between 150 °C and 170 °C. Polystyrene softens at the lower temperature of 80 °C.

Vacuum-forming

This is a process that allows thermoplastic sheets to be formed into complex shapes. Principally, the process involves heating the plastic sheet and then draping the softened plastic over a mould or pattern. Air is then drawn out from between the plastic and mould, and the plastic is forced by air pressure tightly over the mould. Careful consideration will have to be given to the mould design. It will have to be made with tapering sides and no undercuts if you are to avoid trapping it in the formed plastic. First experiments with this process are best done with shallow **reliefs**.

Glass-reinforced plastic (GRP)

This is a material that has a wide range of applications. **GRP** has been used extensively for making large mouldings. The majority of pleasure sailing boats and motorboats are made of this material, as are lifeboats and other working boats. The bodies of several makes of motorcar, from the unglamorous but functional Reliant three-wheeler to exotic and powerful sports cars such as the Lotus and TVR, are also made of GRP. These applications take full advantage of its high strength : weight ratio, its resistance to corrosion, and its ability to be moulded into complex forms. Canoes, caravans, architectural cladding and furniture are also common functional applications. Although GRP is used in mass production, the process by which it is moulded makes it equally suitable for one-off pieces. It therefore has great potential for sculptural work as it is a relatively quick and easy way of casting from a mould, particularly in comparison with casting metal.

The Lotus Europa has a GRP body

Glass-reinforced plastic, as the name suggests, is made from strands of glass fibres set in plastic resin. The glass fibres are approximately 50 mm long and, prior to moulding, are bonded in the form of a flexible mat, the resin, usually **polyester**, being in liquid form.

To produce a piece in GRP, a mould will be needed. These can be made of almost any material, including plywood, hardboard, sheet metal, plaster of

Gel-coat resin is applied to the prepared plaster mould

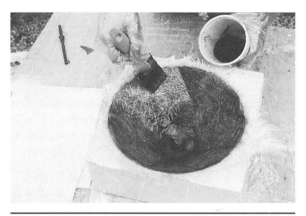

A glass fibre mat and lay-up resin are layered into the mould

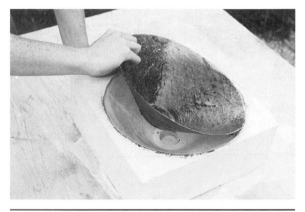

The curved and trimmed moulding is separated from the mould

Paris, rubber and GRP itself. Rigid moulds must be made with tapered sides and have no undercuts to enable work to be removed, and any **porous** materials will have to be sealed. The surface of the mould must be coated with **release agent** before **laying up** with resin and glass fibre or the work will firmly adhere to it.

The actual process of **laminating** should be carried out in a methodical way:

1 Thoroughly prepare the mould, applying release agent.
2 Cut up enough glass fibre mat pieces to enable you to cover the mould in three laminations, i.e. three layers.
3 If the surface of the work is to be coloured, add this special resin pigment to the **gel-coat resin**. (Gel-coat is a resin that is formulated not to run even on vertical surfaces.)
4 Wearing polythene gloves, and having added the specified amount of **catalyst**, apply the gel-coat to the mould, ensuring that it is forced into all small recesses or corners, as this will form the finished surface of the work.
5 When the gel-coat has set or cured, coat it with a layer of catalysed **lay-up resin**. Onto this lay the first lamination of glass fibre mat. **Stipple** the mat using a stiff brush until it is thoroughly wetted and all air is forced out. Repeat with successive layers.
6 After about 40 minutes, when the resin has set but not become too hard, trim the surplus material from the edges.
7 Wait at least three hours before separating the work from the mould.

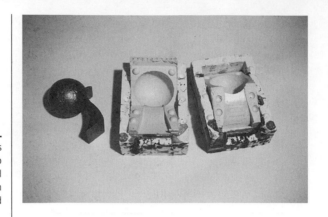

A resin and bronze powder casting gives the impression of bronze casting. A two piece rubber mould was used as several casts of this intricately shaped form were required

Casting with resin

Casting using resin on its own or mixed with filler powder is a good method by which smaller work can be produced. Resin can be mixed with a variety of powders to give the finished casting particular surface qualities. Using metal powders will give the finished casting a surface quality almost indistinguishable from that of hot metal casting, particularly when polished. Sand or marble mixed with the resin will give the effect of stone.

A special clear casting resin is available that has a slow setting time which reduces the risk of cracking of the casting due to heat generated by the faster chemical reaction of lay-up resin. It is still advisable, when casting larger pieces, to do this in stages, allowing each layer to cure before the next is added. Pouring in successive layers also allows you to embed objects within the cast, sitting these on the set layer prior to a subsequent pour. When cured, the resin can be polished to a high finish.

Health and safety note
Polyester resins and glass fibre are not very pleasant to use, and can be harmful if not handled properly.

The fumes from resins, catalysts and cleaning fluids are toxic and therefore should only be used in well-ventilated areas.

Resin and glass fibre are irritants to the skin, and so barrier cream or polythene or rubber gloves should be worn. A catalyst is a strong oxidising agent, so again avoid any skin contact: wash the skin immediately with cold water in the event of skin contact. In the case of resin or the catalyst entering the eye, do the same and always seek medical help.

You should always wear a dust mask when filing or cutting cured mouldings, as the dust is composed of fine, needle-sharp glass fibres and insoluble resin particles. If power sanding, you should use a face mask, goggles and protective clothing.

Always read and follow the manufacturers' instructions when using resins and catalysts, and do not be tempted to use more catalyst than is recommended: too much catalyst can generate high temperatures, leading to toxic smoke, fire or even an explosion of the mix.

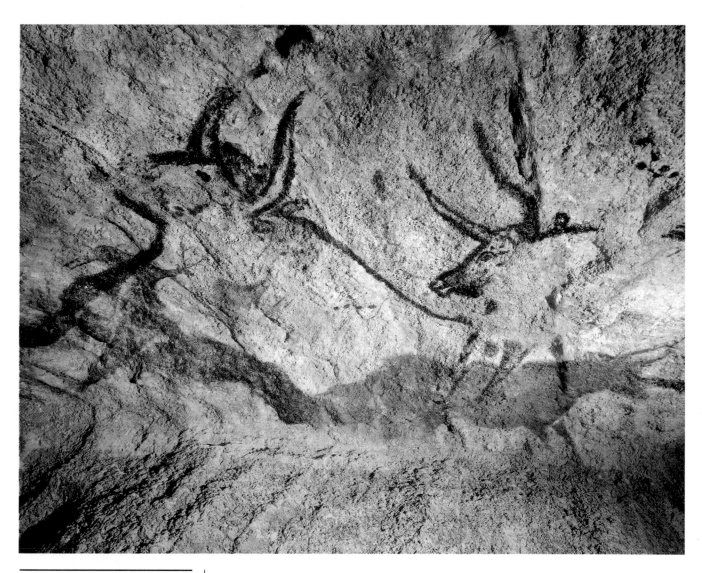

Plate 1.1 Cave painting, Lascaux,
France. These paintings were painted
between 15,000 and 10,000BC using
charcoal, chalk and other naturally
occurring earth colours

Plate 1.2 (a) Additive colour. Mixing the primaries of light will produce white light

Plate 1.2 (b) Subtractive colour. Mixing the primaries of pigment will give black

Plate 1.2 (c) Pigment. Pigment acts like a selective sponge for light, absorbing some parts of the spectrum and reflecting the remainder, which is the colour we see

Plate 1.3 *Light Red over Black* by Mark Rothko (1957). Rothko, the Abstract Expressionist colour field painter produced large canvases that allowed colour to dominate the viewers visual senses

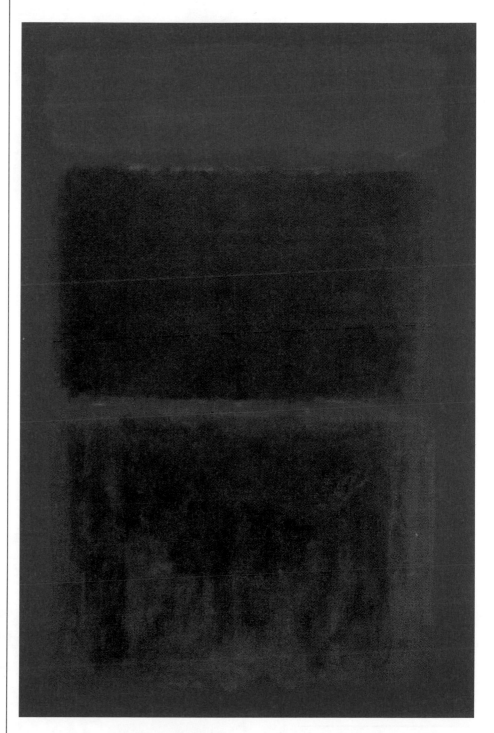

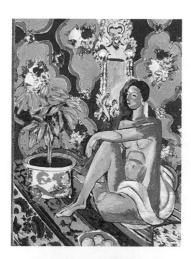

Plate 1.4 Compare *Figure Decorative Sur Fend Ornemental* by Matisse with the sketch by Henry Moore on page 10

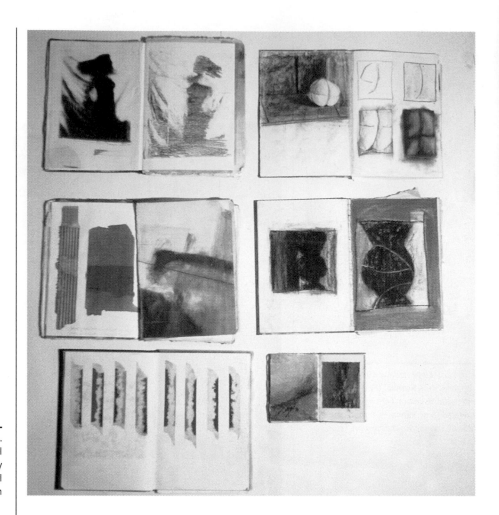

Plate 1.5 Student sketchbooks. Sketchbooks are very personal documents, reflecting the personality and particular interests of the individual who has made them

Plate 1.6 Student worksheets. Worksheets are working documents, used to develop and record ideas, thoughts and observations, through which a dialogue can develop where one thought or observation can act as a catalyst for another, allowing a rich body of work to evolve

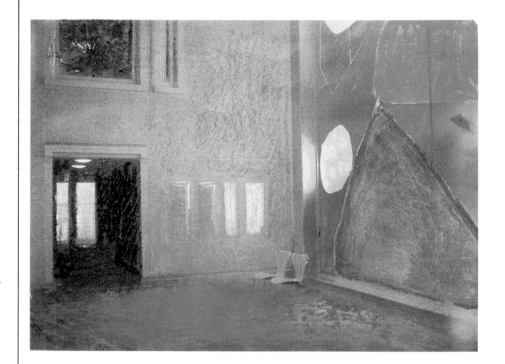

Plate 1.7 This painting of the inside of the Tate Gallery St Ives has been made by an artist interested in capturing the particular quality of light that fills the space

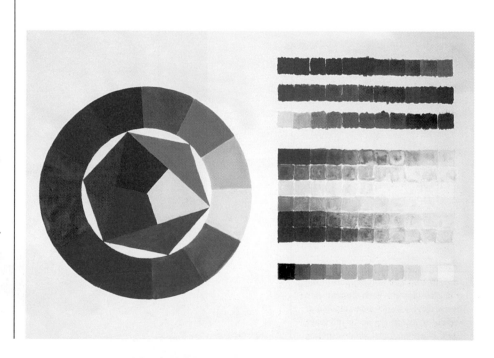

Plate 1.8 Colour wheel. As part of an introductory colour assignment, students made a colour wheel to identify primary, secondary and tertiary colours. They also made grids that identified and explored tonal values, saturation and temperature values. See sample assignments at the end of Chapter 1

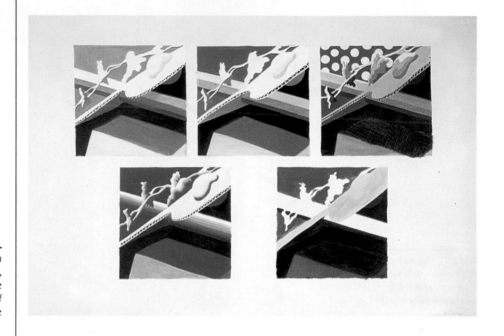

Plate 1.9 These studies are also from the introductory colour assignment, through which students examined the effects of colour on our perception of space

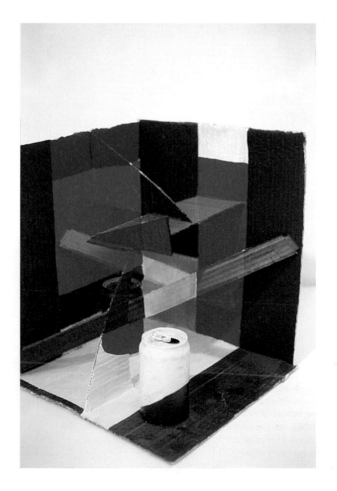

Plate 1.10 As a concluding part of the colour assignment, each student used their discoveries and understanding of colour to distort the perceived space within a simple spatial construction

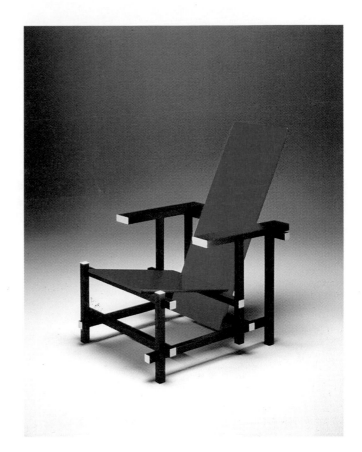

Plate 2.1 *Red and Blue Chair* (1918).
Gerrit Rietveld applied De Stijl
philosophy to the development of this
chair design

Plate 2.2 *Skimmer Flats* (1974).
Anthony Caro has used the process of
construction as the dominant method of
making his work, using industrial metal
beams, sheet and plate steel to develop
abstract structures

Plate 2.3 In the development of the
design for this BSA motorcycle,
commissioned by the company MZ, the
design consultants Seymour Powell used
Styrofoam to explore the different
possibilities of form

Plate 2.4 Paul Spooner has to cut and
shape many small and intricate pieces of
wood to create his automaton pieces

Plate 3.1 *The Guadalupe Islands* by
Frank Stella (1980) is a mixed media
work including acrylic paint

Plate 3.2 *Sicilian Landscape* (1924).
Paul Klee used watercolour paints for
much of his work, using it in a more
abstract way than we normally associate
with this medium

Plate 3.3 This airbrush work, made by a student on a national diploma illustration course, clearly demonstrates the particular qualities of this process

Plate 3.4 These four prints show some of the wide range of qualities that can be achieved using monoprinting

Plate 3.5 Collograph printing offers the opportunity to produce rich and exciting images relatively easily, although good results rely on access to a printing press. The top image is the print made from the plate shown below

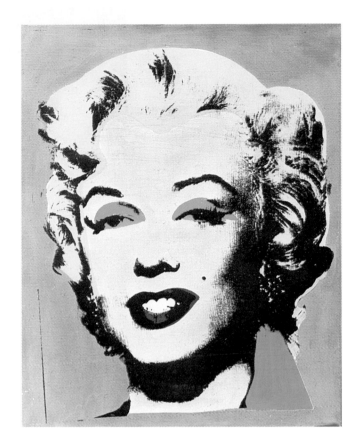

Plate 3.6 *Lavender Marilyn* (1962).
Andy Warhol used the process of
photographic silkscreen printing in many
of his pieces, this process being ideal for
creating repeat coloured images

Plate 3.7 Tie dying. Whilst it is easy to
make arbitrary patterns using this
method of dying, the real creativity
comes by exploring and controlling the
patterns achieved

Plate 3.8 Batik. The basic tools used in the creating of batik work, a wax melting pot and tjanting tools for drawing with wax

Plate 3.9 Good control and practice using the tjanting is needed to create intricate designs like this batik design

Plate 3.10 This woven structure, using painted bicycle tyres, shows the most simple weave pattern. It was used as the basis for a more complex surface

Plate 3.11 Only a simple frame is necessary to begin to explore the possibilities of weaving

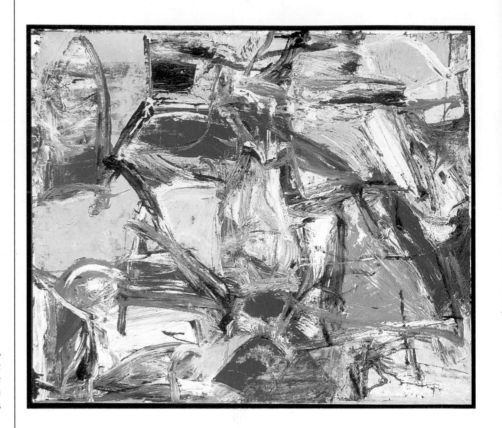

Plate 4.1 *Police Gazette* by Willem de Kooning (1955). De Kooning is one of the most well known of the American abstract expressionists

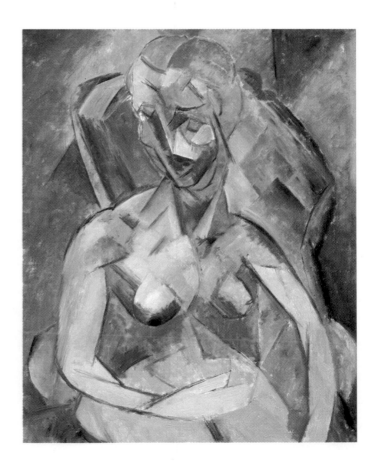

Plate 4.2 *Young Woman*. This painting by Pablo Picasso made in 1909 is from the early phase of cubism, one of the most important phases in the development of art in the 20th century

Adhesives

PVA (polyvinyl acetate)

This is a particularly useful adhesive that has many applications in addition to joining materials such as wood, fabric, paper and board. Although, before drying, it is a white, thick liquid and one that is water-soluble, this adhesive medium dries almost transparent and, according to the particular specification, can be totally waterproof. It can be used to seal porous surfaces, or it can be mixed with powder colours to make a fast-drying emulsion paint to provide a durable finish or to add strength and flexibility to **papier-mâché**.

Epoxy resin

This is a very versatile, although expensive, adhesive that will bond most rigid, dry materials to themselves or to other such materials, e.g. ceramics, aluminium, plastic, glass. It is a two-component adhesive requiring equal parts of resin and hardener to be mixed to start the chemical hardening process.

Contact adhesive

Contact adhesive, as the name suggests, has the great advantage of bonding instantly on contact. Each of the two surfaces being joined are coated in a thin film of the adhesive and allowed to become dry to the touch (which takes one or two minutes). The surfaces are then brought together, and an instant bond is formed. Contact adhesives are particularly good for bonding the large surfaces of sheet metal. They should only be used in a well-ventilated area.

Latex adhesive

This adhesive is particularly suitable for use on fabric, card and expanded polystyrene. It is water-soluble before setting. Latex can also be used to make flexible moulds.

Cow gum

A rubber-solution adhesive, used for studio paste-up work and for mounting photographs. Also used for bonding paper and light card to a variety of surfaces, and particularly suitable where repositioning may be required. It can also be used as a masking liquid as it can be removed with a rubber without damaging the paper's surface.

Superglue

Only a small drop of this adhesive is required on one surface to bond within seconds. It is for use on rubber, metal, jewellery, porcelain and plastics, although not suitable for absorbent surfaces such as paper or fabric. The manufacturer's instructions should always be closely followed as this glue also bonds skin very effectively.

4

Historical and contemporary contexts

Introduction

I t is difficult to imagine a musician, however accomplished, who does not listen to or play other artists' music, and who is not influenced by the work of these other artists during the process of creating new work. As with musicians, the fine artist, designer or craftsperson would find it difficult to develop their own work and ideas without being aware of, and being influenced by, the work of others in the same or related disciplines. If we look back at the history of art and design, we can see how this awareness of others' work and the sharing of ideas allows new and exciting developments to emerge. It also allows us to see how other influences, such as the development of new technologies or the social environment, can affect the development of artists', designers' and craftspersons' ideas and work. These influences are generally referred to as the **context**.

This chapter will focus on:

- **researching others' work**
- **context, influences and references in others' work**
- **the social, technical and industrial context and influences on art and design**
- **the use of visual language in others' work**

Throughout this book, as a way to illustrate ideas, media, materials and processes, examples of other artists' or designers' work have been used. The range that it is possible to show in one book is limited, but hopefully these examples demonstrate the value of looking at others' work. Along with infor-

mation contained in this chapter, they will help you to develop an understanding of historical and contemporary contextual references.

It is important that you develop your awareness and understanding of the work and ideas of other artists, designers and craftspersons, as this awareness will have a direct influence on the speed and success of your own development. The way you acquire this knowledge of artists', designers' and craftspersons' work can take many forms. A lot of the information you accumulate will come through your own general interest in the world around you, through watching television and reading newspapers and magazines, and even through going shopping. Designers, in particular, are great window shoppers! Unlike most other disciplines, being an artist or designer is something that becomes a major part of your life. Although you may not always be consciously thinking about your work, observations of and influences from the world around you, including the work of others, should constantly feed your ideas.

At college, one of the most immediate influences on you and your ideas will be the staff teaching you, but you will also learn a lot by sharing thoughts, ideas and discoveries with other students. You should never worry about using other students' discoveries, or about others using yours. Your own interpretation and development will quickly make the work different and individual, and will lead to further discoveries. Indeed, much of what you will discover on your course will come through this process of sharing, a process which can lead to the creation of an exciting, dynamic and unique working environment. If you progress to higher education, this process of sharing with and learning from other students as well as from teaching staff will continue.

As your work develops, you will need to reinforce and extend your understanding of the practical work you are involved in by finding out about other artists, designers or craftspersons who have explored, developed or produced work that has aspects in common with your own. The common features of this work could take several forms: it might be the subject matter they are working from, the materials they are using or the way they are using them, or an issue or problem they are exploring. Not only will your research help directly with the work you are producing, you will also start to build a broad knowledge and understanding of the work of other artists and designers, and of the exciting creative community you are becoming part of.

This chapter is intended to help you in this process. It gives a brief outline of some of the important developments in art and design since the middle of the last century. This information is not intended to be comprehensive but will give you pointers towards further research. You will see that there are some artists and designers who are associated with more than one development or movement, and that the progression of their work has often come from the sharing of ideas.

Art and design movements and terms

Abstract art. This is art which does not attempt to imitate or directly represent reality, although the work may have originally derived from an observation of reality. Observed reality can be abstracted and still retain a recognisable subject matter. An example of this would be **cubist** painting.

Conversely, the **abstract expressionist** work of **Willem de Kooning** (b. 1904) is almost totally abstract; see colour plate 4.1. Abstract art need not make any reference to observed reality such as forms, shapes and colours, and may instead be largely dictated by process, as in the work of **Jackson Pollock** (1912–56), or by formula, theory or expression.

Abstract expressionism. A term most commonly used to describe non-geometric abstract painting produced between 1942 and the early 1960s in America, although the term was first used to describe some of **Vasili Kandinsky's** (1866–1944) paintings in 1919. Two definable styles emerged within this movement: **brush painting**, concerned with gesture, action and texture, as in the work of Willem de Kooning and Jackson Pollock; and **colour field painting** which was concerned with large unified shapes or areas of colour, as seen in the work of **Barnet Newman** (1905–70), **Mark Rothko** (1903–70) (see colour plate 1.3) and **Clyfford Still** (1904–80).

American streamline. A design style developed in America in the 1930s, in the early days of industrial design. During the Depression, manufacturers struggled to sell their products, and the concept of 'design' was used as a way to encourage the public to buy products. As a result of this, everyday products became styled, with a streamlined appearance being the common theme. Streamlining gave a new, exciting, futuristic and optimistic feel to previously mundane products such as refrigerators, telephones and office machinery. Some of the most influential of these first industrial designers were **Henry Dreyfuss** (1903–72), **Raymond Loewy** (1883–1986) and **Walter Dorwin Teague** (1883–1960).

Art Deco. A style of design that takes its name from the 'Exposition Internationale des Arts Décoratifs' held in Paris in 1925, although work associated with this style dominated the decorative arts and design for the period between the First and Second World Wars (1918–39). **Art Deco** can be recognised by its typically geometric, mostly rectangular and semicircular, shapes and stepped forms. These solid and formal elements were in direct contrast to the previous organic style of **Art Nouveau**.

Art Deco saw a revival in the 1960s, and elements of this style can also be seen in aspects of **postmodernism**, especially in architecture.

Art Nouveau. A style of decoration, design and architecture of the 1890s and 1900s, its designs derived from **organic** plant forms. Good examples of this style can be seen in the wrought-iron entrances to the Paris Metro stations. Artists and designers associated with this work include the illustrator **Aubrey Beardsley** (1872–98), the glass-maker **Louis Tiffany** (1848–1933), the architect and interior designer **Charles Rennie Mackintosh** (1868–1928) and the architect **Antonio Gaudí** (1852–1926).

Arts and Crafts movement. This movement brought a revival of artistic craftsmanship as a revolt against industrialisation which designers, including **William Morris** (1834–96), **Walter Crane** (1845–1915) and **Charles Robert Ashbee** (1863–1942), believed had undermined ornament and design. The movement used craft work of the Middle Ages as its inspiration.

Avant-garde. A term applied to artists thought to be, at any given time, at the forefront of their field.

Bauhaus. The **Bauhaus** was the most important and influential school of art of the twentieth century, founded in 1919 by architect **Walter Gropius** (1883–1969) at Weimar in Germany. The aim was to bring together art, design, crafts and architecture. Running in parallel were the study of form and colour and the study of materials and technology. A basic aim was to

Art Nouveau Metro Station entrance, Paris

teach and develop design suited to machine production technology, the intention being to make good design available and affordable to all. Teachers at the school included Vasili Kandinsky, painter; **Paul Klee** (1879–1940), painter; **Lyonel Feininger** (1871–1956), painter; **Oskar Schlemmer** (1888–1943), sculptor; and **Marcel Breuer** (1902–81). Although the latter was an architect, his tubular steel chairs are some of the best known products from the Bauhaus, and copies of them are still made today. In 1925, the school moved to Dessau into a building designed by Gropius. **Ludwig Mies van der Rohe** (1886–1969), architect, took over as director in 1928. The Bauhaus was then closed by the Nazi government in 1933. In 1937, under the directorship of **Laszlo Moholy-Nagy** (1895–1946), a sculptor, painter, designer and photographer, the school was re-established in Chicago, America. Art and design education, in particular diagnostic courses, still owe a lot to the Bauhaus in establishing fundamental principles which are shared by artists, designers and craftspersons.

Conceptual art. Conceptual art was established in the late 1960s and 1970s as a development from **minimal art**. It questioned the whole idea of 'art'. As concepts and ideas are usually the starting point of works of art, the conceptual artists explored ways of conveying these concepts without the use of traditional media. Artists such as **Sol Le Witt** (b. 1928) and **Joseph Kosuth** (b. 1945) would present and convey their concepts through documents, photographs, statements, maps, film and writing.

Constructivism. An art movement that had its origins in Russia. Influenced by the constructions or collages of Pablo Picasso which utilised solid materials such as glass and wood, it included development of work made in the period 1913–17 by **Vladimir Tatlin** (1885–1953). In 1921–2, there was a split

between those abstract artists who wished to pursue their work as a pure art form and those, who became the **constructivists**, who wanted to develop their work towards more functional ends. These constructivists began to work as industrial designers – namely Tatlin and **Alexander Rodchenko** (1891–1956) – and as architects, or in theatre and film: **Liubov Popova** (1889–1924), **El Lissitsky** (1890–1941). Constructivist principles also influenced graphic design. El Lissitsky produced the first examples of graphic design with his pioneer work in poster and exhibition design. Through artists such as Vasili Kandinsky, **Naum Gabo** (1890–1977) and Moholy-Nagy, along with the work and teaching at the Bauhaus, the constructivist ideas influenced architecture and industrial design throughout Western Europe.

Cubism. Cubism was the first form of abstract art of the twentieth century, in which objects, people and landscapes were represented as many-sided or faceted solids. **Paul Cézanne's** (1839–1906) later work was a strong influence on the development of cubism, and his advice to 'deal with nature by means of the cylinder, the sphere and the cone' was used as a justification in this development. Artists had, at the same time, become aware of African sculpture with its sharply faceted surfaces, and this led early cubist work to show the breaking up of individual form into sharp angular planes. Picasso's painting *Young Woman* (1909) is a good example of this phase of cubism; see colour plate 4.2. Picasso and **Georges Braque** (1882–1963) were working in close collaboration during this period. Their ideas developed towards work that was flatter and more abstracted, as if the painter were looking at various aspects of their subject matter from varying viewpoints and then combining these fragments into a single composition. The final stage of cubism, which became more colourful than the previous work, saw the combination of painting with real materials (i.e. collage).

Many artists explored the cubist style, including **Juan Gris** (1887–1927) and **Fernand Léger** (1881–1955). Cubist work was not just produced by painters: cubist sculptors included **Aleksandr Archipenko** (1887–1964) and **Henry Laurens** (1885–1954). Cubism had an enormous influence on subsequent developments in art and design, and from it grew the **futurist** movement in Italy and the **vorticists** in Britain. It was also an important influence on Russian constructivism and the **De Stijl** group in the Netherlands.

Dada. An arts movement initiated in 1916 in Zurich as a revolt against the First World War. In 1918, **Tristan Tzara** (1896–1963), as the movement's spokesperson, wrote the *Dada Manifesto* which stated that Dada works are nihilistic gestures and provocations. They attacked all traditional forms of logic, art, and culture through magazines such as *Cabaret, Dada, Voltaire, 391* and others, and by mocking established art with works including the *Mona Lisa with a Moustache* (1917) and *The Fountain* (1917), which was actually a urinal sent to the New York Independents show by **Marcel Duchamp** (1887–1968) in 1917. **Jean Arp** (1887–1966), together with his wife **Sophie Taeuber** (1889–1943), were major contributors who made collages according to the law of chance rather than through ordinary aesthetic logic.

De Stijl. This was a group of artists and designers established in 1917 in Holland. It was particularly significant in that it brought painters and sculptors together with architects and industrial designers. Among these was the abstract painter **Piet Mondrian** (1872–1944), who took the name De Stijl from a magazine edited by the painter **Theo van Doesburg** (1883–1931); see colour plate 4.3. The group promoted the use of basic forms, particularly cubes, verticals and horizontals, and the basic primary colours of blue, red

and yellow. Architects such as **Gerrit Rietveld** (1888–1964) and **Jacobus J P Oud** (1890–1963) were connected with the group, as were the artists **Hans Richter** (1888–1976), El Lissitzky and **Constantin Brancusi** (1876–1957). De Stijl ideas strongly influenced work of the Bauhaus (where van Doesburg taught) and geometric abstract art of the 1930s.

Expressionism. This is a term used to describe works of art, painting, sculpture or graphic art (and also literature, theatre, film and dance) in which the artist distorts qualities such as colour, space, form and other naturalistic elements in order to express certain ideas or emotions. First used at the 1911 **Fauvist** and cubist exhibition in Berlin, expressionism is most commonly associated with art of Germany and Austria from the beginning of the century up to the seizure of power by the Nazis who suppressed it as communistic. The *Blaue Reiter* (*Blue Rider*) group evolved a more structured and, in the case of Kandinsky, more theoretically informed art out of expressionism.

Fauvism. This was a style of painting where colour was the dominant theme in the work. The most important artists working in this way were **Henri Matisse** (1869–1954), **Raoul Dufy** (1877–1953), **Maurice de Vlaminck** (1876–1958) and, for a short time, Georges Braque.

Futurism. A movement in art and literature. The first *Futurist Manifesto* was published in Paris in 1909 by **Filippo Marinetti** (1876–1944), a poet and dramatist. This was followed in 1910 by the manifesto of a group of Italian artists including **Umberto Boccioni** (1882–1916), **Carlo Carra** (1881–1966),

Villa Savage by Le Corbusier. One of the most influential of twentieth-century modernist architects, Le Corbusier stated that 'a house is a machine for living in'

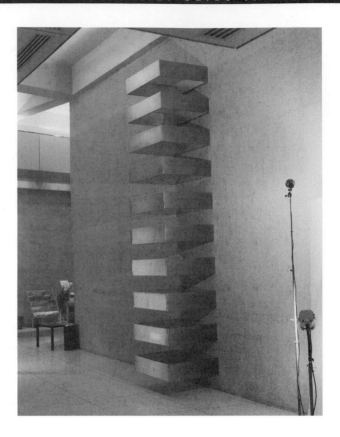

Untitled by Donald Judd. The minimalist work of Donald Judd used simple, identical modular units to explore ideas about space, shape and materials

Giacomo Balla (1871–1958) and **Gino Severini** (1883–1966). These artists wished to glorify the new age of the machine and rejected the art of the past. Their paintings depicted the dynamic qualities of machines and of figures. The painters would create fragmented forms cut with diagonal shafts of light to enhance the feeling of energy and motion.

Impressionism. The best known movement in nineteenth-century art, involving many well-known artists working in Paris between the late 1860s and early 1880s, including **Claude Monet** (1840–1926) (see colour plate 4.4), **Camille Pissarro** (1830–1903), **Auguste Renoir** (1841–1919), **Alfred Sisley** (1839–99), **George Seurat** (1859–91) and **Edgar Degas** (1834–1917). These painters were interested in the play of light within a scene and the creation of a visual impression rather than in a sharper and more solidly defined depiction. The artists made it popular to work in the open air, allowing close analysis of the actual colours of the landscape. The influence of recently developed photography can be seen in the composition of many of these artists' paintings.

Modernism. At the beginning of the twentieth century, architects and designers such as **Anni Albears** (1899–1981), textile designer; Marcel Breuer, architect and furniture and industrial designer; Ludwig Mies Van Der Rohe, architect; Walter Gropius, architect; and **Eileen Gray** (1878–1976) became interested in a design philosophy which, in contrast to the heavily ornamented Victorian architecture and design, would promote a simplicity and honesty in the use of materials and the function of architecture, furniture and products. This new approach to design found its ideological base in **functionalism**. These designers wanted to respond to modern needs by using modern materials, and this led them to create concrete and glass rectilinear white buildings that would contain minimal, functional furniture of metal and bent

wood. **Le Corbusier** (1887–1965), one of the most influential twentieth-century modernist architects, stated that 'a house is a machine for living in'.

Minimalism. An art movement of the 1960s originating in America that was predominantly three-dimensional. The work of artists such as **Carl Andre** (b. 1935), **Dan Flavin** (b. 1933) and **Robert Morris** (b. 1931) was totally non-figurative, with expressiveness minimised. In *Untitled*, Donald Judd (1928–94) explored and redefined ideas about space, shape, scale and materials, using simple arrangements of identical modular units. Conceptual art (see earlier) evolved from this development.

Neoimpressionism. A late-nineteenth-century style of painting, also known as **pointillism**. The best known of the artists associated with this style is Georges Seurat, but it was also practised by Camille Pissarro, **Paul Signac** (1863–1935) and **Henry-Edmond Cross** (1856–1910). Instead of mixed pigments on the pallet, the artist would apply small dots or dashes of pure pigment to the canvas which, when seen from a distance, would combine to create an image of subtle colours that would have a richness difficult to achieve with more conventional ways of applying paint. **Vincent Van Gogh** (1853–90), **Henri de Toulouse-Lautrec** (1864–1901) and Henri Matisse have used this technique in some of their paintings.

Neoplasticism. A style of painting, evolved by Piet Mondrian and other artists such as Theo van Doesburg during the period 1912–18, based on a theory that art was to be entirely abstract. Only right angles in the vertical and the horizontal positions were to be used, painted in only the primary colours of red, yellow and blue, together with white, black and grey. See also **De Stijl**.

Omega Workshop. A craft workshop founded in 1913 by **Roger Fry** (1866–1934), with the support of painters including **Duncan Grant** (1885–1978) and **Vanessa Bell** (1879–1961). Fabrics, furniture and pottery were designed and made which were decorated in the style of the current **Bloomsbury Group** of painters.

Op art. A style of abstract painting of the 1960s which explored the effects of optical illusions. Paintings were often made up of sharply defined contrasting lines, either in vivid colours or black and white, applied in patterns that would give the viewer the feeling that the image was constantly shifting. This style of painting found its initial influence in the work of artists such as **Josef Albers** (1888–1976) and **Victor de Vasarely** (b. 1908). Some of the best known works such as *To a Summer's Day* were made by **Bridget Riley** (b. 1931) who has continued to develop this style of painting. **Kinetic art** was the three-dimensional equivalent, but here, instead of optical illusion, the works actually moved. Some works, including those of **Jesus Rafael Soto** (b. 1923), combine both illusory and actual movement.

Pop art. A movement in painting and sculpture which was concerned with contemporary popular mass culture. Although **Richard Hamilton** (b. 1922) and other English artists in the 1950s had started to comment on post-war consumerism through their work, it was the American artists such as **Roy Lichtenstein** (b. 1923) (see colour plate 4.5), **Claes Oldenburg** (b. 1929), **James Rosenquist** (b. 1933) and **Andy Warhol** (1928–87) who, in the 1960s, gave the movement its strongest identity. In *Blang*, Lichtenstein used the comic book format for which he became best known. The artists not only depicted images of modern consumer society, but also often used commercial art techniques in the production of their work, as seen in Warhol's repeat silk-screen prints (see colour plate 8.1).

To a Summer's Day by Bridget Riley (1979) clearly demonstrates the effective use of optical illusion as explored by the 'op' artists during the 1960s

Postmodernism. Primarily a contemporary design movement (although aspects of contemporary fine art have also been labelled postmodern) which was first associated with architecture. The main feature of postmodernism is that, in contrast to the clean uncluttered simplicity of modernism, there is a return to non-functional decorative elements. References to previous architectural styles, and in particular to classical elements, are happily combined with modern shapes, scale and materials. The architect **Philip Johnson's** (b. 1906) AT&T building in New York was one of the first designs that defined this new movement.

Surrealism. This movement began in 1924 and was a development from Dada. Surrealist paintings take two main forms, those which are produced by conventional methods and depict fantastic or dream-like images, as seen in the landscapes of **Salvador Dali** (1904–89) and **Giorgio de Chirico** (1888–1978), and those, like the work of **Max Ernst** (1891–1976), which use collage and frottage (rubbings), allowing the process of bringing together unrelated images and chance effects to create a new reality.

Vorticism. A British art movement, established in 1912, which was in many respects the equivalent of the French and Italian **Futurists**, although the leader of the movement, painter and writer **Wyndham Lewis** (1884–1957), believed it to be unique. Other artists involved included the sculptors **Jacob Epstein** (1880–1959) and **Henri Gaudier-Brzeska** (1891–1915) and painters **William Roberts** (1895–1980) and **Edward Wadsworth** (1889–1949).

Chronology

This chronology from 1850 to the present day, places art, design and crafts in an historical context and also indicates some of the technical influences that have affected their development.

1850

1851 Great Exhibition at Crystal Palace (Britain). **John Everett Millais** (1829–96) paints *Ophelia*. **William Turner** (1775–1851) dies.
1853 **Holman Hunt** (1827–1910) paints *The Awakening*.
1857 National Portrait Gallery opens (London). Museum of Ornamental Art opens (later to become the Victoria and Albert Museum) (London).

1860

1860 Abraham Lincoln elected President of the USA. **Édouard Manet** (1832–83) paints *Guitar Player*.
1861 William Morris founds Morris, Marshall, Faulker & Co. (later to become Morris & Co.).
1863 The Salon des Refusés* includes works by Cézanne, Manet, Pissarro and Whistler. Manet exhibits *Le Déjeuner sur l'Herbe* (*Luncheon on the Grass*).
1865 US Civil War ends, and Lincoln is assassinated. Manet exhibits *Olympia* at the Salon.
1866 Manet meets Cézanne.
1868 Revolution in Spain. Degas paints *The Orchestra*.
1869 The Suez Canal opened. Cafe Guerbois becomes the favourite meeting place of the impressionists.

1870

1874 Monet exhibits a painting entitled *Impressions: a Sunrise*, giving rise to the name 'impressionism'. The exhibition becomes the first of eight impressionist exhibitions held between 1874 and 1886.
1877 **Thomas Edison** (1847–1931) introduces the **phonograph** in America.
1878 First commercial telephone exchange opens in America.
1879 Thomas Edison develops the electric lamp.

1880

1880 Linotype typesetting machine first introduced (America). Inception of Art Nouveau (France).
1883 First skyscraper build in Chicago.
1884 Georges Seurat's painting *Bathers at Ashières* refused by the Salon jury at Paris. Invention of photographic roll film.
1888 Van Gogh moves from Paris to Arles, paints *Sunflowers*. **Emile Berliner**

*(**Salons** were exhibitions of contemporary art in Paris. From 1737, the French Académie Royale de Peinture et de Sculpture held regular biannual exhibitions. The term 'Salon' was derived from the Salon Carre in the Louvre where these exhibitions were held. In the nineteenth century, the Salons were held annually. In 1830, the jury that selected paintings changed from an elected mix of artists and academicians to a jury of members of the Académie who were resistant to the progressive work of painters such as Eugène Delacroix (1798–1863), Honoré Daumier, **Gustave Corbet** (1819–77) and **Théodore Rousseau** (1812–67). In 1863, the selection jury of the official Salon in Paris was particularly harsh in rejecting a large number of works. The rejected artists, including Manet, **James Whistler** (1834–1903), Pissarro, **Eugène Boudin** (1824–98) and Cézanne, petitioned the Emperor Napoleon III who, in response to this, ordered the setting up of an alternative Salon, the **Salon des Refusés**, in which rejected work could be exhibited.)

The Eiffel tower

1880 contd.
↓

produces **gramophone** using flat discs. Kodak box camera introduced by Eastman company.
1889 Eiffel Tower completed and opened for the World's Fair (Paris).

1890

1890 Levi Strauss and Co. formed as first manufacturers of denim jeans (America).
1891 Paul Gauguin (1848–1903) travels to Tahiti. William Morris establishes the Kelmscot Press (Britain).
1892 Diesel engine constructed by **Rudolf Diesel** (1858–1913) (Germany).
1895 Petrol engine introduced by **Gottlieb Daimler** (1834–1900) and **Karl Benz** (1844–1929) (Germany).
1897 Charles Rennie Mackintosh designs first of the Glasgow tearooms (Britain).
1898 Work begins on Charles Rennie Mackintosh's Glasgow School of Art building, which is finished in 1907.

1900

1900 Prototype Zeppelin airship developed. Kodak Box Brownie camera first marketed. First radio transmission using Morse code sent.
1902 Reginald Fessenden transmits the human voice via radio waves over a distance of one mile (America).
1903 Wilbur (1867–1912) and **Orville** (1871–1948) **Wright** make first successful powered flight.
1905 Antonio Gaudì designs the organic, concrete Casa Mila apartments in Barcelona (completed in 1905); see colour plate 4.6. Weimar School of Arts and Crafts established by **Henry van de Velde** (1863–1957).

1900 contd.

1910

1920

1907 Pablo Picasso completes *Les Demoiselles d'Avignon*, the painting that saw the beginning of cubism.

1909 Model T Ford introduced. *Futurist Manifesto* launched by Filippo Marinetti. Picasso experiments further with cubism; see colour plate 4.7.

1911 Auguste Perret uses concrete for the Théâtre des Champs Elysées.

1914 First World War begins. Le Corbusier designs his little Dorm-Ino house. Model T ford manufactured on mass assembly methods.

1916 Sans serif alphabet first used for London transport, designed by **Edward Johnston** (Britain).

1917 First issue of *De Stijl* magazine published (Netherlands).

1918 First World War ends. Gerrit Rietveldt produces his *Red/Blue Chair* (Netherlands; see colour plate 2.1).

1919 Bauhaus opens in Weimar (Germany). First two-way crossing of the North Atlantic by R34 airship.

1920 Vladimir Tatlin's tower model constructed. First cantilevered tubular steel chair designs made by **Mart Stam** (b. 1899) (Germany).

1922 Tutankhamun's tomb discovered.

1925 Bauhaus moves to Dessau. 'Exposition des Arts Décoratifs' opens in Paris, from which emerges Art Deco.

1926 John Logie Baird (1888–1946) first demonstrates his experiments in transmitting television images. Ludwig Mies van der Rohe produces a cantilever steel chair. Futura, the first of the modernist sans-serif typefaces, is produced by **Paul Renner**.

1927 Richard Buckminster Fuller (1895–1983) develops the Dymaxion

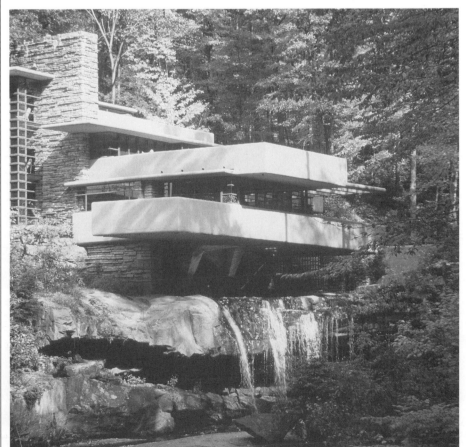

Frank Lloyd Wright made dramatic use of cast concrete in *Falling Water House* (1936)

1930 contd.

House, designed to be mass-produced. Dupont begin to develop nylon.

1928 Charlotte Perriand and Le Corbusier design their chaise longue. **Hannes Meyer** (1899–1954) takes over from Walter Gropius as the director of the Bauhaus.

1929 Raymond Loewy designs casing for Gestetner duplicating machine, using Bakelite.

1930 Mies van der Rohe succeeds Hannes Meyer as director of the Bauhaus. Empire State Building completed in New York.

1932 Bauhaus moves to Berlin. **Stanley Morison** (1889–1967) designs Times New Roman typeface.

1933 Bauhaus closed down by Nazis. Boeing 247 commercial airliner and Douglas DC1 enter service. London Underground map designed by **Harry Beck** put into use.

1934 Anglepoise lamp designed by **George Carwardine** first produced.

1935 Douglas DC3 airliner enters service.

1936 BBC (British Broadcasting Corporation) begin the first regular television broadcast. **Frank Lloyd Wright** (1869–1959) designs Falling Water house, exploring both the aesthetic and structural qualities of concrete.

1937 Raymond Loewy's streamlined locomotive is put into service by the Penn Railroad Company. Pablo Picasso paints *Guernica* a dark and disturbing work as a response to the atrocities of the Spanish Civil War.

1938 Nazi occupation of Czechoslovakia. Volkswagen car factory opens to produce the people's car designed by **Ferdinand Porsche** (b. 1909), later to be known as the Beetle (Germany). **Hans Coray** (b. 1907) designs the classic Landi aluminium stacking chair.

1939 Beginning of the Second World War. Nylon stockings first appear. Citroën 2CV first launched.

1940

1940 Mondrian leaves London to settle in New York.

1941 Japan bomb Pearl Harbor. German invasion of Russia. **André Breton** (1896–1966), Ernst and Chagall move to New York. Pollock, Rothko, Gottlieb and **Robert Motherwell** (1915–91) experiment with automatism.

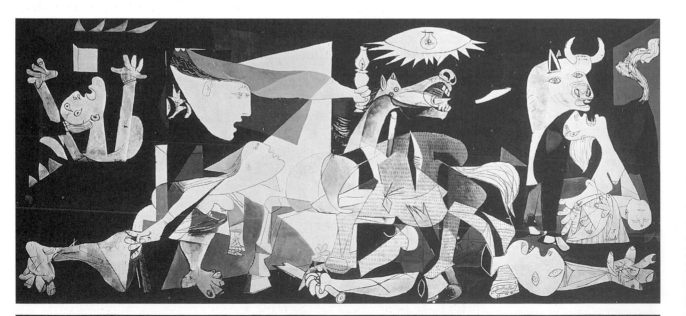

Guernica by Pablo Picasso (1937)

1940 contd.

1943 Pollock has his first solo exhibition.
1944 Jean Dubuffet (1901–85) has his first solo exhibition.
1945 The first atomic bomb is dropped on Hiroshima, killing 75–80,000 people. A second is dropped soon after on Nagasaki. Japan surrender, bringing the Second World War to an end. 'Art Concret' in Paris (first major show of abstract art in Europe since the war). **Wells Coates** (1895–1958) designs the circular Ekco radio made in Bakelite.
1946 Eero Saarinen (1910–61) designs the *Womb Chair*, comprising latex foam on a moulded fibreglass shell supported on chromed steel legs.
1947 Pollock begins his 'drip' paintings; see colour plate 4.8. **Clyfford Still** exhibits his first colour-field abstractions. **Christian Dior** (1905–57) has first collection (France). First Vespa scooter produced in Italy.
1949 Germany divided into the German Democratic Republic and Federal Germany. Chinese People's Republic proclaimed under Mao Tse-tung. **Francis Bacon** (1909–92) starts using photographic source material. The first chair to have a moulded plastic seat is designed by Charles and Ray Eames. Morris Minor launched, designed by Alex Issigonis. First flight of the de Havilland Comet, the world's first jet airliner.

1950

1950 North Korea invades South Korea.
1951 'Abstract Painting and Sculpture in America' exhibition held in the Museum of Modern Art (MOMA), New York. The Festival of Britain takes place. The sculptor **Harry Bertoia** (1915–78) designs the wire shell chair for Knoll.
1953 Routemaster bus introduced in London.
1954 Jasper Johns's (b. 1930) first *Flat* paintings. First Boeing 707 jet airliner flown (America). Sony develop first transistor radio (Japan).
1955 Exhibition entitled 'Man Machine and Motion' held at the Institute of Contemporary Arts in London. **Mary Quant** (b. 1934) opens Bazaar fashion store in London. Citroën DS19 car launched (France).
1956 World's first nuclear power station opens in Britain.
1957 The first silicon chip developed in America. World's first artificial satellite launched by the USSR. Fiat 500 motor car introduced (France).
1958 'New American Painting' exhibition, MOMA, New York. Helvetica and Univers typefaces launched. Honda 50cc moped introduced (Japan).
1959 The Mini, designed by Alec Issigonis, launched (Britain).

1960

1960 Claes Oldenburg has exhibition 'The Street' in New York. Andy Warhol makes his first comic strip painting, *Dick Tracy*. First experiments with lasers in America.
1961 Berlin Wall constructed. First man in space (former Soviet Union). 'The Art of Assemblage' exhibition, MOMA, New York. **Joseph Beuys** (1921–86) begins teaching at Düsseldorf Kunstakademie. Roy Lichtenstein paints his first work based on comic strips. David Hockney paints *We Two Boys Together Clinging*.
1962 Andy Warhol paints Marilyn Monroe and Campbell's soup cans, and has first solo exhibition (Los Angeles). Sony develop 5-inch television (Japan).
1963 President Kennedy assassinated. America begins its involvement in Vietnam.
1964 First Habitat store opens in London.
1965 The world's first communications satellite is launched (America).
1966 Space Age fashion introduced by **Pierre Cardin** (b. 1922) (France).

1960 contd

1967 Ché Guevara killed in Bolivia. 'Lumière et Mouvement' exhibition at Paris. The books *Design for the Real World* (**Victor Papanek**) and *The Medium is the Message* (**Marshall McLuhan** (1911–80)) are published.

1968 Student rioting in Paris. 'Minimal Art' exhibition at Gemeentemuseum, The Hague. Sony introduce colour television (Japan).

1969 First men to walk on the moon (America). First flight of world's first supersonic airliner Concord (Britain/France). First flight of the jumbo jet airliner the Boeing 747 (America). Sony introduce U-Matic colour video-cassette.

1970

1970 'Conceptual Art and Conceptual Aspects' exhibition, New York. **Zandra Rhodes** (b. 1942) introduces her Primavera look, the natural look that dominated a period of fashion in the 1970s.

1971 Fighting in Vietnam spreads to Laos and Cambodia. **Issey Miyake** (b. 1935) has his first fashion show in New York. Intel Corporation introduce **microprocessor** (America).

1972 'The New Art' exhibition, Hayward Gallery in London. World's first pocket calculator launched, designed and manufactured by Clive Sinclair (Britain).

1973 'Photo-Realism' exhibition, Serpentine Gallery in London.

1974 President Nixon resigns. **Giorgio Armani** (b. 1936) launches his first range of menswear (Italy).

1975 Last Americans are evacuated from South Vietnam. 'Bodyworks' exhibition, Museum of Contemporary Art, Chicago. Armani launches his first range of womenswear. Clive Sinclair launches first pocket television.

1977 The Pompidou Centre in Paris opens (see colour plate 4.9), designed by **Richard Rogers** (b. 1933) (Britain). Apple 1 and Apple 2 personal computers introduced (America).

1978 Sony launches the Walkman. **Richard Sapper's** (b. 1932) Tizio lamp appears (Germany).

1979 Joseph Beuys retrospective exhibition at the Guggenheim Museum, New York.

1980

1981 'A New Spirit in Painting' Exhibition at the Royal Academy of Arts, London. Ettore Sottsass Memphis design studio formed along with launch of Memphis range of furniture (Italy). First flight of *Columbia*, the first reusable space vehicle (America).

1982 Ford introduced the Sierra, making a clear shift from hard-edged to soft aerodynamic form.

1983 'The New Art' exhibition at the Tate Gallery, London. **Michael Graves's** (b. 1934) public services building in Portland opens (America).

1984 First Turner Prize – winner **Malcolm Morley** (b. 1931). Issey Miyake's 'Bodyworks' exhibition opens at the Victoria and Albert Museum.

1985 Turner Prize winner, **Howard Hodgkins** (b. 1932).

1986 Turner Prize winner, Gilbert (b. 1942) and George (b. 1943). Lloyds Building, designed by Richard Rogers, opens in London. Amstrad PCW personal computer launched. Challenger space shuttle blows up.

1987 Turner Prize winner, **Richard Deacon** (b. 1949). **Charles Jencks** publishes *Post-Modernism: Neo-Classicism in Art and Architecture*.

1988 Turner Prize winner, **Tony Cragg** (b. 1949).

1989 The Berlin Wall comes down. Turner Prize winner, **Richard Long**. 'L'Art Conceptual – un Perspective' exhibition, Musée de L'Art Moderne de la Ville de Paris. **Linda Nochlin** (b. 1945) publishes *Women, Art and Power and Other Essays*.

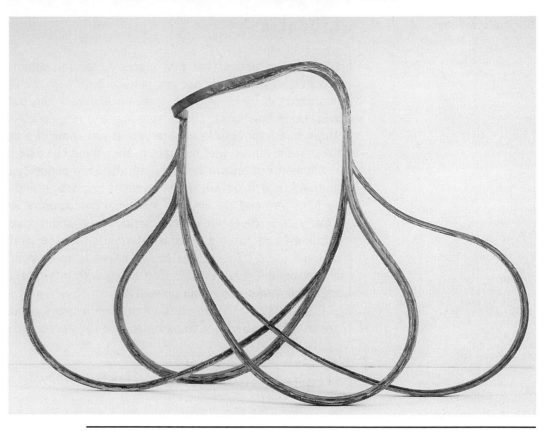

Richard Deacon was winner of the Turner prize in 1987. This work is entitled *For Those who have Ears No. 2*

1990

1990 Germany is reunited. Collapse of the Soviet empire. Turner Prize suspended. **I. M. Pei's** (b. 1917) glass pyramid extension to the Louvre in Paris is opened.
1991 Civil war in Yugoslavia. Turner Prize winner, **Anish Kapoor** (b. 1954).
1992 Turner Prize winner, **Grenville Davey**. 'Young British Artists' Exhibition at the Saatchi Collection.
1993 Turner Prize winner, Rachel Whiteread.
1994 Turner Prize winner, **Antony Gormley** (b. 1950). 'Unbound: Possibilities in Painting' exhibition at the Hayward Gallery, London.
1995 Turner Prize winner, **Damien Hirst** (b. 1965).
1996 Turner Prize winner, Douglas Gordon.

Sources of information

You should take every opportunity to research and find information about other artists, designers and craftspersons in the support and development of your own work. The following are some of the resources you should take advantage of that exist outside your immediate working environment.

Libraries

Libraries are one of the first places to go for obtaining information and research, so you should become familiar both with the library resource in the institution in which you are studying and with the public libraries in your area. Learn how to use the cataloguing and reference systems, and don't feel afraid to ask for help from librarians. If you know of a book that you wish to use and the library does not have it, they should be able to get it for you.

Libraries not only have books but also keep periodicals (i.e. magazines and journals), and there are many excellent art, design and craft ones available, such as *Art and Design*, *Art Review*, *Contemporary Art*, *Modern Painters*, *Crafts*, *ID*, *D*, *Blueprint*, *Architectural review*, and *Vogue*. Magazines contain the latest and easily accessible information on the world of art and design, and will often have articles on work that is being done by young and new artists, designers or craftspersons, along with information on current exhibitions and shows; see colour plate 4.10.

Finally, libraries themselves often have displays of artists' work. Libraries are an amazing and free resource, so take full advantage of them.

Higher-level work

If you are working in an institution that has higher-level art, design or craft courses, you should make a point of looking regularly at the work of the students on these courses, not only their finished work but also the work that is in progress. You will find that most students will be happy to talk to you about what they are doing. Even if you are not in an institution that has higher-level work, it will be very worthwhile arranging a visit to your nearest college or university that does. This will enable you to gain ideas and information for the development of your own current work, and also allow you to see some of the possibilities available to you on completion of your current course. Nearly all higher-level art, design and crafts courses will have a show of work of their graduating students at the end of the summer term, which will be open to the public.

Galleries and museums

These are obviously rich sources of information. If you are able to visit the large galleries and museums which exist in the major cities in Britain you will have the opportunity to see the work of some of the artists and designers mentioned in previous pages. You will also be able to see art, design and crafts from other cultures. Excellent places to visit are: the Tate Gallery in London, St Ives and Liverpool, the Victoria and Albert Museum and the National Gallery in London, the National Gallery of Scotland and the Scottish National Gallery of Modern Art in Edinburgh, the Fitzwilliam Museum in Cambridge, and the Hayward Gallery, the British Museum and the Design Museum in London.

If you are planning a visit to large galleries or museums, spend some time before your visit researching the things you would like to see. It is difficult to absorb all that is available in these vast collections, so make the best use of

your time by being selective in what you look at. Whether you are visiting large national or smaller local galleries and museums, be prepared with a notebook, sketchbook and camera to record information. The use of a camera may be restricted in some galleries or museums, and you will need to check this as you go in. Make a point of collecting any available literature, guides and postcards which may be used later as reference material.

Television

There are a growing number of art and design programmes appearing on television, so make a point of looking out for them and if possible, as well as watching them, recording them for later reference. Ideally, keep some video tapes just for this purpose. You will be surprised how quickly your library will build.

CD-ROM

The recent technology of **CD-ROM (compact disc read-only memory)** can offer easy access to information on art and design. There is already a growing number of programmes that will, for instance, take you on a tour of the National Gallery, allowing you to stop and examine individual paintings and learn some of the background information on the painting and the artist that created it. Obviously this is no substitute for actually going and seeing the real paintings, but it is very useful for background research and as preparation for an actual visit to the gallery.

Always remember that developing an awareness of and interest in others' work is not an isolated activity. Your growing knowledge in this area should evolve naturally alongside your practical work, with each aspect becoming interrelated. As your portfolio of practical work builds and develops, so should an equivalent body of research and reference material relating to other artists', designers' or craftspersons' work. This may take the form of written and visual notes, magazine and newspaper cuttings, photocopies, postcards and photographs.

The need to write clearly your own views and observations in relation to others' work will form part of the requirement of any study programme. Not only will this give you the opportunity to clarify and confirm your understanding of the work of others, it will also give you an opportunity to fulfil aspects of the **key** or **common skills** requirements of the qualification. Further information on this can be found in the introduction to this book.

Sample assignments

Rather than showing other students' work, these assignments are for you to try yourself.

ASSIGNMENT ONE

Rationale

New technology has often had a dramatic effect on the development of the work of artists, craftspersons and designers. The effect on the content, composition and use of colour within painting resulting from the introduction of photography and the development of synthetic pigments are clear examples of artists' responses to technological advances.

T a s k ① Write a short illustrated essay that identifies and examines the effects of a particular 'new' technology on art, crafts or design in the nineteenth century.

T a s k ② Write a short illustrated essay that examines a recent technology and how it is affecting the development of contemporary art, craft or design.

ASSIGNMENT TWO

Rationale

The human figure has been the dominant subject of paintings since the earliest of times, yet the reasons for these paintings and the ways the figures have been represented have varied enormously, from ritualistic and religious, symbolic images to photographic realism.

T a s k ① Select two periods of artistic history, as early or as contemporary as you like. Study representations of the human figure in both those periods.

T a s k ② Write a comparative study of the human figure in these two periods. This should take the form of an illustrated essay. You should refer to specific artists, sculptors, illustrators etc., and be aware of the context in which they worked. Give an account of the work in the context of the artistic tendencies and the social setting of the time.

5

Professional practice

Introduction

The aim of this chapter is to help you to develop a broad understanding of how artists, craftspersons and designers survive and function as professionals and business people in the world of work. This chapter, along with the following two chapters, **Working to self-devised art briefs** and **Working to design briefs**, should help you to recognise the range of opportunities that exist in the field of art, craft and design, and the different ways that artists, craftspersons and designers work. This understanding will then help you to clarify your own, longer-term direction. Chapter 9 **Progression opportunities**, contains additional information about opportunities available to you on the completion of your present course.

This chapter will focus on:

- **the products and services provided by artists, craftspersons and designers**
- **business practices**
- **professional roles and work practices**
- **responsibilities to clients**
- **occupational standards and qualifications**

The influences and products of art, craft and particularly design touch most aspects of our lives. From the moment we get up in the morning, we are surrounded by the products of design: the clothes we put on, the tube and packaging for the toothpaste, the toothbrush, the chairs we sit on, the toaster, the kettle and the cereal packaging have all been designed. Your television and the programmes seen on it – the sets, the costumes, the graphics and the advertise-

ments – are all products of designers' work, as are the magazines, newspapers and books we read.

We come into contact with the products of design more than with those of crafts or art because the majority of designers work within, or are associated with, industry, where their designs will be mass-produced and bought and seen by hundreds, thousands or even millions of people. In contrast, artists' and craftspersons' work is produced only by an individual, and therefore the quantity of products made is comparatively small. The contribution that artists and craftspersons make to society is nonetheless significant, although less easily quantified. Not only do individual pieces of their work give particular pleasure or provoke thought and heighten awareness, the fact that artists and craftspersons have greater freedom to push back the boundaries of creativity means that their work constantly inspires and influences that of designers. Artists' work may often question and challenge society's values, and will both reflect and affect the way we see both ourselves and the world we live in. Artists', designers' and craftspersons' work greatly influences and enriches our culture, and there will always be a need and a place for them in our society.

Because of the huge variety of work conceived and made by artists, craftspersons and designers, there are many ways in which individuals work to make a living. Chapter 4 gives more detailed information on individual artists, designers and craftspersons and their work.

Working as an artist

The decision to become an artist is not one that is made on the grounds of wanting to progress a financially rewarding and secure career! Very few of the hundreds of art students that graduate each year will make a secure living from just the sale of their work. Having said this, there are thousands of artists who are managing to survive whilst producing and selling their work. Most artists will have to find ways to supplement any income they make from selling their art. This will be done by working in art-related employment, or by doing other work that provides an income and enough time to continue their own creative development. Many artists work in education as teachers or lecturers, where they can share their knowledge, experience and enjoyment of the creative process with others, whilst continuing their own work. It is very likely that the teaching staff who are working with you are in this situation, and they will hopefully share their experience of working as an artist with you. Unfortunately, cuts in funding and changes in educational policy are reducing the number of part-time staff in most institutions. Consequently, the opportunities for artists to find employment in this area are not as great as they have been.

It is common for artists to work with other creative people, like those in theatre groups, to provide creative workshops and support for community events such as carnivals or arts festivals, or other events that need the creative and practical expertise an artist can give. Many of these activities attract funding from local or even national councils or associations, which means that some small income may be had from this type of work. An important quality that successful artists develop is a resourcefulness in finding and making opportunities to exploit their creative abilities.

Within the field of art there is a broad spectrum of types of work being

produced, and a corresponding range of potential markets for this work. At one end of the spectrum is the more traditional figurative painting and sculpture, which tends to be more easily understood and accepted by a larger audience. It is therefore this type of work that is most likely to find buyers. There are also opportunities for artists working figuratively to obtain commissions for illustration work. This is usually done through agencies that specialise in the promotion of artists working in this area. At the other end of the spectrum are artists that are exploring concepts and making work that push back the boundaries of creative thought and expression. This area of art is both very exciting and extremely challenging, requiring enormous self-motivation and commitment, with no guarantee of recognition or financial reward. Whilst it is this area of work that produces the most famous artists, comparatively few will achieve success or status.

If you decide that you would like to pursue a career in fine art, where you fit into this spectrum will emerge as your work develops. It is not easy to predict or dictate the type of work that will eventually become your main focus at this stage of your development. It can be seen by examining the early work of many well-known artists (Paul Cézanne, Pablo Picasso or Piet Mondrian, for example) that work produced in the early stages of their career gave little hint of the later work that made them so well known. The drawing below, entitled *Mario Picasso Lopez, the artist's mother* by Picasso was made in 1896 when the artist was 15. Although it clearly demonstrates the artist's ability, it gives no hint of the work that we now associate with him.

Mario Picasso Lopez, the artist's mother, by Pablo Picasso (1896). Although this is an accomplished drawing, there is little hint of the work that we now associate with this artist

Exhibiting and selling work

Showing work and hopefully selling it are obviously major aspects of an artist's life. The first experience, for most artists, of showing work to a public audience will be at college. It is likely that, at the end of your present course, you and your fellow students will put on a show of your work which, hopefully, will be open to the public. Whilst you may not sell any work, the experience of presenting your work to an audience in this way will be both informative and rewarding.

If you are serious about a career as an artist, you will almost certainly need to progress onto a degree course. It is on this course that you will begin the process of making contact with others that will support the development of your work and its exposure to a wider audience. Degree shows, where final-year graduating students have an opportunity to show their work to the public, are a major event in the calendar of anyone connected with art, crafts or design. Many courses now arrange to hold these shows in major galleries or exhibition centres in London or other cities. The shows attract hundreds of people, including gallery owners and private collectors on the lookout for new talent. It is often at these shows that the first significant sale of work takes place.

These shows are also likely to provide the first real experience of the cost of putting on a show of work at a major venue. It can cost thousands of pounds to hire exhibition space, whether in a large public venue or a private gallery, and it is likely that students will have to meet some of these costs. Moreover, there will invariably be some further costs associated with the actual display of the work, if the work is to be seen to its best advantage. Even simple framing, if done professionally, is likely to involve some expense, particularly if an artist is putting up a one-person show and is having to frame enough to fill a gallery.

A successful show is dependent on attracting as many people as possible to see the work. Advertising will also therefore have to be organised and paid for, along with the cost of any literature, invitations, posters and price lists. It is likely that work will also have to be transported to and from the gallery, and again this will involve expense, even if it is only the cost of petrol.

Putting on group shows is a good way of sharing the cost and the work involved, as well as of gaining and giving moral support. A group exhibition will also mean that a variety of work can be shown, which will attract a larger audience.

Galleries and agents

Having an **agent** or **gallery** that promotes the artist and their work is a common way to sell work. The advantage of working with an agent or gallery is that it is as much in their interest to sell work as it is in the artist's. The income they make will come from taking an agreed percentage of the selling price when a piece of work is sold. It is primarily the agent's or gallery's responsibility to ensure that as much of the artist's work as possible is seen and sold, leaving the artist to concentrate on their work. The disadvantage of this arrangement is that the percentage taken by the agent or gallery is likely to be quite high, anything from 33.3% to 60%. The gallery has to cover the costs of running a show space or office and, in addition, will want to earn a

living for themselves. It is therefore important that an artist fully understand and carefully consider any agreement made with a gallery or agent.

Working to a commission

Artists may sometimes have the opportunity of working to a **commission**. This means being asked to create a new piece of work for a specific **client**, who may be an individual or organisation. In this case, an artist will work in a very similar way to a designer, with a client setting a brief stipulating the requirements that the work has to meet. How specific or how open the requirements for commissioned work are will vary enormously. When a client chooses an artist for a commission, they will already be aware of the artist's existing work and will have chosen them because they like the qualities they have seen. It is likely that the work will be for a specific site and may also be required to project a particular quality or image.

As with a design brief, the artist will discuss ideas and proposals with the client before making the finished piece. This will probably involve presenting drawings, maquettes and samples, along with costing. There may be several meetings, with modifications and changes to meet the requirements of the client, before the final proposal is agreed. When working to a commission, there will be several things that should be clearly agreed with the client in addition to the work itself. These may include agreeing responsibility for transporting the work to the client, for framing and hanging, or for erecting in the case of a piece of sculpture. Transporting and erecting a large metal sculpture can be an expensive exercise and may need a lot of planning and forethought. Responsibility for insuring the work until it has been paid for, and for taking care that the work is safely displayed, may also need to be agreed. The artist will also have a responsibility to the client to ensure that the work will meet the purchaser's expectations as far as is reasonably possible. To produce paintings that fade or change colour, or sculptures that crack or decay (unless this is an intended aspect of the work, as with some of Damien Hirst's pieces) would be unreasonable and unacceptable.

Anthony Gormley was commissioned by Gateshead Council, and produced his proposal for a 65-ft-high, 100-tonne *Angel of the North*. The artist has had to deal with controversy and criticism surrounding the work, including from those who complain that it is a waste of money and a potential distraction and hazard to drivers passing on the A1.

Support agencies and funding for artists

The **Arts Council** and, more importantly for individual artists, **Regional Arts Associations** have been set up to support and promote the arts. This support is not just for the visual arts but also for music and the performing arts. Consequently, the funding available to support the visual arts is limited, and only a small proportion of this is available to individual artists. Private or corporate **sponsorship** can sometimes be gained by artists, but this has become increasingly rare over the last few years.

Some educational establishments offer funded artist **residencies** or **fellowships** where, for a limited period of time, an artist is offered a studio space

Antony Gormley had to contend with
heavy criticism and debate associated
with this commissioned work, *Iron Angel
of The North*

and is paid a small income. The artist makes their own work as a demonstration to students of working practice, and at the end of the residency, they will usually exhibit the work that they have made. They may also teach classes as part of their residency.

The National Artists' Association

The **National Artists' Association (NAA)** is an independent body, although it receives funding from the Arts Council. The NAA's aim is to represent practising visual artists at all levels, to advance the economic situation, working conditions and professional status of artists, and to raise the status of the visual arts as a whole. The NAA is recognised as the main representative organisation for visual artists in the UK, and has published a code of practice concerning the engagement and payment of artists.

Working as a craftsperson

There are about 25,000 craftspersons working in England, Scotland and Wales, and over 90% of craft businesses are one- or two-person operations (the former being **sole traders**). The range of crafts, the types of work and, in consequence, the ways in which craftspersons work and make a living, varies enormously.

There are craftspersons, making their own work, who have a way of life that is almost identical to that of a fine artist. They work on their own and sell the majority of their work through galleries, sometimes working to commissions. The majority of this type of work will be non-functional.

Probably the largest group of craftspersons who are working independently are those who are making individual pieces of functional work. This work will be sold through galleries, craft shops and other retail outlets that sell similar functional items. The work that they make includes jewellery, pottery, knitwear, hats, shoes, leathergoods and glassware. Examples, and often reviews, of this sort of craftwork will gradually be seen in magazines such as *Interiors*, *Country Living*, *House & Garden*, *Vogue* and *Woman's Journal*, as well as in the specialist magazines such as *Crafts*.

There are other craftspersons who make a living by designing and making only functional pieces, and who sell nearly all their work by commission, in a way that is very similar to working as a designer. A furniture designer-maker who produces work for specific interiors and may work closely with an interior designer, is a good example. There is a further group of craftspersons who make little of their own work but instead make their living by selling their particular practical craft skills, expertise and resources to others. Craftspersons who work in the area of conservation would fall into this category.

The quality that identifies all of these people as craftworkers is that the practical skills and expertise they have acquired and developed forms the major element in their work. Most craftspersons focus this expertise in one media, material, technology or skill, such as ceramics, textiles, metals, wood or glass.

Opportunities exist within the crafts field either for working as a self-employed person or for being employed by others. There are also opportunities in some areas of the crafts, mostly associated with trades, for gaining employment on an **apprenticeship** basis – work associated with the building trade: architectural restoration, stone masonry or joinery, for instance. Boat-building, signwriting, ceramics and textiles are among other possibilities. A combination of apprenticeships and part-time training at college is a possible option in some areas.

For anyone intending to become self-employed following a higher-level course, it would be useful to gain some experience by working in an already-established craft-based business. The biggest difficulty for almost all self-employed craftspersons is not their ability to produce good work but their ability to run a successful business. Working with someone who is already managing to sustain a living as a craftsperson will give an opportunity to see the various aspects of making and selling craftwork as a business. The following are some of the things that would have to be considered when setting up as a self-employed craftsperson:

Where will the work be made?

For some crafts, such as jewellery or knitting, the amount of space needed to make the work may be quite small, and could even be carried out on the kitchen table or in a spare bedroom. Most crafts, however, will need a dedicated workshop with electricity, water, good ventilation and even special facilities such as those for air or dust extraction.

It will be necessary to ensure that it is permissible to carry out the type of work that is proposed. There are restrictions on running a business from a domestic property, or even on changing the use of a business premises.

What tools and equipment will be needed?

Again, for some crafts, this may be quite limited and consist of little more than has already been acquired while studying. But on the other hand, setting up a pottery or a blacksmith or woodworking workshop may mean the purchase and installation of large pieces of machinery or equipment, and, in consequence, a large financial investment.

What materials will be needed?

Materials that are apparently insignificant and always to hand at college (dyes, glazes, metal, wood, fabric) can be surprisingly costly or even difficult to obtain when you have to buy them. Often, these materials come from specialist suppliers that may only sell in minimum quantities. The cost of materials will have an effect on the price that a piece of work sells for, and the craftsperson will have to take this into account, particularly if the materials are rare or expensive.

Who will buy the work, how will it be sold and what price should it be?

The freedom to explore, make mistakes, push back boundaries and find your own personal direction are the most important aspects of your present work. However, priorities change when you consider setting up a business, and the above three questions will be of vital importance when progressing from education to the world of self-employment.

The type of work being made will, to a large extent, dictate the answers to these questions. Examining and becoming familiar with other craftspersons' work and noting where it is sold and the price that is being asked for it, will give a good idea of how to answer these concerns. There are a lot of things which dictate the price of work. Well-known and established craftspersons are likely to be in a better position to dictate higher prices for their work. It can be quite exciting and encouraging to see craftwork sold in galleries and craft shops for what appear to be quite high prices, possibly hundreds of pounds, for work that may not appear that dissimilar from your own. Remember, however, that the craftsperson who made the work is unlikely to receive all of this money: the gallery or shop selling the work could be taking 50% of the price being asked. The money that the craftsperson actually receives will also not be clear profit. This money will have to cover many expenditures: the costs of renting a studio or workshop, materials, electricity (for lighting, heating and machinery), water and building rates, telephone

charges and transport (for delivering work and collecting materia
just some of the costs that will have to be met. Taking all these things
consideration, one can see that the income that the majority of craftspersons
make, for what are usually long working hours, is likely to be relatively small.
This is compensated for by the enjoyment and freedom of making the work
that you choose and being your own boss.

Legislation

Running any business will require conforming to certain pieces of legislation.
Because of the practical nature of craftwork production, there may be a
whole range of requirements that a craftsperson needs to be aware of and
conform to. Much of this legislation will also apply to your current educa-
tional working environment, and you will see evidence of this around you: fire
extinguishers, health and safety notices and guards on machinery, as well as
instructions and information given to you by teaching staff. The legislation in
question covers the environment (Control of Substances Hazardous to Health
Regulations 1988) and health and safety at work (Manual Handling
Operations Regulations 1992; Personal Protective Equipment at Work
Regulations 1992; Electricity at Work Regulations 1989), and is important
when selling work, to give consumer protection (Consumer Protection Act
1987).

Professional bodies and support agencies for the crafts

The Crafts Council

The **Crafts Council** is an independent organisation funded by government
which promotes and gives support to the crafts in Britain. As well as provid-
ing financial support through grants to individual craftspersons organisations
and education, the Crafts Council provides an information service, maintains
a growing collection of modern British craftwork and publishes a bi-monthly
magazine *Crafts*. Work from the collection and other craftwork is exhibited in
the Council's own gallery in London and in their shop in the Victoria and
Albert Museum. The Crafts Council also has a comprehensive reference and
slide library of the work of hundreds of craftspersons. Slides from the library
can be bought or borrowed.

The Society of Designer Craftsmen

The **Society of Designer-Craftsmen (SDC)** is the largest and oldest multi-
craft society in Britain. The work of its members ranges from ceramics, tex-
tiles and silversmithing to furniture, toy-making and stained glass, and
includes many other disciplines. Application for Licenciate membership may
be made towards the end of a specialist course of study, and will involve the
assessment of work. Full membership can be obtained after a few years of
practice. Members are selected in a critical review of work by a panel elected
by the Society.

Benefits of joining the society include: having work exhibited at well-known venues in and out of London, the chance to meet with other craftspersons at society events, a lecture programme by distinguished practitioners, a bi-monthly news sheet and annual magazine *The Designer-Craftsman*, a point of contact for buyers wishing to commission work, and the opportunity to join regional society support and information groups.

Working as a designer

Although there is an enormous range of design disciplines, some of the main ones being graphic design, fashion and textile design and product design (more specific information on the range of specialisms can be found in Chapter 9, **Progression opportunities**), the way in which different designers work and make a living across all disciplines is very similar.

It is in these different areas of design that most of the opportunities for employment exist: working within a manufacturing company as a **staff designer** or as a designer within a consultancy; or alternatively, setting up as an independent and self-employed **freelance designer**.

Working as a staff designer

Working as a staff designer means being employed by a company that manufactures and sells products, such as cars, electrical products, clothing, cosmetics, books or magazines. Large companies – Ford or Sony, for example – that produce a great number of different products will employ large teams of designers who will be responsible for the design of new products and the modification and updating of existing ones, for their company only. Staff designers will work as part of a team that will include technical staff and staff responsible for the marketing of the products. With a complex product like a car, an individual designer may be responsible for designing a certain aspect of the product: the seats, instruments or even the wheel trims. The design studios of most companies are located within or close to the manufacturing centre, which gives the designers invaluable first-hand experience of the production processes being used.

Design consultancies

Some companies, especially smaller ones, feel it is not economical to employ their own full-time designers, and therefore rely on the assistance of **design consultants**. Large companies may also sometimes choose to employ outside consultants in addition to their own designers.

The size of a design consultancy may vary, from one designer working on their own to a large organisation employing many designers in several offices around the world. Consultants work in many areas of design but predominately in graphic, industrial and interior design. They sell their design expertise to companies, or possibly individuals, who are wanting, amongst other

things, to develop a new product or to update an existing one, to promote their products or services through better or new advertising or packaging, or to create a new commercial or domestic interior.

The types of client a design consultant will work for vary, and may range from multinational organisations to small companies or individuals. Many consultants develop long-term associations with clients. The benefits of this to the consultant are that they establish a continuity of work, whilst the client benefits from having designers available to them who have acquired in-depth knowledge of their business, facilities and resources, leading to better design solutions. A good design consultant will also be able to predict the client's needs, thus allowing a quick response to changing trends in the market for the client's products.

A major aspect of running a design consultancy business, whether large or small, is that of promoting and selling the design services offered. In small companies, and particularly if a designer is working on their own, time has to be carefully organised to allow for the actual process of designing, talking to clients and others, such as engineers, involved in the development of current design work, whilst still finding time to develop and attract new clients, along with maintaining contact with established ones.

Many graduating students aspire to set up their own consultancy, but the transition from being a student to being a self-employed designer is a difficult one, and most find it easier, initially, to find employment as a staff designer or **junior designer** within an existing design consultancy. Doing this gives the opportunity to gain experience of working in a commercial environment before trying to set up independently or, more commonly, in a **joint venture** with another designer working in a **partnership**.

Legislation

Designers are responsible not only to their client or employer but also to the end-user of the product designed, as well as to society as a whole. This responsibility exists whether the design is a piece of clothing, a vacuum cleaner, an advertising poster or a car. The responsibilities involved range from ensuring that a design effectively performs its proposed function, to thinking about how it will be disposed of at the end of its life. There is a wide range of legislation, associated with these responsibilities, which relates (as with craftwork) to the environment, health and safety, and consumer protection. Often, designers, with their degree of awareness and concern to make positive contributions to society, will take the lead in responsible design and produce work that exceeds the requirements of any legislation on safety, reliability, environment or social needs.

Another aspect of legislation that a designer needs to be aware of is the legislation that protects the designer's own interests. A designer works in an environment where ideas, inventions and designs are valuable commodities, and it is from these that they make their living. Legislation in the form of **copyright** (which relates to two-dimensional work including illustrations, photographs, film and video, as well as written work) and **patents** (which relate to ideas and inventions) enables designers to protect their work and ideas from being reproduced and copied against their wishes (Copyright, Designs and Patents Act 1988).

Professional bodies and support agencies for design

The Design Council

The **Design Council** is a government-funded body set up to promote and support design in a similar way to the Crafts Council's role in supporting the crafts. The Design Council gives advice to companies about the use and importance of design in the development of a competitive and successful business. It promotes and encourages good design through its yearly British design awards, and publishes a quarterly magazine *Design*.

The Chartered Society of Designers

The **Chartered Society of Designers (CSD)** is the professional body for designers in Britain. It is the largest multidisciplinary design association in the world, with over 9,500 practising members. It represents designers practising in product, fashion and textile design, interior and graphic design, design education and design management. Application for diploma membership can be made to the CSD on successful completion of an approved BTEC HND, degree or post-graduate course in design. Diploma membership is the basic qualification from which a designer may progress, by evidence of practice, to the grades of Membership (MCSD) and eventually Fellowship (FCSD)

The CSD also lays down strict rules of conduct for its members relating to professional practice.

RSA

The **Royal Society for the Encouragement of Arts, Manufacturers and Commerce (RSA)** was established in 1754. Today its main interests and involvement are in business and industry, design and technology, education, the arts and the environment.

One of the Society's major activities associated with design is the annual RSA design awards. These awards are given to students who have produced the best designs in response to briefs set by contributing organisations. There are awards for a wide range of design disciplines, including product, fashion, interior and graphic design. Many HND and degree design courses include participation in these awards as part of their programme. An exhibition of the work of winning and commended students tours the country during the year, and it is worth finding out if it comes to your area. This will allow you to see the high standards of work that are being achieved by students around the country. You will also be able to see where these students were studying, which may give you some idea as to the courses that may be of interest to you if you intend progressing onto higher education.

Other professional bodies that represent design include the British Institute of Interior Designers, the British Display Institute, the Design and Industries Association, the Designers and Art Directors Association, and the Textiles Institute.

Useful Addresses

The addresses of many of the organisations mentioned in this chapter can be found at the end of Chapter 9, page 146.

Plate 4.3 *Composition No. 8*. This work was made over the period 1939–1942 by Piet Mondrian, the developer of Neo-Plasticism and a major influence on de Stijl

Plate 4.4 *Poplars on the Epte* (1891). Painted by Claude Monet, a major contributor in the development of Impressionism. He made many paintings of this subject near his house at Giverny under varying climatic and seasonal conditions, trying to capture the quality of colour and light and a new kind of realism that was the focus of concern for these artists

Plate 4.5 *Blang* by Roy Lichtenstein (1962). Although Lichtenstein first established himself as an Abstract Expressionist, in the late 1950s he rejected this and turned to pop culture for his subject matter. In 1961 he began making the large-scale paintings based on comic strips for which he is best known

Plate 4.6 These apartments built around 1905 in Barcelona show the innovative use of concrete in the development of organic plastic forms, characteristic of the work of the Catalonian architect Antonio Gaudi

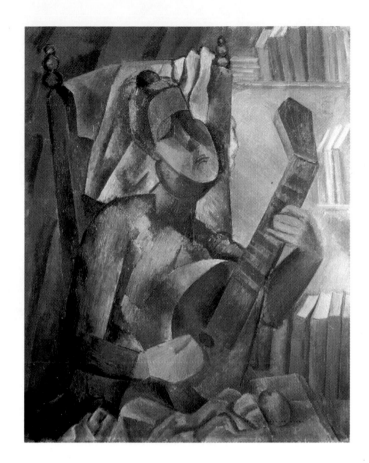

Plate 4.7 *Woman with Mandolin* by Picasso (1909) is an example of early cubism

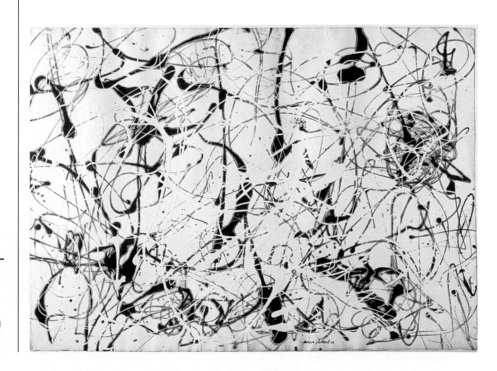

Plate 4.8 *Number 23* by Jackson Pollock (1948). Pollock was an important Abstract Expressionist who began to develop his 'Action' techniques of creating work in 1945, made by dripping and throwing paint onto large canvases which were laid on the studio floor

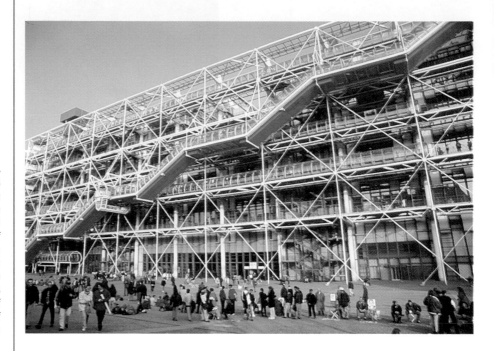

Plate 4.9 The Pompidou centre in Paris opened in 1977 and was designed by the British architect Richard Rogers with the principle that all the space contained within the building should be left free of intrusion, and so major supporting structures and the services, ventilation and heating pipes, escalators, etc., were placed on the outside. The Lloyd's building in London is a later example of Rogers' use of this principle of architectural design

Plate 4.10 This is a small selection of the many art, craft and design journals available. Journals give easily accessible and current information on all aspects of art, craft and design and should become essential and regular reading

Plate 6.1 *Musical Forms* by George Braque (1918). One of Braque's contributions to the development of cubism was the early use of collage. This idea was probably influenced by the fact that his father was a painter and decorator

Plates 6.2 & 6.3 These student
paintings are developments of the work
seen on page 111 all of which were
based on the exploration and
examination of the theme of balance.
See the sample assignment at the end of
Chapter 6

Plates 6.4 & 6.5 This work evolved
from experiments made whilst exploring
the theme of layering and tying. The
student progressed this development
towards a specialism in constructed
textiles. See the sample assignment at
the end of Chapter 6

Plates 6.6 & 6.7 These paintings are from a series made as visual research for the theme of townscape/landscape (see the sample assignment at the end of Chapter 6). The work was made at the end of the first year of a two-year National Diploma course but continued to be a recurring theme of this student's work throughout the second year

Plate 7.1 These two worksheets are part of a series that explored the possibilities for a set design, associated with the design assignment outlined at the end of Chapter 7. A scale model of the final proposal is shown in plate 7.5

Plate 7.2 These worksheets are from the research stage of the design assignment outlined at the end of Chapter 7. This student had chosen to examine the work of the Expressionists

Plate 7.3 This piece resulted from a
design assignment, in which students
worked to combine text and imagery
(see Chapter 7)

Plate 7.4 This costume design was
developed from the earlier research into
Expressionist work and as a response to
the third task set in the design
assignment outlined at the end of
Chapter 7. The picture also makes
reference to work made by this student
in the assignment shown at the end of
Chapter 2

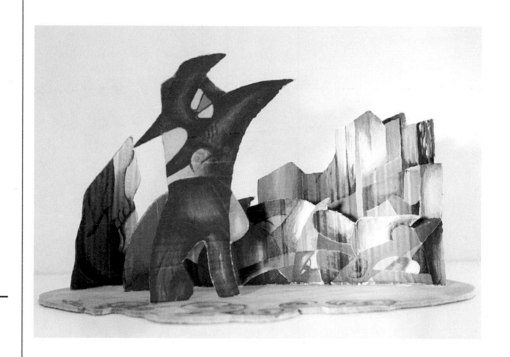

Plate 7.5 This scale model was made
from the design shown in colour plate
7.1

Plate 8.1 Number 2 from a series entitled *Four Colored Campbell's Soup Cans* by Andy Warhol (1965). Much of Warhol's work demonstrates how our perception and understanding of objects and images can become very different when they are taken from their normal context and presented to us in another

Plate 9.1 Advertising is one of the most common of the design courses available in higher education. These label designs are the work of a first-year student on a Higher National Certificate course at Cornwall College. HNCs are part-time courses which have the advantage of allowing students the time to work in paid employment whilst they are studying

Plate 9.2 Another area of visual communication, Illustration courses are available in many institutions. This work is from Bournemouth and Poole College of Art and Design

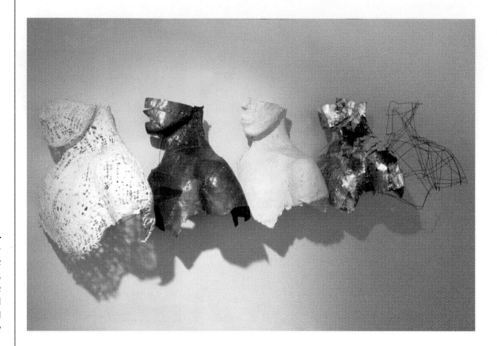

Plate 9.3 Sculpture remains a well-represented discipline in the many fine art courses around the country, alongside painting, printmaking and the newer areas such as installation and time-based work, video, film and computer generated imagery

Plate 9.4 This example of product design work from Kingston University shows the type of work from this broad discipline area covering the design of three-dimensional products and can include the design of products as diverse as a toothbrush and a motorbike

Plate 9.5 This example of student work is from Rochester School of Three Dimensional Design and Technology. Spatial design is an area of three-dimensional design and includes the design of the interiors of buildings, the design of exhibitions, window display, set design and other space-related design. Courses in this area can be general or specialist, for example, theatre design

Plate 9.6 Craft design courses vary, from specialist courses dealing specifically with one material such as ceramics, to the broad-based, combined studies courses that allow the exploration of a range of materials such as wood, metal and glass. This example is from the 3D Design – Silversmithing and Jewellery course at Loughborough College of Art and Design

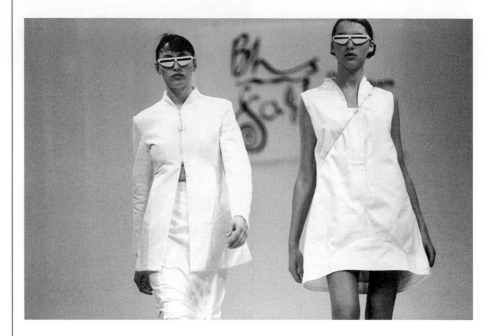

Plate 9.7 The opportunities available within fashion are not limited to just the designing of garments; there are other fashion-related courses such as those that deal with fashion promotion that should be examined if you are considering this area. These designs are the work of students on the BA Honours Degree Fashion course at The Surrey Institute

Plate 9.8 There is a wide variety of textile options offered in higher education and courses can vary from those that focus on the design of mass-produced fabrics to textile art courses that encourage students to develop individual work that has much in common with fine art. This work is from a student on a part-time Higher Certificate course at Cornwall College

6

Working to self-devised art briefs

Introduction

Although many aspects of working as a fine artist, designer or craftsperson are similar to each other, and although the work of many individuals crosses these broad discipline boundaries, there are some fundamental differences both in the way work is developed and in the criteria to which each individual is working. This chapter, and the following chapter **Working to design briefs**, will identify and explain these differing characteristics. One of the essential functions of any general or foundation art and design programme is to help you identify the area in art, design or craft that you would like to specialise in. Working both to self-devised art briefs and to set design briefs will help you in this process of selection.

The fundamental characteristic of working as a fine artist or artist-craftsperson is that the type of work you produce will be decided by *you*, and any constraints on your work are likely to be practical ones of cost, facilities and resources. The idea of being free to develop and make the work that you choose can be an attractive and exciting one, and it may also seem, initially, to be an easy one. However, it should be recognised that the level of personal commitment, energy, determination and self-discipline needed for long-term success is very high.

This chapter will focus on:

- **establishing your personal aims and practical parameters**
- **researching, originating and developing ideas**
- **planning your work and monitoring your progress**
- **producing successful work**
- **evaluating the progress of your work and assessing the final results**

This chapter will give you the opportunity to apply and develop the knowledge, skills and understanding you will have established through the exploration of ideas, media, materials and processes set out in the previous chapters. The work produced in relation to this and the following chapter will also give you the opportunity to deal with issues examined in Chapter 8, **How to present work.**

Establishing your aims

To make any work, you obviously need a starting point and some idea of what you would like to achieve. You may already have thoughts and ideas of things you want to make, but these ideas should be seen as a starting point for development, not as final pieces. The concept of having an idea and then just making it as the final piece is unlikely to be successful and will certainly be limiting in your overall development. You would also find that this way of working is not sustainable as you would quickly run out of ideas.

You will also find that you do not have to set yourself a big task or problem to achieve exciting and successful results. Apparently very simple concepts or ideas can sometimes lead to the best work. There is an almost infinite range of possibilities to use as your starting point, but one major consideration in your choice should be whether you will have enough information to work from to develop your idea. Again, relatively simple ideas are likely to give you the most easily accessible information and research material to work from. Trying to work just from ideas in your head or even from second-hand sources such as books or photographs will not give you the range and quality of information you will gain by working directly from the subject matter of your work. The other major consideration in defining your personal brief is the practicalities of achieving what you have set out to do. Will you have enough time? What resources are available to you in terms of space, materials, equipment etc.? If some of your practical requirements are not available, can you adapt your initial aim or find alternative materials? Being resourceful and adaptable is a major quality of artists and artist craftspersons.

A good starting point for your work could be something that you have some established knowledge of. This may be a practical aspect of work you have already produced, or a media or process that you would like to explore further. It could be a view that you have noticed in or around your working environment, or a drawing or painting made at some earlier stage of your course. Or you may wish to explore some quality that you have noticed in someone else's work.

Defining your aim as an exploration of a theme offers enormous potential: reflections, looking through openings, structures, enclosed spaces, textures. The possibility of a theme could come from one specific idea or observation. The thought that you would like to paint a picture of the view through a particular window is given much greater potential for research and exploration by broadening this idea to the theme of looking through openings.

You will also need to identify the practical limitations of the work you would like to produce. Not only will this avoid frustration if you have started to develop work that you cannot carry through to completion through lack of resources or time, it will also help in defining your aims and giving them more

focus. Georges Braque in 1912, was the first person to exploit the idea of collage. What now seems a simple and familiar way of making images, was a major influential development of the time. Braque was probably influenced by the fact that his father was a decorator; see colour plate 6.1.

Researching, originating and developing ideas

Effective research is crucial for success: insufficient research will limit new possibilities and the potential for ideas, and therefore the success of the final work. Research does not necessarily mean spending hours reading in libraries (although that may be necessary for the work you are involved in). Research can take many forms, and will vary with the aims of the brief; and often, more than one type of research may be needed for one brief. Research is essentially the gathering of sufficient information to allow you to progress your ideas.

Although your main body of research will be carried out in the early stages of a project, it is likely that some research will continue in support of your developing body of work. Researching your subject matter through observational drawings before making a painting, for example, will be essential, but further drawings, or visual research, might have to be done during the subsequent development of your painting to clarify some aspect of the work.

Apart from the subject matter of your work, you may also have to research the technology needed to produce it. This research might take the form of direct help from teaching staff, examining others' work, obtaining information from books, or experimentation.

You should always make sure you keep a record of the research you make. If this research was carried out through drawing or some other two-dimensional work, it can form part of your portfolio or sketchbook. Other research will have to be recorded in differing ways: written notes, photocopies or samples. If the research was in the form of three-dimensional work or experiments with three-dimensional materials or processes, you should make a photographic record of these. Not only will you need this information in the development of your current brief, these records will also be useful in the development of future work. Your ability to demonstrate successful research will also form a major part of your assessment, and will ultimately play an important part in interviews for higher-level courses, if this is the route you wish to take.

The underlying and fundamental way of achieving sustainable, successful and exciting results is through an ongoing process of making and reviewing your work and ideas, along with an ability to respond to, and take advantage of, things that happen as your work develops. These may be unplanned and unexpected. No matter how good your initial ideas are, they cannot develop without your actually making work. As soon as you start making, you can also start the process of reviewing and responding to what is happening in front of you. This process is like having a conversation, a dialogue, with your work, and by keeping a balance between your initial aims and being open to modifying and changing your ideas in response to the way the work is progressing, you should achieve some good results.

Looking at the work of one of the most energetic and prolific artists of this century, Pablo Picasso, we can see that over the 80 or so years of intellectual inquiry and practical exploration of media and materials, a diversity of work came about by an evolutionary process. One idea or concept being explored, often over several years, would evolve into another through many small, almost imperceptible changes. If we look at the work of almost any artist or artist-craftsperson, for example Paul Cézanne, Henry Moore, David Hockney, **Anthony Tapies** (b. 1925), Andy Warhol, Rachel Whiteread or Anthony Gormley, we can see this process of evolution involving relatively small changes from one piece of work to the next, with one piece acting as a starting point, or catalyst, for the next.

Planning your work and monitoring your progress

Although working within an art or craft context gives you a large amount of freedom to dictate your own way and pace of working, it is still essential that you use your time efficiently and effectively. This will mean planning and monitoring the work as it progresses.

As you will see in the next chapter, a designer will be working with a client, and often as part of a team, to agreed deadlines. Working as an artist or artist-craftsperson, however, you will largely be working on your own, and will therefore have to set your own goals and deadlines. Being self-disciplined and able to work on your own initiative is therefore an essential quality. Although you will, at present, be working in an environment where others will set both deadlines and some parameters within which your work will be produced, it will still be necessary to demonstrate your ability to plan and organise the development and production of your work.

Having established your starting point and commenced your initial research, you should, as the work progresses, find ways of recording and reflecting on this developmental process. Whilst the work that you produce will itself show evidence of the process, some of your thoughts and ideas may be lost as you change and manipulate the work. Making notes, both visual and written, will help you to clarify issues that you are dealing with and will also assist in the assessment of your work by you and by others. The way you record and monitor this progress will vary according to the work you are making. It should include the use of sketchbooks or notebooks, but may also require other methods such as photography or video recording. Often, chance events or unexpected discoveries can lead to major changes in the direction of your work. It is particularly important that you record these changes and recognise their potential for future development, particularly if you are unable to take full advantage of them within your current brief.

Evaluating your progress and assessing the final results

It is essential that, on completion of your work, you review what you have achieved and how well you have used your time. You should recognise both your successes and the areas of your work that have not progressed as well as you would have liked. You should make notes of your observations and should be prepared to discuss these with staff and other students. Discussion and debate will help you clarify certain things about your work and will bring up issues that you may not have recognised. Do not be afraid to state the obvious. 'My work is very colourful', or 'I have enjoyed working with clay', but spend some time asking yourself why you have worked the way you have, and be prepared to explain your reasons to others. You may have been working intuitively and not been fully aware of certain things that were happening as the work developed. Reviewing a body of work as opposed to individual pieces can be very revealing, and will begin to expose your likes and dislikes, your strengths and weaknesses. You may recognise that your work has an energetic, dynamic quality, or that it may all be quite controlled and passive. The use of colour may have emerged as a strong feature, and could be giving the feeling of space and light throughout the work. You may recognise that your work has a feeling of structure and form. The recognition of these emerging qualities will help you to progress your work and will contribute to establishing your future direction and eventual specialism.

You should also look at other artists' or craftspersons' work throughout the development of your own. On review of your completed work, you may recognise, particularly with the help of teaching staff, the need to examine other artists' or craftspersons' work as new aspects of your work are revealed. The completion of one body of work should be seen as the begining of the development of further interests, opportunities and research.

Although working as an artist or artist-craftsperson is predominantly about the development of your own personal work and ideas, there will be times when you will have to work in association with others. Whether this is to organise exhibitions of your work with other artists, craftspersons and gallery owners, or to work to a commission, you will find that you will have to work to deadlines and to the constraints of others. In this respect, aspects of the following chapter, **Working to design briefs**, will be relevant.

Sample assignment

This assignment is from the end of the first year of a two-year course. It was designed to provide students with an opportunity to work under their own initiative and to demonstrate work that suggested interests and directions for the second year of the programme. It also offered the students the opportunity to demonstrate and confirm their ability and understanding of the working process, which followed a thoughtful progression of visual ideas.

The project

The assignment is divided into stages, placing emphasis on the drawing quality and depth of enquiry in stage 1, ability to manipulate, change and develop this information in stage 2, and quality of outcome in stage 3. Students were to consider the opportunities offered by the following starting points, and to select the one which would offer the best opportunity to develop and explore personal interests that they were beginning to establish in their work:

1 Journey time. Make a journey within the college location, collecting visual information from the environment, buildings, figures, or other observations. Take into account times, lighting, moods, viewpoints, angles and distances. Consider different ways in which this information can be put together. Your outcomes should deal with images that combines different times and places.

2 Architectural/mechanical shapes, forms. Explore a variety of architectural/mechanical forms or shapes, e.g. gears, switches, sockets, columns, roofs, posts, doorways, windows, corners, details, etc. Select an item to draw, but don't draw the whole of it; consider its form, relationships, scale, materials, etc.

3 Balance. After carefully setting up a collection of objects or forms in your work space, investigate balance, imbalance, weight, tension, symmetry, harmony, stability, poise. Balance could be explored through composition, colour, tone, structure, etc. See colour plates 6.2 and 6.3.

4 Layering and tying. Make a set up derived from a variety of sources that are of interest, and that will enable you to explore the following possibilities: parcelling, covering, veneering, disguising, hiding, enclosing, containing, masquerading, veiling, shrouding. See colour plates 6.4 and 6.5.

5 Townscape/landscape. Using views from the art block, make studies of the surrounding townscape/landscape. Pay particular attention to the contrasts between man-made structures and natural features. Also consider how the subject is changed by effect of the weather and time. Study tone, colour, atmosphere, space, scale, viewpoints, textures, etc. (Students had a particular advantage here as they were working from a six-storey building). See colour plates 6.6 and 6.7.

Whilst students had to select one of these starting points, they were free to interpret them as they felt appropriate to their own interests and development. They were required to demonstrate clearly the three stages of development in their work, to set their own objectives, and to identify constraints that would restrict areas of development, for example the time allocated to the assignment or the availability of materials or resources. They were also to record development and discoveries, identify the context in which they were working and make a final presentation to the student group and staff of the final outcomes.

The form that the final work should take could be two or three-dimensional and in any media or materials. The work could be a single piece or a series of pieces that represented a stage in an on-going enquiry.

These two drawings were part of a series of observational studies examining the physical and compositional balance of different structures. They were evolved into paintings; see colour plates 6.2 and 6.3

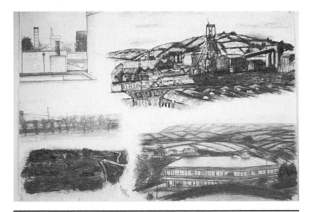

Research studies from direct observation

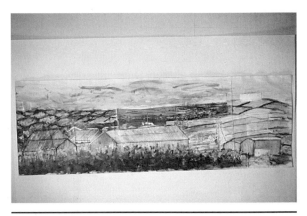

Development drawing made by combining several different images

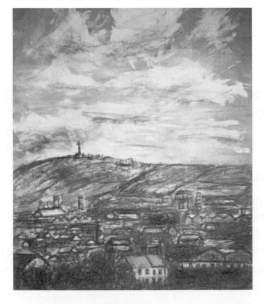

This drawing evolved by combining different viewpoints and elements of the surrounding landscape. See also colour plates 6.6 and 6.7 which were also made as part of this assignment

7

Working to design briefs

Introduction

This chapter will help you to develop an understanding of working in a design context. You will recognise both similarities to and differences from the previous chapter where the process of developing work in an art or craft context was examined.

The fundamental requirement of working as a designer is that the work you produce will be in response to a specific need or function. The process of design will involve the assessment and understanding of the needs both of the client and of the user of the final product. You will have to take into account such things as function, **aesthetics**, costs, ethics, production facilities and processes, marketing, and the time and resources available. Design will often involve the creative and innovative use of materials and processes, and the work produced can be assessed by its ability to meet these needs and criteria.

This chapter will focus on:

- clarifying and researching design briefs
- planning your work and monitoring progress
- originating and developing ideas
- producing successful work

Working to design briefs will give you the opportunity to apply and develop the knowledge, skills and understanding you will have established through the explorations of ideas, media, materials and processes explained in the previous chapters. The work produced in relation to this and the previous chapter will also give you the opportunity to deal with issues examined in chapter 8, **How to present work.**

Design covers an enormous range of disciplines, including graphic design, fashion design, textiles, product design, ceramics, theatre, film or TV design, and furniture design. Chapter 9, **Progression opportunities**, outlines in greater detail the range of design opportunities that exist.

In some areas of design, the designer is also the maker of the final work and is often referred to as a **designer-maker**. In this context, you would be responsible for the whole designing and making process, from the initial concept through to the final and functioning product. People who work in this way include jewellery and textile designer-makers, and potters.

As a designer, you would be responsible for developing concepts and proposals to meet peoples needs, but in most cases the final product would be produced by others and would probably involve the use of industrial processes. For example, a graphic designer would be responsible for the concept and design of work such as advertising literature. They would have to understand the process by which this literature was going to be produced, and would have to take this into account when producing the design proposal. They would specify the type of lettering used, as well as any images to be included (illustrations, photographs, diagrams), and the type of paper to be used, but they would not be responsible for the actual printing. This would be done by a specialist printer.

Clarifying and researching design requirements

Although as a designer you may have identified a need and established your own brief, it is most likely that you will be fulfilling the requirements of a client who will already have set their own agenda. The client may or may not be the eventual end-user of the work produced. For example, if someone commissions an interior designer to design a new kitchen for them, this client will also be the end-user. A bicycle manufacturer, on the other hand, may have recognised the need for a trailer that can be pulled by a bicycle, and whilst they have the manufacturing expertise to make and sell this product, they themselves will not be the end-user. The needs of the people who might buy and use this product will have to be researched by the designer, and this information, in addition to the client's own requirements concerning cost, materials and processes, will form the criteria on which the design will be based.

Whether you have identified a need from which you can develop your own design brief or have already been set a design brief, you will have to clarify and confirm the range of criteria you are working to. The following are some of the things that are important to consider; you will need to add and adapt as appropriate to your particular brief.

Clarification

Are you clear on both the client's requirements and those of the user? This may sound obvious but it is easy to waste a lot of time researching and developing ideas only to find halfway through a project that you have taken

an inappropriate direction because you misunderstood the criteria you were working to. Even if you have been given a written brief, it is almost certain that you will need to discuss and clarify some aspects of what is being asked. Never be afraid to ask if you are unsure of anything, even if you think the question is too simple: it is often the simple aspect of a brief that can be mis-interpreted.

As a student working to a set brief, you should also clarify aspects of the brief both with your tutor and by discussion with other students.

On the wall of the design studio in one of the largest multinational design and manufacturing companies, there is a notice which says, 'Don't ask a designer to design a bridge, ask them to design a way to cross the river.' There is a lot of difference. Which are you being asked to do?

Deadlines

How much time have you got to fulfil the requirements of the brief, and what other targets or deadlines during the development of the work have to be met? The most obvious deadline you will have to meet is the presentation of your final proposal to the client, but to achieve this successfully you will need to organise your time up to this point. It is likely that some short-term dead-lines will be agreed with the client at the initial briefing. These will be to pre-sent your work at various stages of development: research findings, initial sketch designs (from which the client may make a selection of the designs they would like to see developed further), the refined proposal, and the pre-sentation of the final work.

As well as meeting targets and deadlines agreed with the client (or lecturer if you are a student), you will also need to organise and plan the best use of your time throughout the project. You will need to take into account your level of access to resources such as workshops or specialist teaching staff that may only be available to you at certain times. Planning ahead will help you both to make the best use of your time and to meet your deadlines.

Constraints

What are the resource and technical constraints of the brief? You will need to establish both the resources and technology that will be available for the development of your design proposal (i.e. workshops, materials, media) and, if the brief specifies that the design is for production, the technology and resources available for the manufacture of your design. You will also need to establish any cost constraints of the brief. If you are writing your own brief as a designer-maker, don't forget that it is not just the cost of materials and facilities that you need to take into account. Your time also costs money, and will affect the selling price of the finished work. Having said all this, don't give yourself unnecessary constraints if the brief does not call for them. Use the freedom to explore challenging, unconventional and exciting ideas. Car manufacturers have always been prepared to spend money on concept designs that are often impractical and incapable of realistic production, because these designs are valuable in exploring innovative thinking, and often lead the way to the introduction of new technological advances, along with

A concept car – the *GM Sunraycer*

developments in the visual appearance of production vehicles. The *GM Sunraycer*, a solar powered car, will never be seen on the road, but designs like the one shown above give designers and engineers the opportunity to explore concepts and ideas that are likely to influence how their cars may look and perform in the future.

Researching and developing your ideas

In the previous chapter, it was explained how important thorough research is in achieving successful work. When working as a designer, your research becomes even more critical. You may be examining areas that are unfamiliar to you, and your design proposals will have to meet not only your own criteria but also the needs of others. Both the client's and the end-user's requirements will have to be clearly understood. Research will have to be undertaken to give you the understanding necessary to develop a design that will fulfil these needs.

To this end, your research may need to cover a varying range of criteria, including the following:

- *researching how the work will be used.* This will require an examination of other similar designs and products. You should look both at the successful aspects of these other examples and at areas that could be improved.
- *researching media, materials, technology, processes and techniques.* Again you should look at how other designers or designer-craftspersons have exploited these in their work. This research should be carried out alongside your own practical explorations.

You should ensure that your research is clearly and thoroughly recorded and rich and exciting in its presentation, both to enable you to make best use of it in the development of your design proposals, and to assist in the presentation to your client. These research records can take various forms depending on the information you are collecting, and may consist of writing, drawings, paintings, photographs, photocopies, samples and models.

Originating and developing ideas

Having clarified the requirements of the brief, the client and the end-user, and having established a body of research material, the challenge of being a designer is now to bring all these elements and findings together in the production of a final design or piece of work. The process of developing your ideas towards the final piece will vary according to the work you are producing. If you are working as a designer-maker, it is likely that a lot of this development will take place during the process of making and during the exploration of media or materials and techniques, as you work to refine your ideas towards a final conclusion. If you are working just as a designer, the development of your ideas will occur through drawing, mock-ups and **prototypes**. You should not be content just to pursue your first idea, however good it may seem. You can always come back to this idea if it proves to be the best solution after exploring other possibilities, but it is most likely that further investigation and experimentation will lead to better and more interesting proposals.

Whatever context you are working in, you will need to keep a balance between aesthetics and function, performance and innovation. The emphasis of these criteria again will vary according to the brief, but the excitement and challenge of being a designer involves finding ways of meeting and successfully bringing together a range of diverse qualities and requirements.

As with your research, you should make sure that the development of your ideas is fully recorded. This will allow you to make reference to these ideas during the development of subsequent work, and will also ensure that this work is available for debate, discussion and assessment. And again here, you should record the development of ideas in a clear and exciting way as it is this record, plus a demonstration of the way you work, that will form the substance of your portfolio. Both assessors and – if you wish to progress onto higher education – interviewers will be looking at how and why your ideas developed in the way that they did and what led you to your final conclusions, just as much as they will be looking at your final results.

Evaluation

At the end of a design project, it is important that you make an assessment both of the final work, measured against the criteria of the initial brief, and of how well you used your time and organised the development of the work. The criteria for assessing your work will vary according to the nature of the

work. If the brief was for the design of a practical, functional product and you have developed and made a working prototype, it should be possible to carry out practical tests. These tests should allow a clear and *objective* assessment of the product's ability to meet the functional aspects of the brief.

The success of the design's aesthetics will have to be assessed in other ways. Although you will have a strong opinion on the aesthetic qualities of your design, this is a personal or *subjective* view only, and it will need to be tested by asking staff and other students for their opinions before coming to any conclusions.

As a further part of this self-assessment, you should be clear about the processes you have followed in the development of your ideas and be confident that you can present and discuss this development along with your final conclusions. You should always be prepared to listen to and take criticism in a positive and constructive way. The consideration of others' views can only lead to your own personal development and to the progression of your work.

Sample assignment

ASSIGNMENT ONE

This assignment was designed to cover a range of design problems in both two and three-dimensional work. It offered students the opportunity to explore a wide range of media and process, and to extend their knowledge and understanding of a range of historical contextual issues.

The assignment was based around the subject of performance, which gave the opportunity to explore design problems in three main areas:

■ Graphics design
■ Costume design
■ Spatial design

For the final presentation, students were asked to produce a poster and invitation card, a wearable garment and design proposals for a stage set.

As a common underlying theme to the work in all three areas, each student selected one of the following art and design movements after preliminary research:

■ Cubism
■ Constructivism
■ Expressionism
■ Impressionism
■ Futurism/Vorticism
■ Surrealism
■ The Bauhaus (not strictly a movement but a school of art and design)

As a means of focusing the development of their work, students were also asked to place the development of their ideas within a context which they considered appropriate to their chosen movement. Examples given were:

■ Cubism – The City
■ Expressionism – An Industrial setting
■ Impressionism – The Circus
■ Surrealism – Landscape

T a s k ① Research

Research was made into the chosen movement using a range of resources available to the students, including the college library, local public libraries, galleries and personal resources such as book magazine articles, and postcards.

Working from this information, they were asked to produce a minimum of two colour worksheets which explored, examined and represented aspects of the research that students found particularly interesting; see colour plates 7.1 and 7.2, 7.1 relates to the scale model shown in 7.5. This could include details, sections, passages, colour relationships, paint application, mark making, shape, texture, form, materials, and general observations. This material was to form the basis on which subsequent work was to be developed, so it needed to be thorough and well observed.

T a s k ② Graphic design

For this aspect of the assignment, students were required to produce a small body of work that explored the possibilities/implications of combining image and text; see colour plate 7.3.

Following the research, students were asked to design and produce an A2 poster and invitation card (size 10 × 21 cms) taking into account the chosen art movement and subject matter. Both poster and card were to include the words 'Collection '97', 'Work by 1st year GNVQ/GAD students', venue details and date of performance. The College logo was also to be included.

The size and format of this information was entirely up to the student but was to be a major element of the design. Students were required to find, examine and record existing examples of graphic design that performed a similar function.

Students were also to consider all the different approaches and processes that had been explored on the course up to this point as possible ways of creating their design. It was suggested that they would perhaps need to combine processes, e.g. computer generated images and text with paint/colour.

A strict deadline for the completion of this work was set, at which point each student was required to make a short presentation of the development work and the final proposal, to a small group of students and staff.

T a s k ③ Costume design

The second part of the assignment required students to develop work which explored forms, structures, colour and shape in relationship to the human figure.

Research from books, magazines and other available sources was made by the students into costume and clothing, e.g. ball gowns, jackets, suits, waistcoats, corsets or hats. The main consideration in the choice of material was that the work should be visually interesting and have strong qualities of form and structure. Suggested examples that could be examined included ethnic costume, uniforms, theatrical costume, armour, Elizabethan dress, astronauts, protective/industrial clothing, Japanese ceremonial costume. Students were encouraged to choose aspects of different costumes from different cultures or time periods; see colour plate 7.4.

Following this research, the students were to consider ways in which the various elements of this research and the work from their chosen art movement could be combined to create their own costume design.

Through a series of two-dimensional studies, students were to consider ways in which the qualities of costume designs (structure, texture, pattern, colour, etc.) could be developed through for example distortion and exaggeration to reflect the art movement they had researched as the theme for the assignment. From these studies they were asked to build and create a wearable garment out of paper. This could include wallpaper, cartridge paper, newsprint, paper bags, tissue paper etc. The need to recognise and explore the differing structural qualities of these materials and take full advantage of their varying characteristics was emphasised. The design was to be constructed using masking tape, pva glue, lacing, and stapling as a means of attachment. The methods of joining could be an important and inventive part of the design. It was also important that colour and decoration was to be treated as an integral part of the garment, and not something which was added as an after thought.

T a s k ④ Set design

The fourth part of the assignment required students to consider and explore three-dimensions in terms of space, form and colour; see colour plate 7.5.

They were asked to design a stage set based on the art movement and the subject they had chosen as the focus for their work. The type of performance was not specified in the brief, although various options were suggested including a play, contemporary dance or ballet.

The size of the space they were to design for was given as 20 metres \times 10 metres. The development of their ideas and initial proposals were initially to be carried out in two dimensions but final presentation was to be made using a three-dimensional model made to a scale of 1 : 50. Students did not have to consider the practicalities of making their proposal full size, allowing them the freedom to explore fully the three-dimensional and spatial possibilities offered by this brief.

8

How to present work

Introduction

This chapter looks at the differing ways and varying circumstances in which your work may be presented to others. In the previous two chapters, the need to clearly record the progress of your work and prepare yourself to explain and discuss this work with others was outlined.

However good your work is, unless it is well and appropriately presented, its quality may not be fully recognised or understood. How you present your work will vary according to the type of work, the audience, the environment and the occasion.

This chapter will focus on:

- **preparing your work to meet the aim of the presentation**
- **presenting your work effectively**
- **storing and organising your work**
- **preparing a portfolio for progression**

We are all presented, on a daily basis, with images, information and products, on television, in newspapers, magazines, books, shops and galleries. How much notice we take of what we see and read, and what sense we make of it, is strongly influenced by both the way it is presented to us and the context we see it in. We can see that it is possible to dramatically change the viewer's perception and understanding of an object or image just by changing the context in which it is presented. We can see through examples of work such as Marcel Duchamp's ready made *Bottle Rack* (1914) and *Fountain* (1917), and Andy Warhol's *Campbell's soup cans* (1962–3; see colour plate 8.1) and *Coca-Cola bottles* (1962), that it is possible to dramatically change the viewer's perception

The Fountain by Marcel Duchamp (1917) is one of the major influences on twentieth century art. Duchamp submitted this signed urinal to an exhibition of independent artists. Although it was rejected, it made an important statement about the nature of Art and the role of the artist in society

and understanding of an object or image just by changing the context in which it is presented. Likewise, it is important to recognise that the way you present your own work and ideas can have a major effect on how your work is perceived and understood. Thinking about presentation should become an integral part of your working practice and is not just something to be done when your work is finished. How you develop a worksheet or evolve a sketchbook will need careful thought in terms of presentation. Even before you start work, the size, shape and type of paper you work on, or the size of sketchbook you use, will have to be considered as these will affect how the completed work will look.

Essentially, presentation is an aspect of communication. For effective presentation of work, you need to have a clear understanding of the information you are trying to convey. This applies to all aspects of communication, whether visual, written or verbal. Good presentation will enhance and clarify what you are trying to communicate to others through your work. The ways in which you present your work, as well as the context in which the work is shown, will vary. Presentations may range from talking about your work to staff and other students, to displaying ideas and proposals to a client. Other ways you will be required to present work may include putting up a public exhibition and, perhaps the most important of all, a presentation of your work at an interview.

Presenting work to other students and staff

Presenting your work and ideas to other students and staff is likely to be a regular experience throughout your course. Initially, you may find this difficult, and may not be very confident either in the work or in what you wish to say about it. It is worth realising that you will not be alone in your concerns, and that many other students will feel equally unsure. If you are unconfident, don't be tempted to avoid making your presentations. As with all aspects of your work, only through doing and practice will you improve. The ability to talk about your work is essential and needs to be developed if you wish to progress to a career in art or design.

Prepare yourself for any presentation by spending some time looking at the work you have done and making notes on the aspects that you think are important. As was mentioned in a previous chapter, do not be afraid to state the obvious. Be prepared to talk about personal discoveries you have made, and about both the successful and unsuccessful aspects of your work. Remember, in this context of presenting to other students, you are sharing information and discoveries. Take your time when talking about your work. When making a presentation, particularly when nervous, it is easy to feel you are being slow or hesitant, but taking your time will allow your audience to absorb what you say and to consider your work. Almost everybody speaks too fast in a situation like this.

The response that you get from students and staff will give you some of the most important feedback on how well you are doing with your work, and on the specific issues you need to deal with to enable you to progress. It is important that you note observations of areas of your work which have been less successful, as well as those that are positive. You should not take any comments about areas of your work that can be improved or have not worked, as negative criticism. It is inevitable that, to help you advance, discussion about unresolved issues is likely to form the focus of a critique.

Presenting work to a client

Presenting work to a client will require special consideration and preparation. It has to be assumed that a client has asked for specialist art, design or craft expertise because they do not have any themselves, or because what they do have is limited. If this is the case, it is likely that their ability to interpret visual language will also be undeveloped. (Conversely, students and staff all share common experiences, as well as a knowledge and understanding of the language being used, both visual and verbal.) The ability to communicate through a few pencil marks on a piece of paper becomes second nature, but someone unaccustomed to working in such an environment may feel they are dealing with a foreign language. It is important, therefore, that your presentation to the client take this into account. Even when illustrating initial thoughts and ideas, it is essential that this information be clearly and explicitly presented to avoid the possibility of misinterpretation. Designers, in par-

ticular, need to develop skills in making clear illustrations of their ideas and proposals.

Planning and preparation

The way you make you presentation is almost as important as the content, and you will need to plan, prepare and practise if it is to be successful. Outside clients are likely to be working in a professional, commercial environment. If you are to give them confidence in your abilities, your presentation will need to be equally professional.

At your initial briefing for a project, you will probably agree a time and date for your next meeting with the client. You should ensure that the work you have agreed to present at this meeting is ready well in advance. This will give you time to discuss and clarify the content of the work with staff and others who are involved. It will also give you time both to prepare your presentation and, if you are working on a group project with other students, to ensure that there is no misunderstanding between you.

You will have to consider:

- where you are going to give the presentation
- how you will organise the space
- how you will present the work

Will you make the presentation sitting around a table to allow discussion of the work? Will the work be displayed on the wall or on display boards, or will you make a more formal presentation to demonstrate your ideas, using slides you have taken from your drawings, illustrations and worksheets? You may choose to use a combination of presentation methods, but clarity of presentation should dictate what methods you use.

However you choose to present your work, you should make sure that all the information that you wish to discuss and present is easily and clearly accessible. You do not want to be in the position of having to rummage through a pile of work, in front of the client, trying to find a relevant drawing or piece of information. You will need to make notes beforehand, to ensure that you remember to make the points that are important. You may also wish to write an agenda for the presentation so that both you and other participants are clear both on what you intend to look at and discuss, and on the order in which you will examine each aspect of the work. Careful and efficient structuring of the presentation will ensure that no vital bits of information that you wish to convey are overlooked, and that you do not waste time by covering points several times: the client is likely to be a busy person and will appreciate you using their time efficiently.

Presenting your work to the public

As with presenting work to a client, presenting work to the public will need planning and organisation, not only of the work itself but also of the space in

which the work will be shown. The type of work you present will be dictated by the intentions of the exhibition. The exhibition may be of finished work only, as is usual in degree shows or with the work seen in most galleries, or it may comprise both finished pieces and the research and developmental work leading up to them. Because of the diversity of work that may be exhibited and the variety of spaces in which it might be shown, it is difficult to be specific about how an exhibition should be put together and presented. The following is therefore a broad outline only of things that should be considered, but with practical hints also on how the tasks that these involve might be carried out.

The overriding consideration, as with all presentation, will be to ensure that the method you choose to display the work will allow it to be clearly seen and understood.

The space

The space in which work may be exhibited can vary, from a few metres of wall space in a corridor to a large exhibition hall. The physical qualities of the space may dictate the work you choose to show and the way you present it, and you should therefore spend some time making notes about the space, even if you feel you are familiar with it. You will need to measure the length, the width and even the height, and you will need to note features such as doors, windows, radiators, sockets and switches. If the space has been designed to display work, you will need to note what systems are in place to facilitate this: lighting, display screens, hanging rails, plinths etc. With a space not designed specifically to show work, it will be important to consider whether the surfaces are suitable for pins, screws or other methods for hanging work, and, importantly, whether you will be permitted to fix to them. What does the space look like? In almost all circumstances, a plain white sur-

Plans and models of exhibition space will allow you and others to have a clearer idea of how the exhibition might best work

face is the best background on which to display work: other finishes, and particularly patterned ones, will detract from what is being presented. If you are confronted with a space that will not easily allow work to be displayed – the walls are unsuitable, you need more surfaces, or you need to divide the space – then some form of display system will have to be used or devised.

If you are organising an exhibition of any size, it will be worth making a scale drawing of the exhibition space or even a simple card scale model. Page 124 shows an example. Model making is particularly useful if you are putting on a group show with other students, and where there is a range of diverse types of work, as will be the case if you are putting on a show at the end of your course. For safety reasons, take care, when designing the exhibition layout, that you do not obstruct exits.

Displaying the work

Within a mixed show, different types of work will have differing space requirements. Large paintings will not only require a large wall space but should also ideally be placed where the viewer can stand back from the work, whilst small illustrations or pieces of jewellery may benefit from being displayed in a smaller, more intimate space. Again, a scale drawing or model of the exhibition space will allow you to examine and discuss a range of possible layouts before agreeing on the best solution. With a show that includes a diversity of work, such as graphics, sculpture, painting, textiles and ceramics, ways of achieving a professional and integrated presentation will have to be considered. Simple things will help to give the show continuity and make it more accessible to the audience, such as: agreeing the size, layout and typeface of any written information that accompanies individual displays; agreeing the placing of this information so that it appears in the same relative position for each student; and agreeing a common height and spacing between all two-dimensional work, wherever possible. When putting up your work, try to leave enough space around each piece so that its qualities can be recognised without too much distraction from adjacent work. If you are displaying a lot of work in one space, dividing this work into groups of associated pieces will help the viewer to make sense of what they are looking at and will give clarity to the presentation.

Three-dimensional work will need other considerations. Again, if possible, allow space around the work – and here this means not only visual space but also physical space – to allow movement around the work being displayed. Unless the work is quite large, you will probably have to consider constructing a simple plinth to ensure that the work is easily accessible to the viewer.

There are other types of work, such as textiles, that may benefit from being suspended. Allowing work to hang freely away from the wall or display screen will give it a more dynamic quality. Light coming through fabric and the effects of layering are important aspects of this type of work, and it needs to be presented in a way that exploits these qualities. The rich qualities of fabric such as silk only become fully apparent when it can be presented as it would be seen when being worn, and hanging gives this possibility. Nylon fishing line is particularly good for suspending work as it is strong and yet almost invisible.

When visiting galleries and exhibitions, make a note of how the work is presented, as well as looking at the work itself.

Framing and mounting

It may be desirable to **frame** work if it is going to be presented publicly. Not only will framing give the work a neat, professional appearance, it will also, importantly, protect it from damage. Drawings, prints, watercolours and photographs are normally protected by glass. It is not usual to put oil paintings behind glass, and often, particularly with large canvases, paintings are left unframed altogether. When framing work, you will have to decide whether to have the image filling the frame or to mount the work so that you leave a margin between the work and the frame.

There are basically two ways of mounting work: directly onto the mounting surface or behind a cut window mount. **Surface mounting** involves trimming the image to the size that is required and then fixing it to the front surface of the mounting board. **Window mounting**, as the name suggests, involves placing the work behind a mounting board in which a window, of a suitable size for the work, has been cut.

With surface mounting, several methods of fixing can be used. Stick adhesives such as Pritt Stick, double-sided tape and aerosol spray adhesives are all suitable for surface mounting. Water-based adhesives such as PVA should be avoided as there is a strong possibility that the work will wrinkle, and the adhesive may even soak through to affect the image.

Dry mounting, which is a method normally used for photographs (although it can be used to mount any paper), involves the use of a special dry mounting tissue. To mount work, a sheet of the tissue, which is made from **shellac**, is sandwiched between the mounting board and the work. Using a special press, heat is applied which melts the tissue, and on cooling, a bond is formed between the two surfaces. (With care it is possible to use an iron if a press is not available.) This way of mounting gives a very flat, clean result.

Watercolours and prints are usually set in window mounts. Not only does the mount provide a border around the image, the thickness of the board prevents the work from touching the glass, when framed. Window mounts will also give some protection to unframed work when it is in a **portfolio** or **plan chest**. When window mounting, you have the opportunity, by cutting the window smaller than the image, of altering its size and shape, and consequently its composition, without actually cutting the work. Prints are usually mounted with the window slightly larger than the image, to leave a border between the image and the edge of the mount. Extra space is usually left along the bottom edge to allow for a signature, title and print number.

Whichever type of mount you use, it is important that the work be mounted with a wider border at the bottom than at the top. Mounting the work centrally, with an equal margin at the top and bottom, will be visually uncomfortable as the work will look as if it is too low and slipping downwards.

Preparing a portfolio for progression

Preparing both your portfolio and yourself for interviews for higher education or employment is vital if you are to be successful in progressing to a career as an artist, craftsperson or designer.

The direction you choose for progression will need careful consideration. It will involve discussion with your tutors and with professional artists, craftspersons or designers. It will also involve reading prospectuses and, ideally, visits to institutions offering programmes that are of interest to you. Opportunities for employment may also be examined. Chapter 9, **Progression opportunities**, will explain these aspects of progressing your career, and the routes that exist, in greater detail.

For all courses in art, design and craft, with the possible exception of academically based art history, lecturers will wish to see a portfolio of your work at interview. Whether or not you are offered a place on the course that you are applying for, will largely depend on the quality of this portfolio. It is not uncommon for an institution to ask you to send them your portfolio prior to being offered an interview. It is therefore essential that time and effort be spent organising your portfolio so that it gives the best impression of you and your work. If you have been using your time effectively, leading up to your application, you should have a large amount of work to choose from to create your portfolio.

Although the course you are applying to will want to see clear evidence of your energy and commitment through a substantial body of work, a portfolio that contains *all* the work you have done will be too big and difficult for interviewers to deal with. You will therefore have to spend time selecting the work that you feel best represents your abilities and interests. Get help and advice from lecturers on this. It is often a good idea to start this selection by dividing your work into three sections:

1 the best (and definitely to be included);
2 the worst (that you definitely do not want to include); leaving you with
3 a collection of work from which you can select further as you put your portfolio together.

It is difficult to give hard and fast rules on what should be included in a portfolio and how it should be presented, as the nature of the work of different students will vary enormously.

Remember that interviewers are trying to assess not only your practical abilities but also your ability to think creatively and clearly about your work. They will be looking for a demonstration of your understanding of the issues you have been exploring. They will look for evidence of appropriate research, and for an ability to successfully develop ideas in a personal way. They will also be looking for evidence that you have made an appropriate choice in applying for the particular discipline and type of programme on offer. You should therefore make sure that, as far as possible, your portfolio demonstrates these various qualities. A portfolio containing only final, unconnected, finished pieces will not be able to demonstrate and communicate this range of capabilities.

A successful portfolio should contain:

1 *work that is clearly, cleanly and thoughtfully presented.* Your portfolio needs to give the immediate impression that you are serious about your work, and that it will be worthwhile for the interviewers to spend time carefully considering your application. If your work looks as if you do not care about it or value it, it will be difficult to expect any one else to. This does not mean spending a lot of time or money on elaborate mounting (which is unlikely to impress interviewers), but it does mean spending time to clean up your work, ensuring that charcoal drawings are fixed, masking

tape is removed and dog-eared corners and folds are flattened out. If you have work that is of varying sizes, you should consider mounting this in such a way that the majority of it is presented on the same size of backing, and this should be done simply and clearly.

Assemble your portfolio in an order that makes sense, chronologically, grouped in themes or types (all life drawing together, for example) or as projects or briefs. The initial impact of your portfolio on opening should be exciting and inviting, and it should begin with work that shows what you would like to project about you and your work. You should also try to leave a good final impression of your work, so avoid having your least successful work at the end. Ideally, you should be able to punctuate, throughout the portfolio, with strong pieces, to give an overall feeling of good quality. You may also wish to include clear but discreet divisions between different bodies of work, particularly if you are being asked to submit your portfolio in advance, in which case you should also ensure that your name and institution is clearly written on the back of each piece.

2 *A range of work that demonstrates your practical and intellectual abilities.* By the time you have reached the point of putting together a portfolio of work for interviews, you should have established a clear idea of your personal interests and direction. You should be, to a large extent, working on your own initiative. It is this personal aspect of work that will most interest interviewers. Whilst there may be pieces of work in your portfolio that have come from the early part of your studies, the majority of the work that you include should be your latest work.

Although you should be able to put most of your two-dimensional work in your portfolio, you will have to carefully consider how you might show any large pieces or three-dimensional work. Ideally, it would be good to take examples of these pieces to the interview, but for practical reasons this is not always possible. Making and presenting photographs, slides or videos are likely to be the best alternative options here. (See the section 'Making photographic records and presentations of your work' later in the chapter.)

Whether you have been working primarily from set briefs or from your own self-initiated briefs, you should ensure that your portfolio demonstrates your ability to develop your work through the process of thorough research, the development and exploration of ideas, and a final conclusion or consolidation of this development.

Putting together a successful and professional-looking portfolio takes a lot of time and consideration. Do not mistakenly think you will be able to do it on the evening before your interview.

Having put together your portfolio, you should take the opportunity to prepare yourself for your interview by talking through the work with a member of staff. You should ensure that you can talk clearly and fluently about the content of the work, and about how you progressed and developed your ideas. You should be able to identify, and discuss, any similarities your work has to, or any influences taken from, the work of other artists, designers or craftspersons.

Sketchbooks and notebooks

The importance of sketchbooks and notebooks, as part of your portfolio of work, cannot be overemphasised. Not only does a collection of full, rich and

exciting sketch and notebooks clearly demonstrate an ongoing commitment to your work, it is also in these books that interviewers will get the best insight into your true personality, what really interests you and what you are thinking about on a daily basis. They should demonstrate a continuity of thought and a sustained interest and inquiry. Sketchbooks that are made up of a series of single and disconnected images and notes will give the interviewer the strong impression that you do not have the ability to sustain an interest or make observations, enquiries or explorations that have any depth or commitment.

It may be useful to develop more than one sketchbook at a time. These could be a small A5 sketchbook/notebook that is always to hand for quick visual and written notes, along with one or two larger A4 sketchbooks in which you might wish to develop particular themes and areas of interest. Some examples of differing types of sketchbook are shown in Chapter 1, **Two-dimensional visual language**.

Badly presented portfolios, however good the work, may easily put off interviewers. They could be looking at the work of over 100 other candidates, and will not appreciate having to make additional effort to make sense of disorganised presentation.

Interviews

Different institutions will have differing approaches to **interviews**, some wishing to see your work prior to the interview, and some asking you to present and explain a small selection of your work, with the majority interviewing you with your portfolio. The purpose of an interview is to ensure that you have a clear understanding of the work you are involved in, and that you are able to express and communicate this understanding, not just through your practical work but also verbally through explanation, discussion and debate. Interviewers have only a short time to assess your capabilities and suitability to their course. They will, in that time, wish to examine your interests, ideas, aspirations, understanding and abilities. As a way of achieving this, they may not only discuss these issues with you but also challenge you on some of them. This should be seen not as criticism but as a way of confirming your views, and will require a thoughtful and considered response.

As with your portfolio of work, interviewers will be interested in your own ideas, and in your personal response to problems which have been presented to you on your present course. By way of clarification of your work, you may have to explain a task or brief that was set, but you should avoid justifying or explaining work by just saying, 'I did this because I was asked to.' This could be interpreted as showing a lack of involvement or interest.

Interviewers recognise that many applicants will be nervous, and many institutions carefully organise the interview procedure to minimise this. Several institutions will also send a clear outline of the interview process and of the work they would like to see when they invite you to the interview. Read this information carefully and ensure that you are fully prepared to respond to their requirements.

Making photographic records and presentations of your work

The nature of your work and the facilities that you have available to you will largely dictate the type of photographic record you make. If you have a good photography resource available to you, i.e. darkrooms with enlargers and processing facilities, along with a photography studio and photographic lighting, you should take advantage of these, along with the associated expertise of staff. Access to this resource will, in particular, allow you to consider the possibility of black and white photography. Obviously, if colour is an important aspect of your work, it will make no sense to use this kind of photography, but if your work is three-dimensional, and the most important aspects of it are to do with form, texture, structure or space, black and white photographs can be used effectively to emphasise and enhance these qualities. This kind of photography has the added advantage of not being dependent on a particular type of light source, and you can safely photograph in daylight, tungsten light (normal light bulbs), halogen, flash or fluorescent lighting. It is advisable to use a source that enables you to accurately judge and control the way the light falls on your work, allowing you to model or emphasise the three-dimensional qualities. Fluorescent lighting is very poor in this respect, giving a very flat, even light. A flashlight attached to your camera will also tend to flatten, rather than enhance, three-dimensional qualities, as all shadows will be cast directly away from the viewer. If you have the facilities to process, enlarge and print black and white photographs, you will have the added advantage of being able to directly control the composition, and the size and tonal qualities, of the final image.

You have two main choices when photographing work in colour: **prints** or **slides**. Colour prints are the most common, and generally the least expensive, and it is also usually possible to get your photographs processed and printed very quickly. Unlike slides, you will be able to mount and present the prints in the context of the rest of your portfolio, along with other associated two-dimensional work.

Colour slides tend to give the most accurate colour reproduction, and will show the work clearly and effectively when the images are projected. Projecting slides also means that the work can be easily seen by a group audience, and will thus allow all to participate in discussion of the work. If the slides cannot be projected, the major benefits of this method of presenting work will be lost. If you are considering using slides at your interview, check with the institution in advance that this will be okay, and that a slide projector will be available to show your work.

It is possible to get prints from slides, and it is also possible to get extra-large prints made from both negatives and slides, although this is likely to take more time than standard printing, and will obviously be more costly. A good and relatively inexpensive alternative is to use **colour photocopies.** These can also be made from slides or prints, and although they do not always give totally accurate colour reproduction, they have a particular quality which, in some circumstances, can be a very successful way of presenting work.

Most colour films, whether slide or print, are made to be used in daylight or flashlight. Using daylight film in fluorescent, tungsten or halogen lighting will give very inaccurate and disappointing colour reproduction. If you have no alternative to these light conditions, special film or **filters** will have to be used.

When photographing two-dimensional pieces, try to fill the frame with the work. If the proportions of the work make this difficult, ensure that whatever is surrounding the work is as unobtrusive as possible. In most circumstances, a plain white background will be best.

Photographing three-dimensional work successfully needs careful consideration. Again, photograph the work against plain uncluttered surroundings. This should not be difficult if you have access to a photographic studio, which will be equipped with large rolls of background paper. If you are photographing in other situations, it will be worth spending time setting up a space in which to do this: it is very easy, when looking through the viewfinder of a camera, to focus your attention on the work and fail to notice the clutter of the surrounding space.

As previously mentioned, lighting needs to be carefully considered. Be prepared to experiment by moving the light source, or, if that is not possible, by moving either the work or your viewpoint, or both. Changing your viewpoint can also affect how the work is perceived. For instance, photographing a maquette of a proposed larger piece of sculpture from a low viewpoint can give a better impression of how the work will look on a larger scale. You may only need one photograph to show your work, but it will be worthwhile taking several different shots, from which you will be able to choose the most successful.

It is worth looking to see how art, craft or design work has been photographed and presented in good-quality books, magazines or gallery postcards. These will give you some idea of how to best photograph and present your own work.

9

Progression opportunities

Introduction

Your current course of study is the first stage in what will hopefully be an enjoyable career in art, design or the crafts. The choices you make relating to your progression from this course to higher-level study, or possibly employment, are likely to set the pattern for what could be a lifetime's occupation. Throughout this book, various aspects of art, design and craft have been identified and explained. This chapter identifies more specifically the opportunities that exist within these broad headings and the methods by which these opportunities can be pursued. This chapter closely relates to information given in Chapter 5, **Professional practice**, and Chapter 8, **How to present work.**

This chapter will focus on:

- **the opportunities available**
- **making your choice**
- **making an application**
- **preparing for an interview**

Making a choice about the direction you wish to go, after the course you are now on, can be difficult and will need careful consideration. Even if you are clear about the area of art, design or craft you wish to pursue, the ways in which you can do this, and the range of opportunities available, may still appear confusing. It is essential that you gather as much information as possible about your area of interest and the progression opportunities available. The more informed you are, the better chance you will have of making the right choice. You will need to spend time researching by taking advice from lectur-

ers, obtaining college prospectuses and talking to others working in your area of interest, including students who are already on higher-level courses and professionals.

For the majority of students on diagnostic courses, to successfully pursue a career in their chosen specialism, it will be necessary to progress onto a higher-level programme of study. This, in most cases, will be either a BTEC Higher National Diploma or a Degree.

Making your choice of specialism

For some students, this may be a relatively easy decision, with the diagnostic course only confirming an already established ambition. But for many students – and you may be one of them – the choice of progression route has still to be made. To help you with this decision, you need to examine both the opportunities that exist in art, craft and design, and your own interests and abilities. You should initially avoid identifying these interests and abilities with just one particular specialism. Instead, you should be prepared to examine a range of options and have a clear understanding of what the possible specialisms really entail before committing yourself to one route. Here is an example of why careful consideration is needed. A student may have a strong interest in fashion design, and may feel therefore that the only progression option appropriate to them is to become a fashion designer. However, on careful examination of the requirements of a fashion design course and of their own work, interests and strengths, it may become apparent that their abilities and interests are not that well matched to this specialism. Perhaps they are not particularly interested in making, and are not very confident with the skills and understanding associated with the manipulation of fabric – essential elements in the designing and making of clothes. On the other hand, they may have a strong ability in the manipulation of images and text, and be very well informed about current trends in fashion, constantly examining fashion imagery and the different contexts in which fashion design is presented. In the light of all this, it would be much more appropriate for that student to look not at fashion design courses but at the closely associated fashion promotion courses that have been established in several institutions around the country. Examining and recognising the things that interest you on a daily basis, including possibly things that may seem unconnected with your work on the course, may give you some clues as to the areas that should be explored. Make a note of images, objects and environments that attract your attention, and try to identify what areas of art, design or crafts might be associated with them or have influenced the way they are.

If you look back through the work you have made and the experiences you have had so far on your course, you should be able to identify consistent qualities that are emerging, along with particular developing interests. With the help of staff and an examination of the work of others that interests you, you should be able to identify a broad range of progression opportunities that match your interests and abilities.

When reviewing your work, it may be useful to consider some of the following:

- Do you have a strong interest in making, and much prefer a hands-on practical approach to working, developing your ideas largely through the exploration and manipulation of materials, or are you better at, and more interested in, developing ideas on paper, and would be quite happy to instruct and direct others in the realisation of these ideas?
- Do you work better independently, or do you enjoy the discussion, debate and negotiations which are associated with working as part of a team?
- Do you find that you perform better when working to well-defined briefs with tight deadlines, or has your most successful work derived from more open and self-directed developments?
- Is your work predominantly two-dimensional or three-dimensional?
- Does your portfolio of work have a predominance of work that is colourful and that explores the rich textural qualities of materials, or does it demonstrate a preference for examining the problems associated with form or function?
- Has the development of particular practical skills in the manipulation of media or materials become a dominant facet of your work?

By identifying and grouping these and other qualities, as both positive and negative aspects of your work and interests, you should be able both to identify possible progression opportunities and to eliminate those which clearly need no further consideration.

Having identified the discipline(s) that most interests you, you should establish which institutions offer courses in this (or these) and obtain their prospectus. When you write to or phone an institution requesting their prospectus, you should mention your particular area of interest, as most courses produce literature specific to each of their programmes. This will contain a more detailed and informative description of what is on offer, and of what they will be looking for in prospective students. Having identified courses that look potentially exciting and appear to match your needs and aspirations, and for which you feel you will be equipped to make a realistic application, you should now consider visiting them.

Obviously, all institutions will emphasise the positive aspects of their courses, environment and facilities. It is often difficult to select those that will be best for you, from what could be as many as 50 different options, if you are considering some of the more commonly available disciplines such as graphic design, fashion design or fine art. On the other hand, with some of the less common courses like animation, bookbinding, footwear design or transport design, your options will clearly be restricted to only a small number of possibilities, making your choice simpler.

The following are things which may help you to decide which course to choose, if there are several that appear to offer a similar type and quality of programme.

Geographic location is likely to be an important factor. Moving to another part of the country is likely to offer you a unique opportunity to experience living and working in what may be a very different environment from the one you are now in. Although this may seem daunting, the opportunity to broaden your experience, not just in direct relationship to your work but also in a social and cultural context, can be an important aspect of your development.

The popularity of an institution and course is likely to affect your chances of achieving a place. There is enormous competition for places on higher-level art and design courses, with increasingly large numbers of students applying for a limited number of places, a situation which leaves many students

unplaced every year. However good your work is, it will be necessary to carefully plan your application strategy to give you the best chance of success in your application. Statistics are available from which you will be able to identify the most popular courses, the number of students that applied to each individual course, and the number that were accepted in the previous year. Your tutor should have these details, along with other useful information that will help you in your choice of course. Given all this information, you will need to consider whether an application to the better, and most popular, courses is realistic, or whether it might be more sensible to apply to some of the options that are less popular but for which you have a greater chance of securing a place.

Visiting institutions and courses

Many of the aspects that will contribute to the success and enjoyment of your two or three years in higher education cannot be easily assessed by just reading the information available in a prospectus or course literature. There is no substitute for first-hand experience of the institutes you are considering to enable you to clarify your choices. The workplace, the staff, other students and the type of work they produce, along with the surrounding environment, will all contribute to how comfortable you feel with your choice and how well it meets your needs and expectations.

When visiting a college, it is important that you meet and talk to students, as well as to staff. You should make a point of talking to several students on the course you are considering, to ensure you get a balanced view. Get them to talk about the positive and the negative aspects of their experience. Ask them if they will show you some of their work and tell you about the assignments they have been set. It will be particularly useful if you can see some first-year work as this will give you some idea of the level of ability needed and how well you would cope with the demands of the course. As well as obtaining information about the course and the institution, try to get information about other aspects of student life, such as the type and cost of accommodation available and the amount of money the students find they need to survive.

You should take the opportunity to visit as many of your choices as possible. Being able to make comparisons between one option and another will give you a clearer idea of what is good and what is not so good, and will allow you to see the often big differences between provisions that may on paper have initially seemed similar. It is unfortunate but true that many students who have not visited institutions or courses they are applying to, realise, only when attending their interview, that what is on offer does not meet their expectations. This will not only be disappointing but may also mean that the student has effectively forfeited their main chance of obtaining a place on a higher-level course.

The majority of institutions hold 'open days' or 'open weeks' and will prefer you to visit them during these times, although most will be happy to see you at other times if you contact them well in advance to arrange a convenient time to visit.

Degree or Higher National Diploma course?

Bachelor of Arts or **Bachelor of Science degrees** (BA/BSc Hons) are validated by universities. **Higher National Diplomas (HND)** are validated by the **Business and Technology Education Council (BTEC)**. A degree is the higher of the two qualifications, and takes three years of study, a Higher National Diploma taking only two. However, a higher qualification does not necessarily mean a better qualification in terms of future opportunities available to you. Your future goals and aspirations may mean that a particular Higher National Diploma course will equip you better and offer a more appropriate experience than that which is available on degree programmes.

Whilst it is difficult to be totally specific, a general difference between the two qualifications might best be identified as being that the focus of a diploma is on the development of skills to equip students for working in their chosen discipline, whilst a degree focuses on the individual's personal and academic development. Clearly, it is not possible to separate out these areas of experience and knowledge, and each qualification will deal with both vocational and personal development. It will be the balance between these two factors, and the extent and depth to which each is examined, explored and developed, that will vary. As fine art is primarily about personal development, courses in this discipline only exist within the degree sector. It is advisable to closely examine both HND and degree courses offering programmes in your chosen area of interest before making your final choices.

It may be possible to transfer from a Higher National Diploma at the end of the two years to the third year of a degree course. However, some honours degree courses may require you to do two years following a higher diploma, which may mean that you would not receive grant support for your final year.

The range of art, craft and design courses available in higher education

The following list is an indication of the diversity of programmes on offer in higher education (HE). Given the constantly changing nature of HE courses, a current UCAS handbook, along with individual college and university prospectuses, will give you the most accurate and up-to-date source for current Higher National Diploma and degree programmes available.

As different institutions may use different course titles for similar programmes, the list includes most titles in current use.

Combined studies or multidisciplinary programmes will vary in terms of the range covered from institution to institution.

- Accessories design
- Advertising
- Animation
- Antique restoration and management
- Applied arts
- Architectural glass
- Architecture
- Art (general)
- Art and design
- Art education studies
- Art history
- Arts/events administration
- Audio-visual studies

- Biological imaging
- Blacksmithing
- Bookbinding/bookworks
- Broadcasting
- Calligraphy
- Ceramics
- Clothing
- Combined studies (including modular/multidisciplinary degrees)
- Communication(s)
- Community art
- Computer-aided design
- Computer graphics
- Conservation
- Copyrighting
- Costume (design/construction/interpretation)
- Crafts
- Critical fine art practice
- Cultural studies
- Dance
- Decorative arts
- Design
- Design crafts for the entertainment industry
- Design realisation/interpretation
- Design studies
- Directing
- Documentary
- Drama
- Electronic media
- Embroidery
- Environmental design
- Exhibition design
- Fashion
- Fashion marketing/promotion
- Film, video and photographic arts
- Fine art
- Floor coverings
- Footwear/accessories
- Furnishings design and manufacture
- Furniture design
- Furniture restoration
- Glass
- Graphic arts
- Graphic design/communication
- History of art/design
- Illustration
- Image-making
- Industrial design
- Information/library design/studies
- Interactive arts/systems design
- Interdisciplinary design
- Interdisciplinary studies
- Interior design/architecture
- Jewellery
- Journalism
- Knitwear
- Leisurewear
- Lettering
- Lens-based media
- Live art
- Media
- Media arts
- Media practice
- Media production
- Media studies
- Menswear
- Metal(s)
- Modelmaking/modelling
- Modern art
- Modular degrees
- Museum and exhibition design
- Music
- Newspaper design
- Packaging design
- Painting
- Performance art/performing arts
- Photography
- Photography-related subjects
- Photoreportage
- Plastic
- Printed textiles
- Printing
- Product design
- Public art and design
- Publishing
- Related arts restoration
- Retail design
- Scenic art/construction
- Scientific and technical illustration
- Sculpture
- Silversmithing
- Spatial arts/design
- Sportswear/leisurewear
- Studio art
- Surface decoration/pattern
- Technical illustration graphics
- Television design
- Television production
- Textiles, or textiles/fashion

- Textiles-related courses
- Theatre design
- Three-dimensional design
- Time-based media
- Transport design
- Two-dimensional design
- Typography
- Video

- Visual arts
- Visual communication
- Visual culture
- Visual performance
- Visual studies
- Wardrobe
- Wood

This list of options may be confusing, and some titles will have little meaning. The following main headings within art, design and crafts, within which each of the above titles can be placed, will help you to recognise those which relate to your own interests, abilities and aspirations.

Visual communications

This is the largest group of associated disciplines. Visual communications may also be called communication design or information design. The large number and breadth of employment opportunities in this area is reflected in the large number of courses available, both as Higher National Diplomas and as degrees.

Visual communication is concerned with the communications industries: advertising, publishing, printing, film, TV etc., and covers all aspects of design where words and images are used to convey and promote ideas, information and products. Designers in this area can be either general graphic designers or specialists, the latter working, for example, as illustrators, packaging designers, photographers or specialists in TV graphics, film and animation, computer graphics or advertising. Courses are available that are also general or specialist, with many programmes of study involving a general first year that leads on to specialist options in the final phase of the programme. Common aspects of working within the area of visual communication include those identified in Chapter 7, **Working to design briefs**.

You will be working for a client, and will be required to fulfil the requirements of the client's brief. This will usually mean producing work aimed at a specific audience or end-user. You will usually work to tight deadlines, and will often work as part of a team. You will need to be a good verbal as well as visual communicator, and be confident in dealing with a diverse range of people.

Some of the most common specialisms are as follows:

- **Advertising.** This is the area of graphic design that deals with the promotion of products, services and events through packaging, posters, the press, TV, promotional literature and point of sale; see colour plate 9.1.
- **Typography.** This deals with design and layout, and the process of producing printed lettering in books, magazines, publicity material, forms and stationery.
- **Illustration (general).** This concerns the creation of pictorial images to accompany and support text in books, magazines, book covers, CDs, and tape and record packaging, as well as general advertising material.
- **Illustration (scientific and technical).** This specialist area includes the creation of images to clarify, explain and convey information in the fields of biology, botany, medicine, zoology and history. It also covers visual information associated with industry, products, buildings, machines and processes; see colour plate 9.2.

- **Computer graphics.** Although this is a relatively new specialism, computers are an essential tool for all graphic designers. With image manipulation, both static and animated, becoming increasingly sophisticated through this technology, there are a growing number of opportunities to specialise in this area.
- **Photography.** The large majority of images presented to us in magazines, on packaging and posters and in books are photographic ones, and there are therefore a relatively large number of progression opportunities in this specialist area of visual communication, either as independent courses or as specialisms within broader-based visual-communications courses.
- **Film and animation.** As with photography, these specialisms are available as free-standing specialist courses or as options within broader visual-communication programmes.

If you are considering the last two disciplines, you should also look at fine art courses, since several of these offer the opportunity to explore photography, film and animation as part of the programme or as specialist options.

Fine art

In the past, the majority of courses in **fine art** would normally have expected students to develop their work within the areas of either painting, sculpture or printmaking. Whilst most still offer and encourage work in these areas, many now also support and encourage students to develop their work in other ways, including photography, film, video, installation, using text, computer-generated imagery, and performance, either independently or in combination; see colour plate 9.3.

Whatever the medium used, the underlying qualities needed in a fine art student are a high level of motivation and the ability to be self-directed, organised and endlessly resourceful. It will be essential, if you are considering this option, that you are able to sustain a continuing commitment to working with your own ideas, and are able to maintain an ongoing and serious investigation in a committed and mature way.

You will need to look very carefully at the large range of course programmes on offer. Each will have a differing focus, both for the content and for the way programmes are presented. Whilst all fine art courses will want to encourage the individual and personal development of each student, the experience, expertise and personalities of the staff, the physical resources available, the geographical location and tradition will all dictate a range of parameters within which this development will take place. It may be that a course has developed and established a strong interest in figurative painting, and in this case, if your interests and work are focused towards non-figurative concepts and ideas, not only are you unlikely to be happy on the course, it is unlikely you will be offered a place.

It is essential that you visit courses before making your application, not only to clarify and confirm these aspects but also to see and, importantly, experience the particular atmosphere of the course and environment, something that can only be recognised and assessed first-hand.

Career opportunities

There are no clear career structures for fine art graduates, and whilst a small number will make a living as full-time artists, usually after post-graduate study, the majority will use their skills in other areas either associated or unassociated with art and design. The personal development that takes place on an art degree course gives fine art graduates a self-motivated, flexible and adaptable attitude to life, allowing them to grasp and create employment opportunities for themselves, which could include: artist-painter, sculptor, printmaker, performer, arts officer/organiser, art gallery manager/supervisor, art teacher/lecturer, community artist, conservationist/restorer, craftsperson/technician, occupational art therapist.

Three-dimensional design

This category can be divided into groups of related disciplines: **industrial design**, which covers the huge range of manufactured products that we use in all aspects of our lives: electrical products, products for work, products for leisure, medical equipment, furniture and products for special needs; **spatial design**, which includes the design of interiors of buildings, exhibitions and displays, and set design for stage, theatre and TV; and **three-dimensional crafts** such as furniture design, ceramics, glass and jewellery. If you are considering applying to courses in this area, you will need to be able to demonstrate an interest in, and ability to explore a range of, three-dimensional materials. You will need to show that you can think, develop ideas and solve problems in three dimensions. It will also be important to demonstrate a strong ability to record and communicate your ideas through drawing.

Industrial design

Industrial design is concerned with the appearance and user aspects of manufactured products such as domestic appliances, cars, and office, medical or sports equipment. Industrial design courses will develop the skills and understanding needed to deal with the problems and challenges associated with the relationships between technology, products and the user. Working in this discipline will require you to develop a sound knowledge of a wide range of materials, both natural and man-made, alone with a clear understanding of the associated manufacturing processes; see colour plate 9.4.

Career opportunities

These include: automobile designer, domestic product designer/manufacturer, electronic hardware designer, engineering modelmaker, industrial ceramicist, industrial designer, industrial modelmaker, sports products designer, medical equipment designer, motor car parts designer, product designer – wood, ceramics, plastics, product designer – engineering, prototype producer, toy designer/manufacturer.

Spatial design

This area of three-dimensional design is principally concerned with the design and organisation of space; see colour plate 9.5.

- **Interior design** is concerned with the interior of buildings, commercial, public and domestic, bringing together aspects of architecture, furniture design, lighting and textiles.
- **Exhibition design** covers areas of spatial design which include exhibition, museum, in-store and window display. The conveying of information and promotion are major aspects of working in this area, and this discipline has much in common with graphic design.
- **Set design** covers areas of design related to performances in theatre, film and television. The study and understanding of costume, lighting and performance, and of their relationship to one another, will form major aspects of most courses in this discipline.

Career opportunities

These include: interior designer/decorator, exhibition designer/organiser, film/theatre/TV set designer, theatre/film/TV props and special effects, gallery/museum designer/technician, architectural modelmaker, architectural draughtsperson, display designer, landscape designer, shopfitter.

Three-dimensional crafts

The area of three-dimensional crafts offers a wide range of opportunities. Courses vary from those which focus on one specialist area, such as silversmithing, to those which offer multidisciplinary options, for example combined studies in wood, metal, ceramics and textiles. The common factor in all cases will be that students are encouraged in the development both of a thorough understanding of materials and of an ability to manipulate them in a personal and creative way; see colour plate 9.6.

Career opportunities

These include: ceramics/pottery designer, furniture designer/maker, jewellery designer/jeweller, stained glass designer/craftsperson, bookbinder, conservator/restorer – wood, metal, frame-maker, furniture restorer, glassware designer/craftsperson, leatherwork designer/craftsperson, metalwork designer/craftsperson, mosaic designer/craftsperson, museum modelmaker/technician, plaster modeller/caster, pottery designer/craftsperson/decorator, pottery technician, replica maker, signwriter/manufacturer, silversmith/goldsmith designer/craftsperson, stone carver/cutter, woodcarver/ craftsperson.

Fashion

Within this discipline, there are a range of course options which reflect the varying aspects of the fashion industry. Some courses will focus on the design and manufacturing aspects of garments where practical making skills and a thorough understanding of the characteristics of fabrics will be developed. Others concern themselves with the marketing and promotional aspects of fashion. Opportunities also exist to study and specialise in footwear, accessories and millinery. All courses will include business studies as part of the programme; see colour plate 9.7.

If you are considering this option, your portfolio will need to demonstrate your awareness of current trends in fashion, an ability to think three-dimensionally, with particular reference to the figure, a sensitivity towards fabrics and materials, an ability to explore and demonstrate your ideas through drawing, and an awareness of historical and cultural issues in relation to fashion. Some courses in fashion design will also wish to see a demonstration of an already-established understanding of pattern-cutting and clothes-making.

Career opportunities

These include: fashion designer/manufacturer – womenswear, menswear, childrenswear, high street fashion, mid-range, haute couture, bridalwear, knitwear, corsetry, lingerie, swimwear, sportswear; fashion accessory designer/maker, fashion illustrator, fabric-consultant/buyer, fashion journalist, fashion marketing/sales manager/assistant, fashion stylist, fabric consultant/buyer, film/TV costume designer, film/TV costume consultant, footwear designer, garment maker/dress maker, garment/costume conservator/restorer, knitwear manufacturer/manager, pattern cutter/grader, seamstress, sewing machinist, theatre costume designer, theatre wardrobe costumier.

Textiles

Textiles is often closely associated with fashion, with programmes in both disciplines commonly being found within one institution. The opportunities within this specialism range from courses that are concerned with the design of fabrics intended for mass production – these will cover aspects of manufacturing, including computer technology, dye and yarn science – to crafts-based courses that have a close affinity with fine art. Students on these courses will be encouraged to develop both personal, creative skills and making skills. Because of the breadth of options and the large variations within this discipline, you will have to examine very closely the nature of the courses offering textile programmes if you are considering this option; see colour plate 9.8.

Career opportunities

These include: textile designer – fabrics, knitted fabrics, **Jacquard**, upholstery, curtains and manufactured fabrics; fabric printer, fabric restorer/conservator, household hangings/curtain designer, knitted and constructed/fabric producer, rug and carpet designer/manufacturer, tapestry designer/maker.

Combined study or multidisciplinary courses

There are a range of Higher National Diploma and degree programmes that give students the opportunity to study more than one subject. How these programmes are organised and the range of subjects on offer vary from institution to institution. There are for example:

- programmes that offer an art, craft or design subject with other academic subjects such as English literature or a foreign language
- those which combine different art, craft and design disciplines, for example, textiles with ceramics, or painting with photography
- those which offer a combination of the arts subjects, visual arts, performance, music, theatre, dance and literature

The skills, abilities and qualifications that are needed to make a successful application to these types of programmes will vary, but many have similar application requirements and procedures to those of academic courses not involving art, design or craft. You should check with the individual institution on their requirements.

Career opportunities

Many of the opportunities that exist following combined-study or multidisciplinary courses will be similar to those that are available to graduates from individual specialisms, although some opportunities may favour graduates with the breadth of knowledge that these multi-disciplinary courses develop.

Making an application to higher education

The **Universities and Colleges Admission Service (UCAS)** is the central agency which acts on behalf of the majority of UK universities and colleges to process applications for entry to their first degree or Higher National Diploma courses. To allow the UCAS scheme to work successfully, and to give all applicants an equal opportunity to apply to the courses of their choice, there is a clearly defined procedure and timetable. The timetable ensures that institutions receive applications in good time, and that applicants receive decisions

promptly and are able in turn to respond to offers by a given date. Application forms, and the UCAS Handbook which lists all the courses using the scheme, should be obtained from your school or college.

Along with details of the qualifications you have already achieved and the courses to which you wish to make an application, you are required to write a personal statement about yourself and your work. Once you have done this, and before the form is sent off to UCAS, a confidential reference will be made and added by the staff who have been working with you. Their reference will describe your creative abilities, how well you have used your time on your current course, and the broader contributions you may have made to the group you have been working with.

Personal statement

Writing a **personal statement** about yourself and your work is not easy, and you will need to give careful consideration to this, allowing yourself plenty of time to do it. You should not write an essay but instead list a series of points which are clearly expressed and can be easily and quickly understood.

- Describe your enthusiasm for and interest in your proposed study area, and the particular aspects of the work that you find most stimulating, challenging and satisfying.
- If you can, briefly describe the basis of your present concerns, and how you would like to progress these. You should try to give an indication of your range of interests within art, design and crafts, and in particular those which directly influence and inform your own work. If you have been to any notable exhibitions, films or plays, or read any books or magazines that have made a particular impression on you, mention these.
- List other interests, especially those which interact with your art, design or craft work.

The things that you say in your statement are likely to form the focus for part of your interview, and you will therefore need to be in a position to enlarge on and discuss issues you have mentioned. Do not be tempted to make statements just because they may sound impressive, if you cannot substantiate them. If you have been using your course effectively, constantly examining your work and explaining it to others, you should be able to convey through your personal statement a clear outline of your interests and abilities along with an indication of the influences of others on your work. Try to be concise in your writing, avoiding unnecessary elaboration. Whilst you need to be positive about yourself and your work, avoid sounding boastful or arrogant.

Applications for art and design courses through UCAS

Art and design students are uniquely placed within the UCAS system in that they have two routes available to them through which to make their applications:

- **Route A.** This route adheres to the normal UCAS timetable and requires applications to be made from 1 September up to the deadline of 15 December. It is advisable to apply by mid-November to enable institutions to make arrangements for the inspection of portfolios. Leaving your application to the last minute may limit your chances of entry as places may already have been filled. If you are wishing to apply to the Ruskin School of Fine Art, Oxford, your application must be made by mid-October. When applying through Route A, you do not indicate any order of preference in your choices.
- **Route B.** Applications through this route need to be made between 1 January and a UCAS-specified closing date, usually towards the end of March.

In all, you are allowed six choices of institution/course, with a maximum of four being made through Route B. When applying through Route B, you will be required to indicate the order in which you wish to be interviewed by the institutions.

Applications outside UCAS

Not all courses in art, design or crafts use the UCAS scheme: applications for the Scottish colleges of art, for instance, need to be made independently. You will need to contact these institutions directly to establish their application procedure. It is worth noting those courses which recruit outside the UCAS system as these may give you application opportunities in addition to your UCAS choices.

See Chapter 8, **How to present work**, for further information on preparing your portfolio and interviews.

Employment

It is not on the whole the intention of diagnostic foundation programmes to prepare students for direct employment following completion of their courses. There are, however, some employment opportunities that do not require the specialist knowledge or abilities developed on higher-education courses but which do require strong evidence of creative ability and commitment. The portfolio of work and the qualification obtained from a diagnostic foundation course will give this evidence. The sorts of employment available here are likely to be at the level of **apprentice/trainee** and may require further part-time training at college. Possibilities in this area could include: work in a printing company, work as a photographic assistant or studio assistant, work associated with the building trade, signwriting, work in specialist shops (e.g. fashion, fabrics), or work as a workshop assistant, (e.g. in ceramics, wood, stained glass).

If you are considering this route, it will be worth trying to obtain a **work placement** in the field you are interested in whilst on your current course. Not only will this give you a clearer understanding of working in a commercial environment, it could lead to longer-term prospects and possible employment.

A year out

A third option to employment or higher education may be to take a year out from education before progressing onto HE. It is understandable that some students may wish, after having been continually in education, to have a year's break before entering the highly committed environment of a higher-level programme of study. The opportunity to broaden one's experience by travelling and/or to earn some money by working are clearly attractive. Courses also look very favourably on prospective students who have gained the extra maturity that experiences outside education can give.

However, it is very important, if you are considering this option, to note that, unlike academic university courses, very few art, design or craft courses will hold or defer an offer of a place on their programme from one year to the next. This is understandable since primarily all disciplines in art, design or the crafts are about the active and ongoing process of developing ideas and making work. If this process is interrupted for any amount of time, an artist's, designer's or craftsperson's abilities will begin to decline. It is vital that anyone entering a programme of study at HE level should be currently involved in making work. Most courses will therefore require applicants, even if they have been previously offered a place, to reapply and follow the same application procedures as new applicants. Being accepted in one year does not guarantee being offered a place in the next: the course's requirements may have changed, the other applicants may be better, or your current portfolio may no longer demonstrate what is required. You should also recognise that whilst it is demanding enough preparing and making an application to higher education in a supportive educational environment making a successful application independently, without the advice and support of staff and other students, will be doubly difficult. The difficulty of continuing to maintain and develop your work without support, and alongside other interests and commitments such as employment is likely to be much more difficult than might at first be anticipated. It will be essential, however, if you are to succeed in your later application, that the development of your work continues.

Useful reading

The Art and Design Directory, published by Avec Designs Ltd (PO Box 1384, Long Ashton, Bristol BS18 9DF), gives details of all HE art, design and craft courses in Britain.

Useful addresses

UCAS (Universities and Colleges
Admission Service)
Fulton House
Jessop Avenue
Cheltenham
Gloucester GL50 3SH
Tel.: 01242 222444.

Arts Council of England
14 Great Peter Street
London SW1P 3NQ
Tel.: 0171 333 0100

Arts Council for Wales
Holst House
9 Museum Place
Cardiff CF1 3NX
Tel.: 01222 349711

Scottish Arts Council
12 Manor Place
Edinburgh EH3 7DD
Tel.: 0131 226 6051

The Design Council
Haymarket House
1 Oxendon Street
London SW1Y 4EE

The Crafts Council
44a Pentonville Road
Islington
London N1 9BY
Tel.: 0171 278 7700

Society of Designer Craftsmen
24 Rivington Street
London EC2A 3DU
Tel.: 0171 739 3663

The Design Museum
28 Shad Thames
Butler's Wharf
London SE1 2YD
Tel.: 0171 403 6933

The Royal Society of Arts
8 John Adam Street
London WC2N 6EZ
Tel.: 0171 839 5805

Edexcel (Formally BTEC)
Central House
Upper Woburn Place
London WC1H 0HH
Tel.: 0171 413 8400

Scottish Vocational Educational
Council (SCOTVEC)
Hanover House
24 Douglas Street
Glasgow G2 7NQ
Tel.: 0141 242 2168

The Chartered Society of Designers
(CSD)
32 Saffron Hill,
London EC1N 8FH
Tel.: 0171 831 9777

Glossary

Agent	a person that represents and promotes an artist and his work and will act as an intermediary between the artist and the buyer of the artist's work. Freelance illustrators and photographers commonly use agents.
Armature	a rigid structure on which to build sculptural pieces in clay or plaster. Twisted wire, aluminium or mild steel rod are ideal for this as they can be bent to follow the main form of the proposed piece. Wood, polystyrene or chicken wire can be used to provide bulk in larger work. To make it easier to remove the armature from clay work that is eventually going to be fired, bulk can be added by wrapping with newspaper.
Assignment	a task or series of tasks set by tutors or developed by students in consultation with their tutor, that lead to the development of a coherent body of work.
Binder	in painting, any medium of some liquidity which forms a paint when mixed with powder pigment.

Brief	written or verbal instructions or suggestions specifying an assignment or project.
Client	a term used to describe a person or a group that buy, commission, order, use or view art, craft and design work.
Collage	from the French word colle: to stick. It involves pasting fragments of newspaper, cardboard, wallpaper, cloth etc. to a support of paper or card to create an image. First used by artists such as Braque and Picasso in the early part of the 20th century.
Commission	a request from a client to an artist, designer or craftsperson, to produce a piece of work or a design specifically for them.
Contemporary	present day, up to date.
Context	circumstance or environment
Conté	a non-greasy crayon. The name comes from the French scientist who invented it, Nicolas-James Conté (1755–1805).
Co-operative	where everyone involved in a business shares the work, the profits and the decision-making. Co-operative craft workshops allow members to share facilities that would be difficult for an individual craftsperson to establish. Members also benefit by sharing in the commercial aspects of a craft business.
Critique	a critical examination of work.
Diagnostic	courses that enable students to experience a broad range of art, craft and design activities in order to find out or 'diagnose' where their particular interest and aptitude lies, in relation to future specialisms.
Ethics	code of conduct or principles.
Exploration	investigate, study and examine through practical analysis.
Figurative	representational drawing or painting in which figures or objects are portrayed just as they appear.
Glaze	a glass-like film applied to ceramics to give a smooth finish and also to some pottery to make it non porous, in painting glazes are thin transparent overlaying layers of paint.
Ground	a mixture placed on the surface of a canvas, wood, or paper prior to painting to prevent it absorbing the paint and to achieve good adhesion of the paint.
Jacquard	method of controlling the weaving of a pattern in woven fabric.
Malleable	a material that is easily formed or reshaped.
Maquette	a small-scale model used by an artist as a way of exploring the potential of a larger piece of work.
Medium (pl. media)	the physical means by which an artist, craftsperson or designer makes work, e.g. oil painting, charcoal, photography, clay modelling. Medium also refers to the substance used to suspend the pigment in paint, e.g. linseed oil, egg yolk.
Monochrome	an image made using only one colour.
Narrative	a story.
Negative space	the area(s) between objects, and objects and the edge of the image in figurative work, an important element in the dynamics of a composition. The shape of negative spaces should be carefully observed when making observational drawings as these give a useful measure to the accuracy of the drawing of the positive elements.
Objective	unbiased, impartial view.
Objective drawing	drawings that record the figure, objects or environments just as they are seen.
Organic	based on or relating to nature.
Palette knife	a flexible blunt edged knife used by painters to mix paint on

	the pallet or to apply paint to the support in the creation of an image.
Papier mâché	the name comes from the French 'chewed paper' made from paper pulp mixed with a glue binder or of sheets of paper pasted together to create three-dimensional work.
Partnership	a business that is owned and controlled by two or more individuals. This is common in design consultancies.
Plan chest	a chest of drawers designed specifically to hold large sheets of paper.
Plastic art	a term for three-dimensional art, especially work that has been modelled.
Plein-air	painting out of doors.
Portfolio	both a collection of work, drawing and paintings, and also a case in which to store and transport this work.
Press moulding	a method used to form clay by pressing slabs or sheets into an open plaster mould.
Processes	work sequences, employing a number of techniques and tools or equipment in the development of work.
Prototype	the first model of a design usually used to assess the design's potential.
Realism	paintings or drawings made to portray subject matter as realistically as possible.
Relief	sculptural design which extends out from a flat surface but is not free standing, the degree of three-dimensions a relief may have can vary from almost flat and little more than a textured drawing, to almost totally three-dimensional work that has been mounted on a flat surface.
Research	collecting information, both written and visual, to gain an understanding of a particular set of circumstances or facts.
Resist	a method of making an image by applying a protective coating such as wax, to areas of a design, onto surfaces such as paper or fabric, so that paint or ink will not take to those areas when applied across the surface and so leaving the underlying surface uncoloured.
Slip	liquid clay used as a means of decoration to the surface of a ceramic piece, or used to cast ceramic pieces in plaster moulds.
Sole trader	a business owned and controlled by a single individual. The majority of craftspeople fall into this category.
Stencil	a sheet of paper, card, film etc. in which a design has been cut through. The sheet can then be laid onto a surface allowing the design to be transferred by brushing or spraying paint through the cut out design.
Technology	the tools and equipment required to work media and materials and can range from simple hand tools to sophisticated computer equipment.
Template	a sheet of material such as card or thin metal that has been cut to a specific profile and is used as a guide to cut or draw round, and so allowing the accurate duplication of the shape.
Three dimensional	often shortened to 3D an object with depth, height and width, which can be viewed from every aspect.
Two dimensional	often shortened to 2D work that is flat, created on a surface, usually sheet material such as paper, canvas or board and viewed from the front.

Index